THE TINY MESS

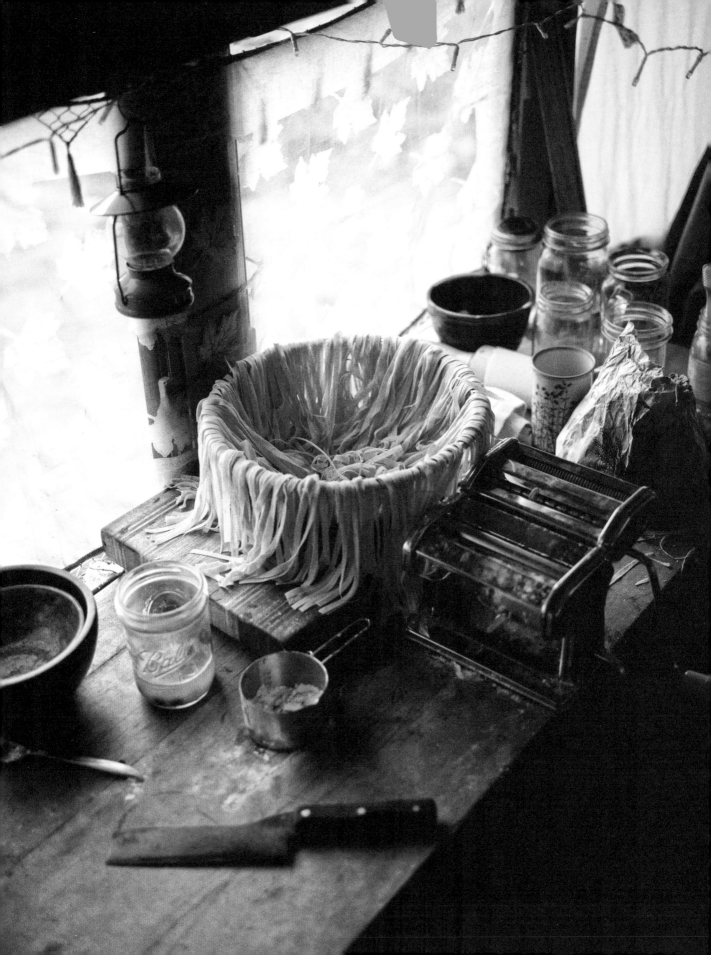

THE TINY MESS

RECIPES + STORIES FROM SMALL KITCHENS

MADDIE GORDON · MARY GONZALEZ · TREVOR GORDON

TEN SPEED PRESS
California | New York

CONTENTS

The Evolution of a Tiny Kitchen | 6
About the Book | 7

Brooke & Emmet, Orcas Island, WA
Tiny Cabin | 8
Land & Sea Breakfast Salad | 15

Tyson, Big Sur, CA
Water Tower | 17
Ebelskivers | 20

Natasha & Brett, Seattle, WA
Airstream | 22
Stovetop Skillet Granola | 24

Tim & Hannah, Truckee, CA
Cabin | 29

Barrett, Santa Barbara, CA
Sailboat | 30

Carie, Mill Valley, CA
Cottage | 33
Kitchen Sink Quiche | 34

Jazmin, Gaviota, CA
Cave | 37
Peach & Mint Spring Rolls | 41

Landon & Friends, Carpinteria, CA
Trailer | 42
Hippy Dippy | 44

Trevor & Maddie, Santa Barbara, CA
Sailboat & Camper | 47
Stinging Nettle Mayonnaise | 53
Carrot-Coconut Slaw | 54
Sourdough Tempura Root Vegetables | 56
Marinade for Low-in-the-Food-Chain Underrated
Sustainable Fish | 59
Smoke Mackerel Empanadas | 60
Sourdough Pancakes | 67

Sespe, Santa Barbara, CA
Octagon Cottage | 69
Mallow Dolmas | 70

Marie & Dean, Skamania County, WA
School Bus | 74
Nopal Cactus Salad | 79
Slow-Stewed Rabbit Tacos | 80

Jessie & Hannah, Roseburg, OR
Cottage | 82
Overnight Vinegar Potatoes | 85
Pickled Eggs | 86

Quincey & Mitchell, Berkeley, CA
Sailboat | 88
Boat Borscht | 92

Aiyana, Santa Barbara, CA
Cottage | 94
Sweet Ginger & Date Dressing | 97

Foster, Columbia River Gorge, WA
Treehouse | 98

Sierra & Colin, Santa Cruz, CA
Trailer | 100
Cider Vinegar | 103
Tomato Jam | 103
Abalone Meatballs | 104

Monique, Santa Barbara, CA
Sailboat | 106
24-Hour Chicken Broth | 108

Mikey & Lisa, Montauk, NY
Tiny House | 111

Mary, Carpinteria, CA
Trailer | 113
Watermelon Poke | 118
Rainbow Carrots | 121
Wild Weed Soup | 122
Tamales Steamed in Avocado Leaves | 124
Yerba Santa Ice Cream | 128
Rich Chocolate Jars | 130

Tomasso & Eva, Oakland, CA
Sailboat | 132
Amatriciana Sauce | 134

Tatsuo, Central Coast, CA
Van | 137

Sonya & Jack, Berkeley, CA
Sailboat | 139
Stovetop-Roasted Chicken | 143

Charlie, Marin County, CA
Tiny House | 144

Jeremy & Sarah, Vancouver Island, BC
Float House | 147
Marinated Lamb Cooked on Coals | 148

Lindsey & Zach, Lopez Island, WA
School Bus 151
Fresh Pasta | 156
Blueberry & Lime Pie | 158

Serena & Jacob, Ventura, CA
Trailer | 160
Mocha Fudge Pie | 163

Meg, Ojai, CA
Tiny House | 165

Ally & Andrew, Santa Barbara, CA
Railcar | 166
Superfood Balls | 169

Ashley & Ryan, Carpinteria, CA
Outdoor Kitchen | 171
Honey-Persimmon Spice Cookies | 175
Rosemary-Honey Gin & Tonic | 176

Zachary, Carpinteria, CA
Trailer | 181
Blackberry Cadillac | 182

Dawn, Santa Barbara, CA
Powerboat | 184
The Aurora Cocktail | 186

Notes on Ingredients | 188
Acknowledgments | 189
Index | 190

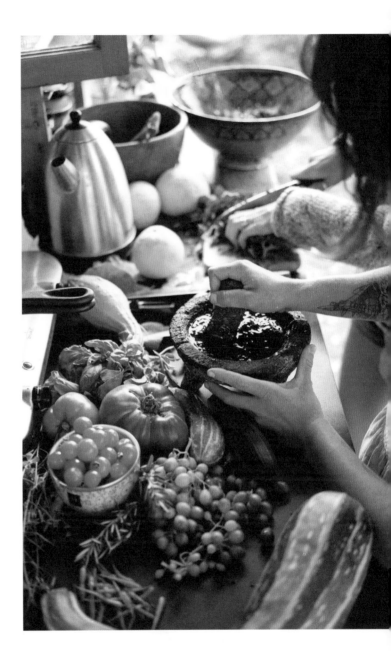

THE EVOLUTION OF A TINY KITCHEN

Writing *The Tiny Mess* got us all thinking about the evolution of our own little kitchens. We haven't always lived in teeny, tiny, unconventional homes, so adapting to a life of less space has most certainly been an evolution for the three of us. We have come a long way from our big, old, cluttered spaces full of useless junk to our small, cluttered spaces full of wonderfully useful junk.

Perhaps you and your living space have had a similar journey into the abyss of extreme downsizing. Perhaps it went something like this:

You started with about eight plates, a dozen mugs, pots and pans in every size, and a plethora of tools and gadgets. You thought you would really need that apple corer, egg slicer, and avocado keeper. There'd be room for them, you said. You had already gotten rid of so much stuff, you said. But then you spent that first month in your new home—navigating your way around your new microsized kitchen, organizing Tupperware like Tetris blocks, and realizing all over again, every single day, that you still have too . . . much . . . shit.

So for your next move, you gutted the kitchen and tossed everything that doesn't fold, stack, stow, or nest. You knocked out some built-ins or ripped out a wall and added some extra countertop. You reanalyzed your inventory and decided to keep only two of everything you eat on or with. Nothing more. You decided you'll be making cowboy coffee from now on. No need for that electric coffeemaker, pointless! Cowboy coffee it is.

Finally, you have space. Real room to breathe. Unfortunately, your kitchen now looks like the inside of a camping store. You want to have friends over, but they'd have to eat with sporks, so you get a couple more plate settings, ditch the enamel mugs that burn your lips, and buy a pour-over coffeemaker because good coffee is something you are unwilling to sacrifice. You acquire a cast-iron skillet because it does nearly everything you could ever ask a pan to do, and like a well-seasoned pair of old Levi's, it doesn't really need washing. That sleek multitool utility knife contraption goes back into your camping kit and instead you find yourself one decent, sharp knife that cuts anything. You part with the color-coded cutting boards and replace them with a lone burly wood board, one that will get funkier and funkier with each meal and fits perfectly over your sink.

Substance over style. Function as a part of form. Simpler. Slower. You are getting the hang of it now.

Perhaps the hardest thing of all during this process is learning how to accept various gifts from well-meaning parents, family, and friends. You know—those completely incompetent small versions of normal tools or some gimmicky ceramic measuring cups that don't even say the damn measurements on them. The people in your life are so excited for you and want to support you, so in the end, you wind up with a special place somewhere in your tiny home for all these mostly pointless gifts because you love the folks who gifted them to you. Sound familiar?

Well, that's because we have been there, too. The three of us have all gone mad with the work of trying to live smaller so that we can lead bigger, more enriching lives. We've plotted and planned, reworked, reconfigured, and redone things a thousand times in our pursuit of a better kitchen, easier cooking, and tastier food. It hasn't been easy, but it has made us wildly more efficient, creative cooks who continue to grow with every obstacle.

Our pantries are filled with food, not appliances. Our cupboards are full of spices and sketchy condiments that most everyone else refrigerates. Our fridges might technically be coolers, but they are packed exclusively with perishables because that's all we have room for. Our counters are stained with stories of meals gone by and roads long since traveled.

And you know what? These are good things. These are things that we are proud of. These are things we continue to work on every day. What we lack in physical space we can gain in peace of mind. At some point, the passing on of unwanted or unneeded goods becomes almost spiritual in feeling. The evolution is endless, as the effort becomes part of the fun. The challenges become part of your charm.

Make no mistake, this book is gritty, grimy, and grubby. It is the real deal from the front lines of the tiny home realization. Other than a few minimally styled food photos, *The Tiny Mess* is a raw account of all the blissful and chaotic cooking currently going on in small kitchens everywhere. Inside you will find stained linens, dirty dishes, works-in-progress, and cheap beer, but with them come soulful meals, tender moments, and deeply nourishing traditions. Sure, elbow room may be hard to come by, but tasty and healthy food most definitely is not.

This book is as much about food as it is about kitchens, and it is as much about kitchens as it is about people. It is those people, their homes, and their favorite recipes that you will meet in the pages ahead. They are but the tiniest selection of all the resourceful and talented cooks out there doing big and delicious things with humble means.

ABOUT THE BOOK

Every recipe in *The Tiny Mess* is accompanied by a short profile about the person or people who created it. We visited each contributor in their home and had them cook their favorite recipe for us in their tiny kitchen. We took the recipes home with us, busted them out in our own little kitchens, and tested them meticulously until they were just right for the purposes of this book. This was a crucial step, as many of the contributors, just like us, are intuitive and versatile cooks who are more inclined to wing it than to follow some rigid recipe. Through careful reverse engineering, trial and error, and, of course, tasting—lots of tasting—we translated each dish into a real-life, easy-to-follow method. You will find credit for the published recipes at the end of their descriptions.

Before we ever made our first kitchen visit, we knew we wanted *The Tiny Mess* to be something that cooks of all experience levels could use and interpret as they see fit. After all, we rarely follow recipes ourselves. This isn't because we are antirecipe but because we rarely, if ever, have all the ingredients on hand. We also like to switch out the occasional ingredient for a flavor that we prefer. We hope this book encourages you to do the same.

On the pages ahead you will find recipes woven into each other, creating culinary trails for you to follow. You might find yourself making Carie's Kitchen Sink Quiche (page 34) and read that Lindsey's piecrust (page 158) would make the perfect quiche crust. Or perhaps you're making Trevor and Maddie's Sourdough Pancakes (page 67) and think that Zachary's blackberry simple syrup (see page 182) would make an excellent topping. You get the gist. This book is a jumping-off point, not a destination. Let this be your invitation to get even more creative, no matter the size of your kitchen!

BROOKE & EMMET, ORCAS ISLAND, WA

When we embarked on this project, we had a picture painted in our heads of the kind of people we'd meet and the lives they'd be living in. We had no idea who we'd run into or who we'd sit down for coffee with. People can live in tiny homes and not care about or have a connection with food. Well, that's not Brooke and Emmet. We think they are the definition of *The Tiny Mess*. Their space was both functional and fantastical, and we came away from our visit with a bellyful of ideas for our own homes and food-first lifestyles, as well as a crystallized vision of what we wanted this project to become.

If you have ever set foot on the San Juan Islands then you already know that things are different there. Time moves slower. It's quieter, too, both physically and in spirit. Your life must adjust to this pace or you will find yourself rushing ahead and missing the magic that the islands are sharing with you. All of the residents are in on this cosmic pace and you'd be a fool not to be a part of it. Brooke and Emmet are living and breathing this mystic island spirit. Their lives are slow and their food is slow, both in growth and preparation. They work with the tides, live with the seasons, and use only what is available to them as they lead modern twenty-first-century lives.

The first thing we learned about Brooke and Emmet upon meeting them was that they are seriously creative folk. Using reclaimed lumber, they built their tiny home from scratch for just over $1,000! Patience prevailed with this project, as scouring estate sales and loitering around the local saw mill eventually helped them bag almost all the lumber they needed. In a similar do-it-yourself fashion, the couple conjures up delectable food, healing medicine, soulful music, and beautiful artwork.

Their home is tucked away in a clearing of woodland on Orcas Island. It is surrounded by salal berries and is a stone's throw away from both their garden and the ocean. They don't own the land, so they built their home on wheels, allowing them to move when they find the perfect plot. Their first summer on the island was spent in

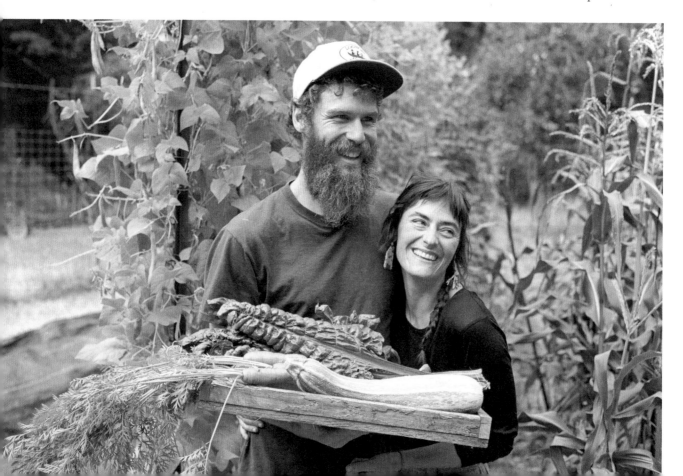

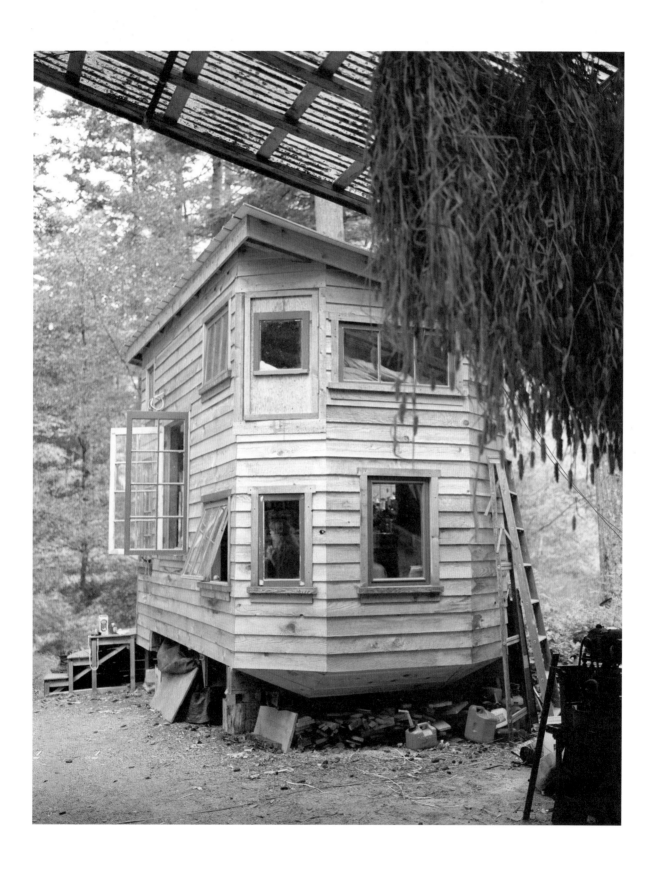

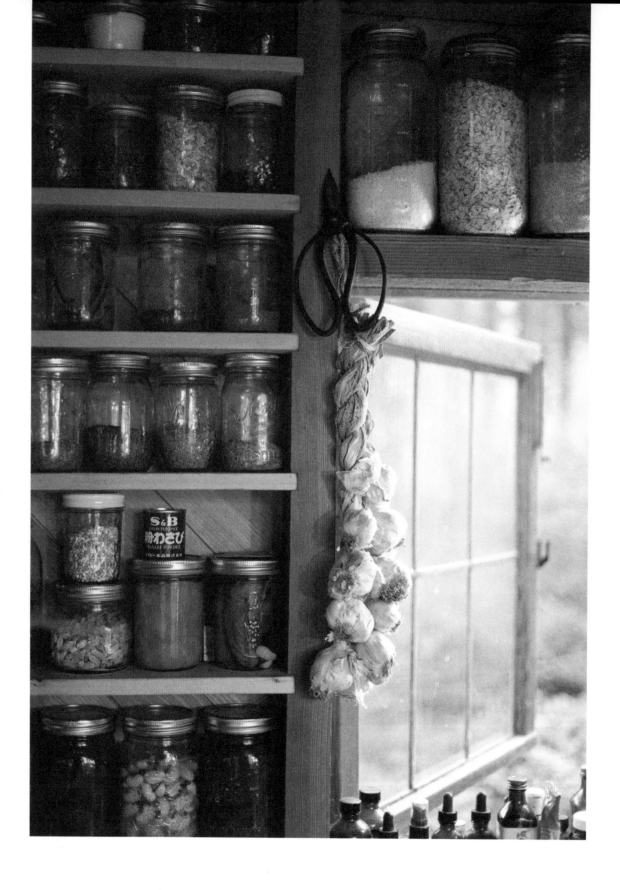

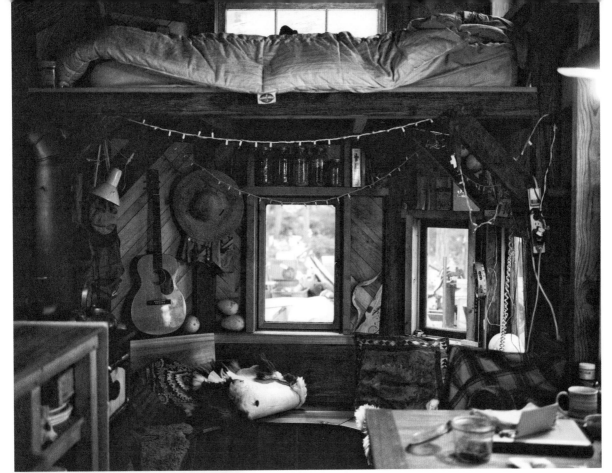

an open-air apartment with no real walls, and that same space remains today as their food storage and preserving spot.

The home itself is open plan, consisting of one room and a loft. The woodstove is lit almost year-round, and when it is, they cook on it exclusively. The sleeping loft is kept warm from the rising heat of the stove, and beneath it is a comfortable U-shaped seating area, lined heavily with rugs and skins and shadowed by an intense collection of books. Every space in the kitchen is occupied with food and tools, but somehow, none of this comes off as cluttered. It's not crap that is everywhere, it's important and useful items, things that they use daily to cook with and to eat. The shelves are groaning under the weight of dried pulses, grains, nuts, and seeds. Braids of homegrown garlic, strings of chiles, and bunches of herbs hang from nails, drying up high in the warm air. Jars of active ferments gurgle away on the countertop beneath a leg of curing venison, while under the floor, cans of stewed game meats wait patiently to be pried open once winter arrives.

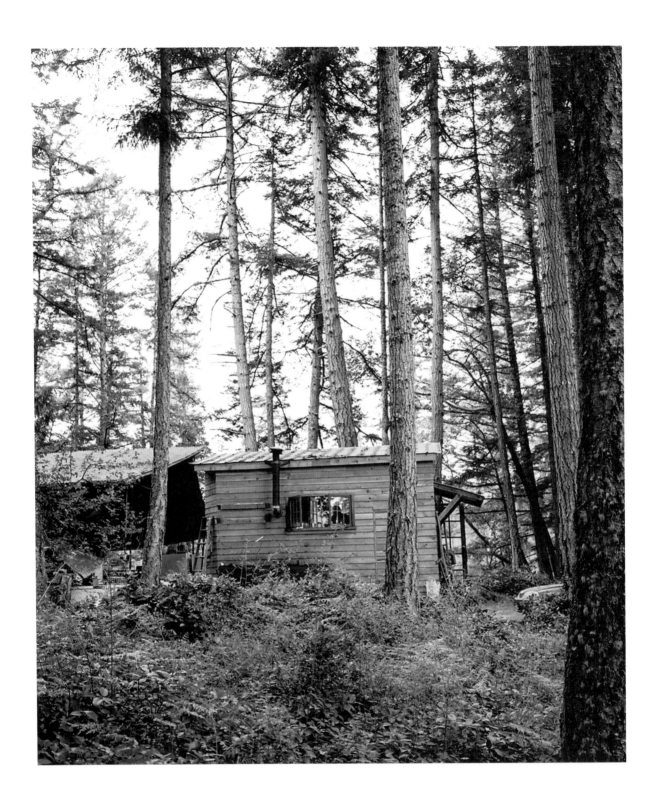

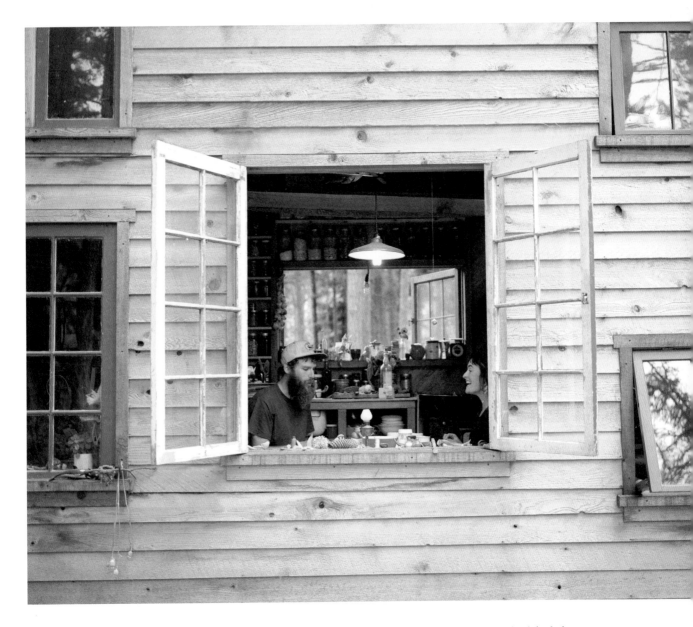

An average meal in their modest island hideaway looks something like this: fresh greens and herbs drizzled liberally with olive oil and lemon juice and sprinkled with plenty of Brooke's Landsea gomasio. Throw in some homegrown polenta and venison sausage made from deer killed by Emmet, and you've got dinner. And that's just the start. They also ferment kraut, kimchi, fish sauce, vinegars, cider, and fruit wines. They make yogurt and cheese, dry their own beans, and cure their meat into salami, prosciutto, and jerky. It's safe to say that Brooke and Emmet are completely and unintentionally apocalypse-ready. They are a true Jackie- and-Jack of-all-trades couple, honing in on practical skills that sustain and enrich their lives.

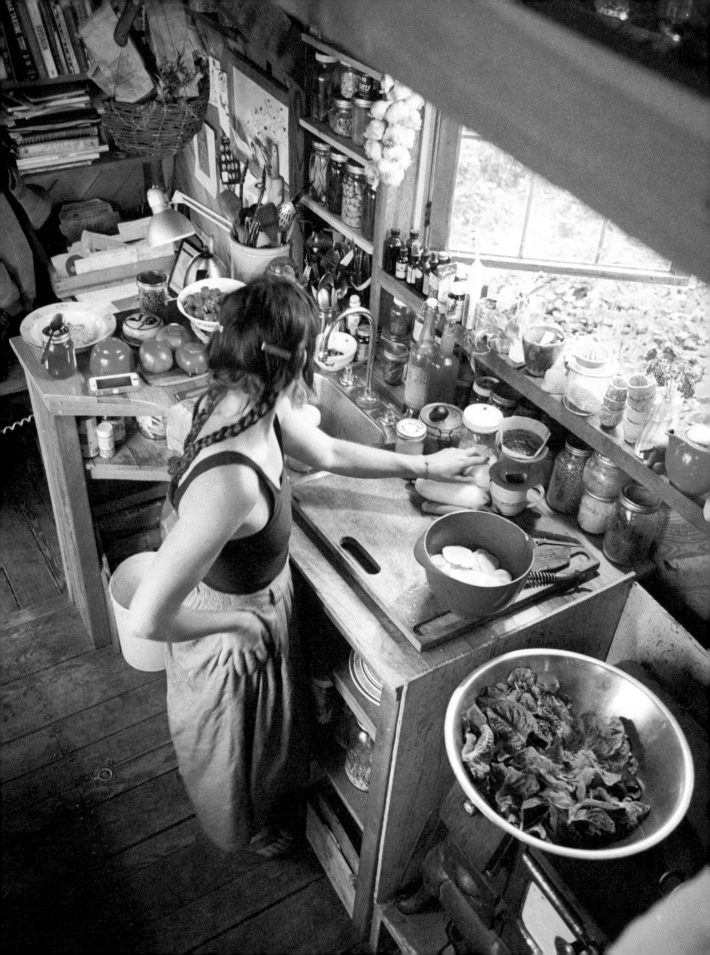

LAND & SEA BREAKFAST SALAD

Tangy sourdough rye toast, creamy seasoned avocado, soft-boiled eggs, and this crisp and refreshing salad make for the most scrumptious breakfast. The addition of Brooke's spectacular Landsea gomasio lends subtle flavors of the ocean and the earth, kind of like the tiny island home they inhabit.

SERVES 4

Salad

4 heads Little Gem lettuce

1 bunch French radishes

2 Persian cucumbers

1 small bunch green onions, white and green parts

1 teaspoon sea salt

2 tablespoons olive oil

1 tablespoon lemon juice

2 tablespoons Landsea gomasio (see note)

Toast

4 eggs

4 slices good-quality sourdough rye bread

2 avocados, sliced

Flaky sea salt and black pepper

To make the salad: Rinse the lettuce, spin or pat dry, and rip the leaves into bite-size pieces. Finely slice the radishes, cucumbers, and green onions. In a large bowl, combine the radishes, cucumbers, and green onions, add the salt, and gently massage it into the vegetables. Add the lettuce, drizzle with the olive oil and lemon juice, and toss gently. Top with the gomasio.

To make the toast: Bring a pot of water to a boil for the eggs. Drop the eggs into the boiling water and cook for 6½ minutes for perfect soft-boiled eggs.

Toast the bread.

Spread the avocados thickly over the toast. Sprinkle with flaky salt and pepper. Halve the soft-boiled eggs, place 1 egg on each toast, and finally pile on the salad.

LANDSEA GOMASIO IS BROOKE'S DELICIOUS VERSION OF THE TRADITIONAL JAPANESE SEASONING, WHICH INCLUDES NETTLES AS WELL AS BULL KELP AND SESAME SEEDS. IF YOU CAN'T GET HOLD OF BROOKE'S, STANDARD GOMASIO WILL WORK GREAT.

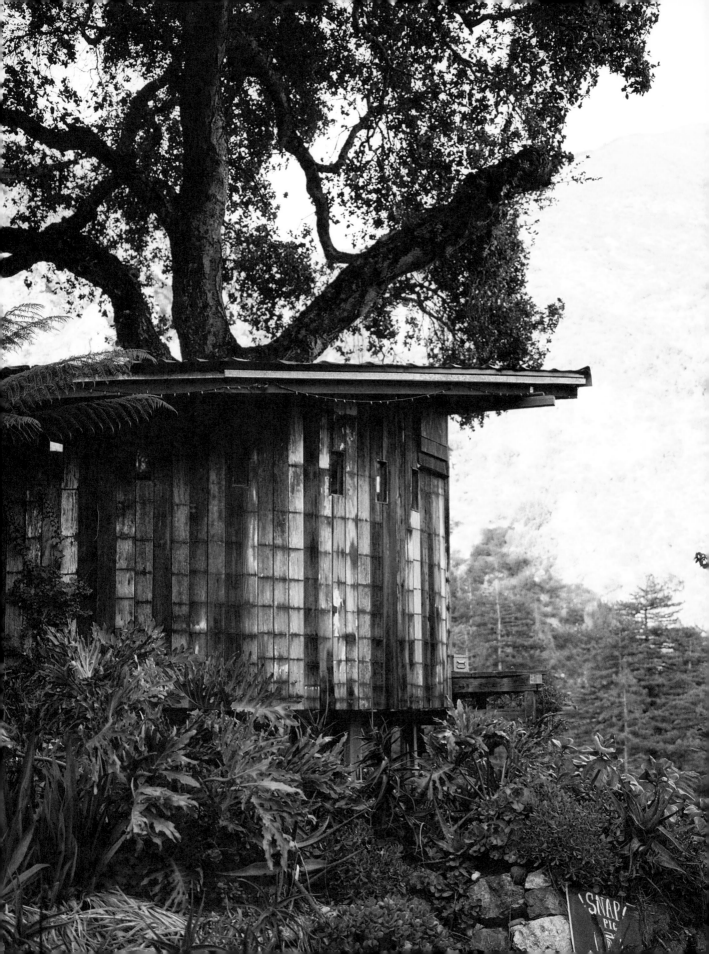

TYSON, BIG SUR, CA

If the apocalypse strikes, you would be hard-pressed to find a better place to weather the storm than the mountaintop ranch that Tyson's family calls home. Above the fog in Big Sur, California, the property is a marvelous yet functional mix of fruit trees, whimsical outbuildings, a clothing-optional swimming pool, chickens, gardens, random art installations, and the converted old water tower that Tyson inhabits. The latter is affectionately known as "The Barrel," an impossibly small and round redwood structure that sits precariously along the edge of a steep, tree-filled canyon.

A self-trained botanist and world traveler of the highest order, Tyson is growing a plant and food collection that most museums would pay big money for, much of it housed in a massive greenhouse he made a few years back. The place is a palace of green and almost entirely made up of reclaimed or reused products, including thousands of old glass booze bottles that Tyson saved over many years working as a bartender. In fact, his backyard operation is so impressive that Tyson managed to go an entire calendar year recently without spending a single cent. He called the exercise Zombie Apocalypse Preparation and lived entirely off things he grew, hunted, or bartered for. Be sure to check out his website (www.zombiesinbigsur.blogspot.com) if you want to see more from that adventure. It includes everything from skinning roadkill to making blue jay stews!

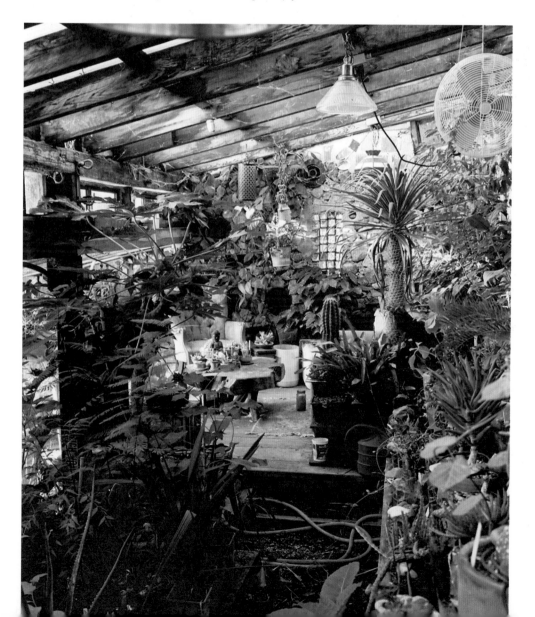

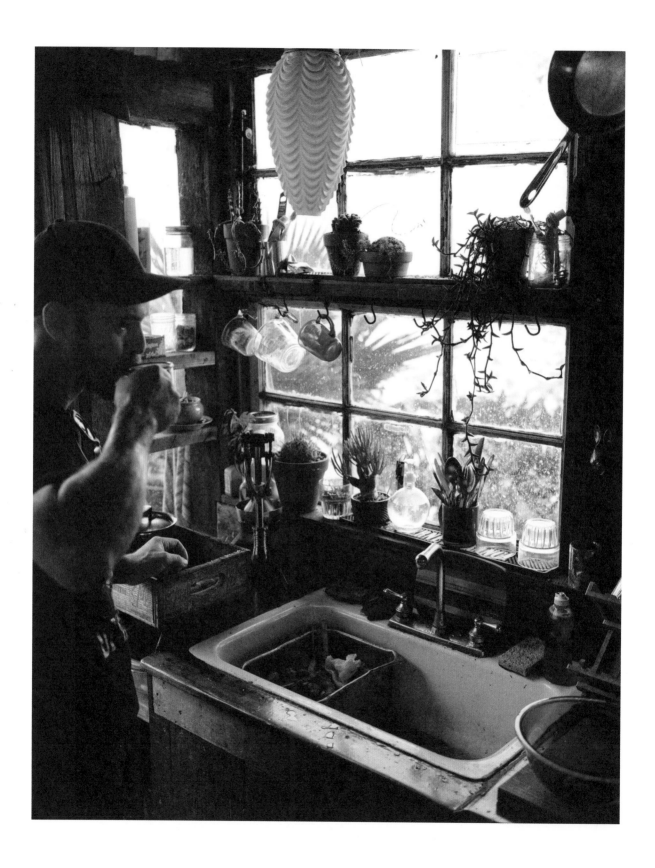

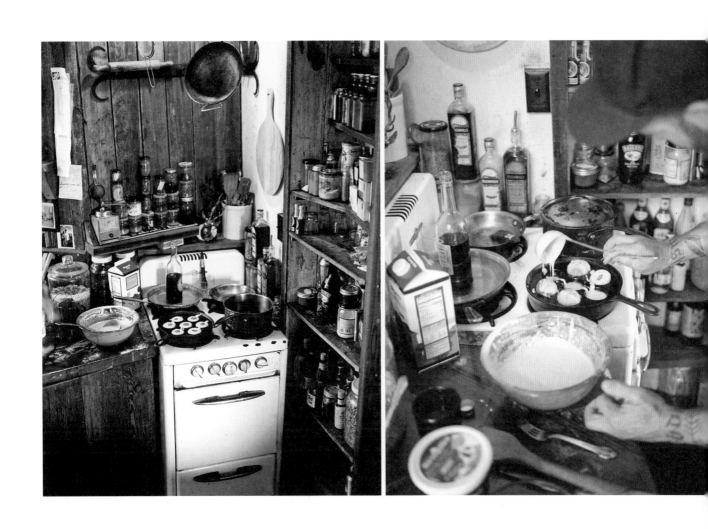

EBELSKIVERS
WITH FRUIT & YOGURT

When we showed up to Tyson's place, we had no idea what an *ebelskiver* was. Turns out that he makes these little Danish breakfast treats using an old recipe his mother passed down to him. These are beyond tasty. In short, ebelskivers are small balls of light and fluffy pancake batter cooked in a special kind of cast-iron pan, and they require meticulous rotation to get their signature shape. Chances are you don't own one of these specialty pans, so we've also tested this in a regular skillet. We baked it like a Dutch baby and topped it with Greek yogurt and fresh fruit. It's not quite a traditional Dutch baby, but it is light and fluffy and really hits the spot.

SERVES 4

3 egg whites

1 egg yolk

2 tablespoons maple syrup,
plus more for serving

1 tablespoon honey

1 tablespoon butter, melted

1 cup whole milk

1 cup all-purpose flour,
plus more as needed

1 teaspoon baking powder, sifted

¼ teaspoon baking soda, sifted

Pinch of salt

Fresh blueberries, for serving

Whole-milk Greek yogurt,
for serving

Maple syrup, for serving

In a clean, dry bowl, whisk the egg whites until soft peaks form.

In a separate bowl, combine the egg yolk, maple syrup, honey, butter, milk, flour, baking powder, baking soda, and salt. You should have a batter reminiscent of thick pancake batter. Add more flour if needed. Fold in the whipped egg whites until just combined, being careful not to overmix.

If you are using an ebelskiver pan: Lightly grease the pan and heat it over medium heat. Pour batter into each section, leaving ¼ inch of room. Add some fruit and a blob of yogurt so the batter reaches just under the edge of the pan. When the batter bubbles and browns at the edges, flip one ebelskiver half on top of another half to make one fantastic round ebelskiver! Rotate the little pancakes to cook the seam edge.

If you are using a cast-iron skillet: Preheat the oven to 425°F. Heat a large, well-greased cast-iron skillet in the oven for 10 minutes. Pour the batter into the heated skillet and bake for about 20 minutes, or until it turns a light golden color.

Serve the ebelskivers or Dutch baby with fruit, yogurt, and maple syrup if you please.

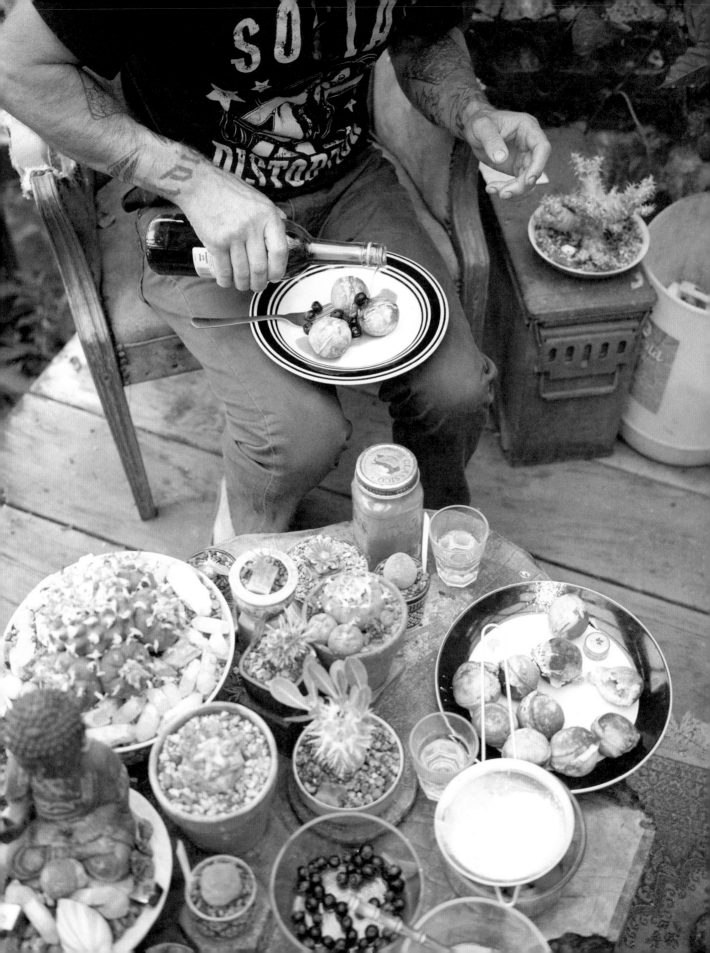

NATASHA & BRETT, SEATTLE, WA

Natasha and Brett live in their remodeled Airstream in northern Washington. This creative couple purchased their home in 2015 and, with plans to live in it full-time, spent an entire year gutting and remodeling it. Prior to the rebuild, they'd spent six months gallivanting around North America in a 1978 Volkswagen camper. They had made it to the northernmost tip of Newfoundland before heading back through the States to their home in Washington, and the thought of simply cut-and-pasting themselves back into "real life" didn't feel right anymore. Enter the Airstream.

Their home is immaculately styled thanks to Natasha's eye for design. An illustrator by trade, Natasha has put a personal touch on everything in the Airstream. She also threw most of the ceramics they own and use. The bright whites, light wood, and pops of color of her preferred Scandinavian style keep things clean but welcoming. Plants make this place feel like an oversize terrarium, and the patterned textiles add a nice contrast to the whitewashed walls. The kitchen is ever so petite and a real treat to look at. Jars of unique wooden utensils, stacks of half-glazed bowls, and fun handcrafted mugs fill the open shelving and the countertop. There's a surprising amount of counter space, which makes prepping meals a breeze. The stove is adjacent to the bulk of the kitchen, giving them even more room to do the tiny kitchen dance. Natasha swears by her Dansk Kobenstyle Dutch oven for quick meals like her favorite work pick-me-up: a grilled Swiss and date butter sandwich.

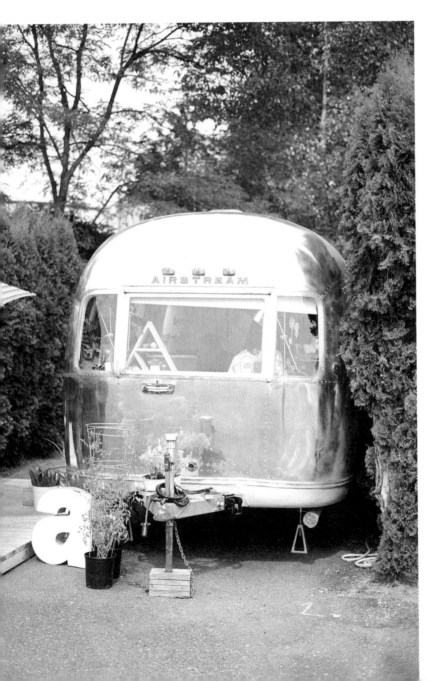

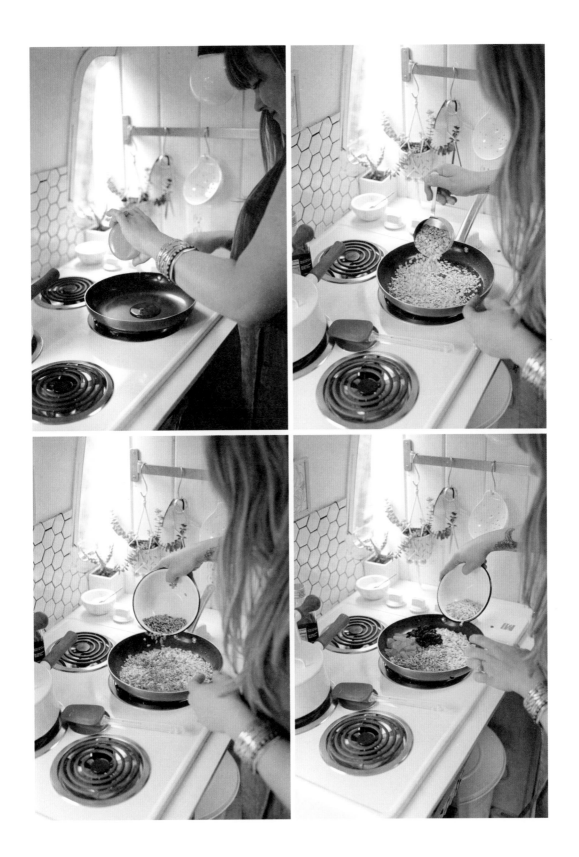

STOVETOP SKILLET GRANOLA

We think this granola recipe from the folks at the "Tin Can Homestead" is just so neat. All three of us have, at some point, lived in a space without an oven and know what a pain it can be to convert recipes that are meant for an oven into ones that work on the stovetop. Thanks to cast-iron skillets and the innovation of Natasha and Brett, granola is now possible. You're going to need to toast your grains for this recipe. It helps make a crunchy granola and adds a pleasant nutty flavor, too. We've written this out as a basic formula because we think it is really fun to create your own combination of flavors. We've added some suggestions, but honestly, just do what feels good.

MAKES ABOUT 4 CUPS

1½ cups grains
rolled oats, rye flakes, buckwheat, millet flakes

6 tablespoons solid fat, plus more as needed
coconut oil, ghee, butter

6 tablespoons honey or brown rice syrup

1 tablespoon molasses

1 teaspoon sea salt

1 tablespoon seasonings
cinnamon, ground ginger, nutmeg, black pepper, allspice, cloves, cardamom, turmeric, vanilla, chai spices, thyme, rosemary, raw cocoa powder, spirulina, medicinal mushroom powders, bee pollen

1 tablespoon citrus zest
grapefruit, lemon, lime, orange, Meyer lemon

1½ cups nuts and seeds
almonds, hazelnuts, cashews, pecans, peanuts, macadamias, walnuts, pine nuts, sunflower seeds, pumpkin seeds, sesame seeds, chia seeds, flaxseeds, coconut flakes

½ cup dried fruit
raisins, apricots, figs, dates, prunes, cherries, persimmons, cranberries, blueberries, banana, goji berries, golden berries

Heat a dry pan over medium heat. Add the grains and toss every 10 seconds until they are lightly golden and smell deliciously toasted! Keep your attention on them, though; they'll burn in the blink of an eye.

In a cast-iron skillet over medium heat, combine the fat, honey, molasses, salt, and seasonings. When the mixture is bubbling vigorously, lower the heat and add the citrus zest, toasted grains, nuts and seeds, and dried fruit. Stir really well and, if it seems too dry, don't be afraid to add another tablespoon of fat. Stir often, making sure you scrape the pan to prevent sticking or burning. Cook for 2 minutes, or until granola is sticky and smells toasted. If you begin to smell burning sugar, remove the skillet from the heat immediately. Let it cool before putting it into an airtight storage container. It will be soft initially, but will harden up as it cools.

FOR GRAIN-FREE GRANOLA, LEAVE OUT THE GRAINS AND REPLACE WITH THE SAME AMOUNT OF NUTS AND SEEDS.

TRY SOAKING, SPROUTING, AND DEHYDRATING THE GRAINS FOR A MORE NUTRITIOUS ADDITION.

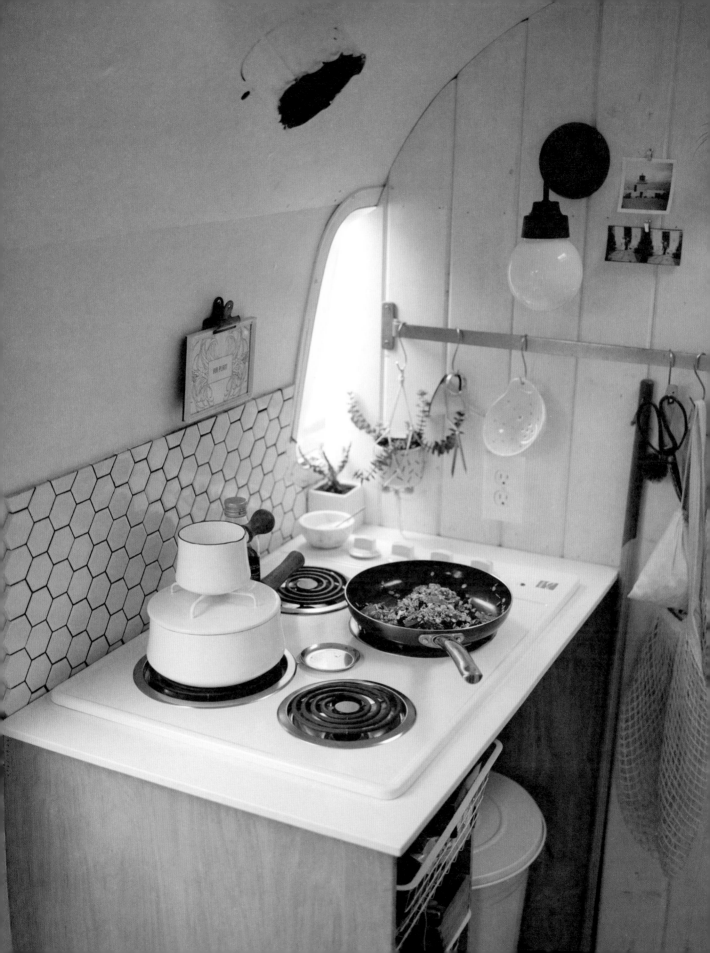

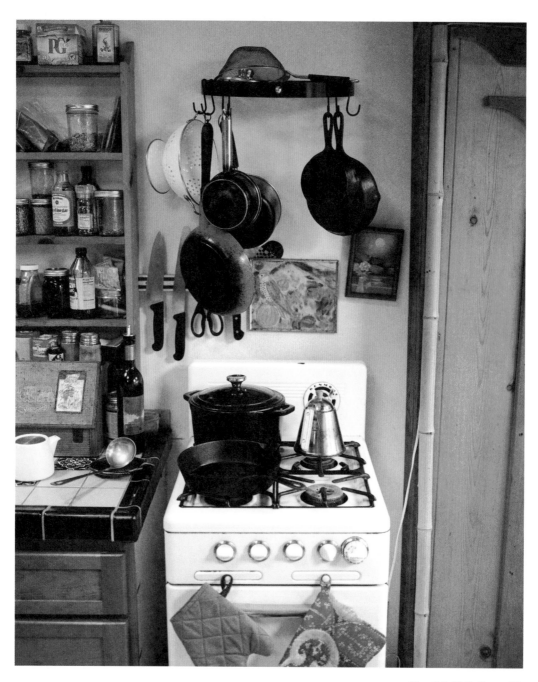

Van & Jeff, Bolinas, CA

Chris & Kate, San Francisco, CA

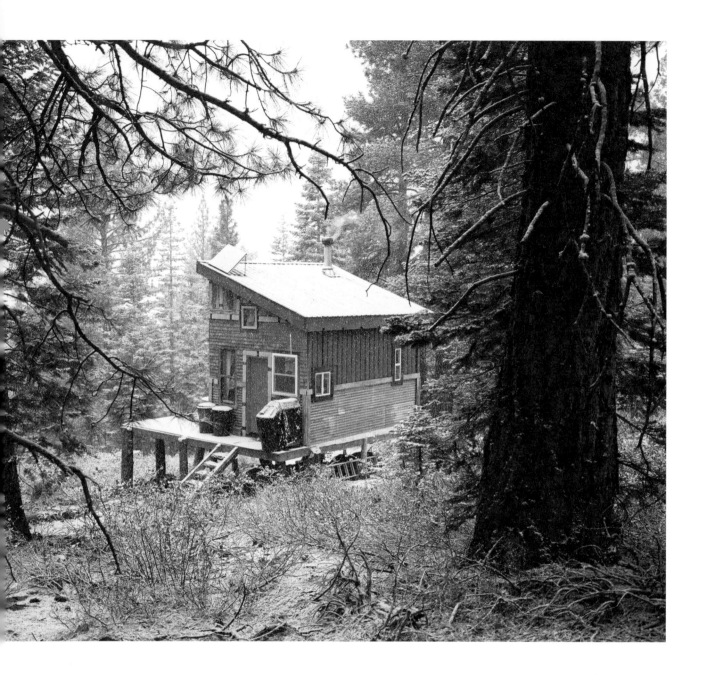

TIM & HANNAH, TRUCKEE, CA

Tim and Hannah's idea was to live within their means and build something that would let them do so with minimal impact on the planet. After a visit to their mountain cabin, we are happy to report that they have achieved their goal and then some. This place is the stuff off-the-grid fantasies are made of.

This couple met at a snowboard camp on Mount Hood in Oregon, a detail that does not surprise you within five minutes of meeting them. Their shared fondness for snowboarding, skating, surfing, and good food, and an intense concern for the environment eventually led them to Truckee, a small mountain town near Lake Tahoe in California. They found a piece of land that ticked all the right boxes for them, and soon enough, they built a cabin that is truly and completely off-the-grid. That term can get thrown around pretty willy-nilly these days, but Hannah and Tim are beyond serious in their quest to cut all cords. There is a well and pump for water, solar panels for electricity, and a composting toilet and bucket shower for bathroom time. A large wood-burning stove burns all winter long, warming the miniature cabin and sleeping loft.

Their only means of refrigeration is a cooler filled with gallon jugs of water, frozen on the porch in the winter months. They feel strongly about limiting their food waste and have found that having fewer resources in their kitchen keeps them on their toes, keeps them conscious, and encourages them to be creative. They cook almost exclusively on the woodstove when it's burning and use their propane stove the rest of the time. The cabin that they have built with their own hands, the garden they tend each season, and the comforting pancakes they griddle on the woodstove for breakfast reassure them that this is exactly where they should be.

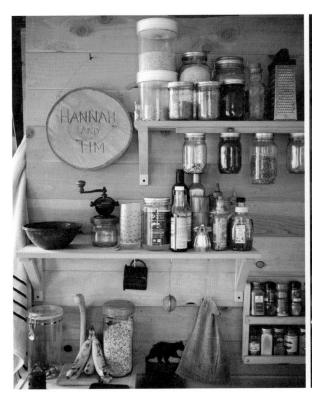
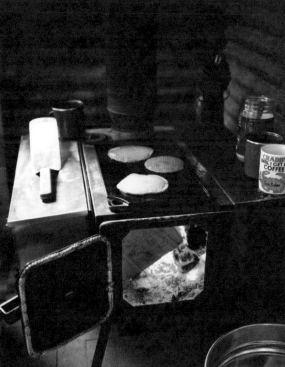

BARRETT, SANTA BARBARA, CA

After a particularly stressful run of housing in Ocean Beach, San Francisco, Barrett promised himself that he'd never pay rent or live with housemates again. Four years, two vans, and one big tent later, he met a 20-foot sailboat named *Eykis*, and they have lived happily ever after.

The galley is but a speck on the tiny scale. It is a truly miniature space. The countertop is broken up into three simple sections: a stove, a sink, and an ice-box cooler. That's it. Barrett keeps a small collection of stoves and cookers under the counter and sets them up wherever he can find space and only when needed. This system is relatively efficient when at dock but is troublesome on the open ocean with no built-in stove or gimbals. With a food spill ratio of 60/40—40 percent being what Barrett actually gets to consume—he is trying to figure out a better system, but without having to take on the challenge of a total galley refit. Such is life in a tiny kitchen.

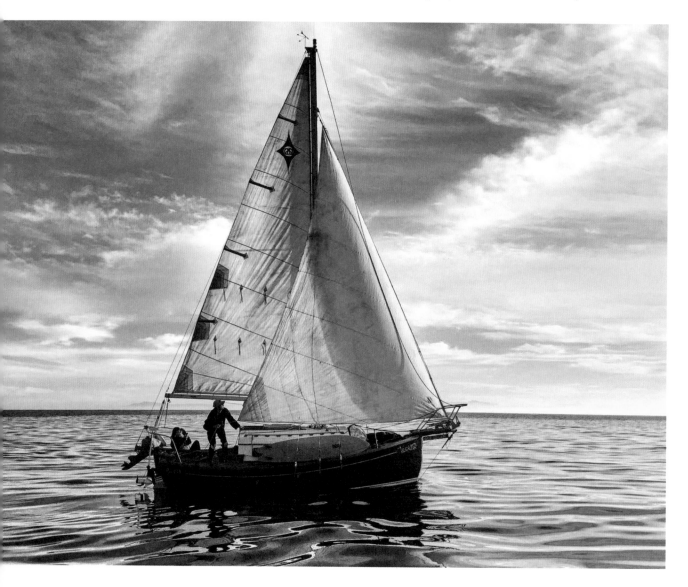

"It took me a while to build up my confidence upon settling in with *Eykis*. I am kinda self-taught, and grew up inland. My first time ever out on a sailboat, my friends crashed their boat into Santa Cruz Island and me and one friend had to bring a 35-foot off the beach. So I entered sailing with a learned cautionary attitude, to say the least. That being said, caution throws itself to the wind whether I want it to or not, and every time I sail to the [Hollister] Ranch or the [Channel] Islands, I get into some kind of shit. The first time I took my girlfriend, Leigh, to the Islands, we got our butts handed to us upon entry and twice exiting. I see why everyone sails in the summer now— we were out there in February during a big northwest swell and took some serious waves to our beam crossing 'windy lane.' A seemingly small wave came above our rail into the cockpit, and it hit Leigh with such force that it knocked us both down on top of each other, soaked. The next day, we made another rookie mistake of trying to cross midday . . . We broke a shackle on the mainsheet and the boom was swinging like a death stick in white capping 'windy lane.' That sucked. After a bumpy fight back at anchor, we fixed the rigging and made an early morning sail back to Santa Barbara, and it was bliss.

"I seem to have the most fun, and the most satisfying adventures, on *Eykis* when I sail solo. It scares the poop out of me, but it is something I just have to do sometimes . . . I try and make these events as drama-free as possible, but they never are. Just yesterday I had to leave anchor with no motor, just my one-mile-per-hour electric trolling motor, and sail home through dense fog with no radar and no gas motor. That sucked, too. The motor came back online ten miles out, and I powered home a little cold and wounded . . . Two of my friends here left two weeks ago for Fiji in a 17-foot slip keel! I pray for them every day."

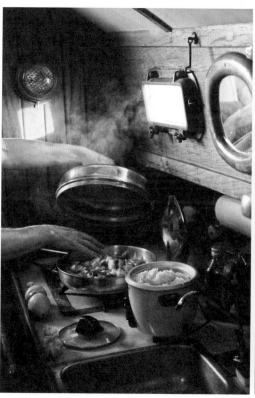
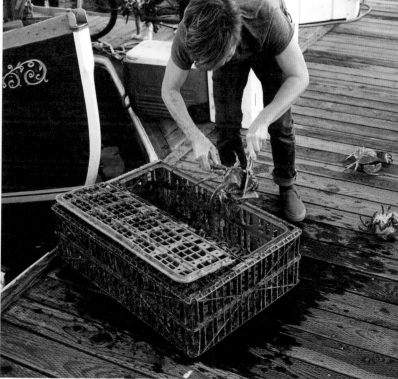

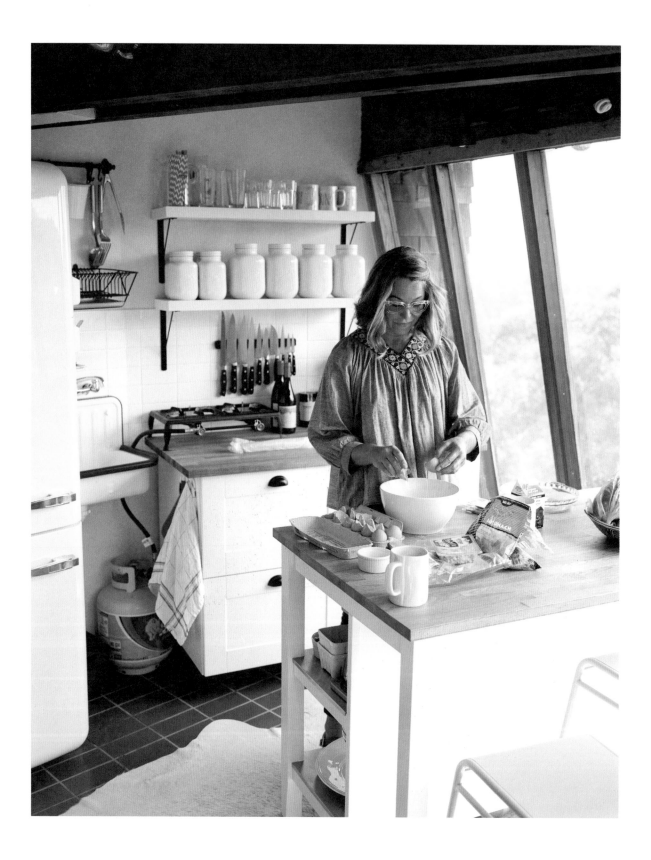

CARIE, MILL VALLEY, CA

A friend put us in touch with Carie, and we were really excited to visit someone on the outskirts of San Francisco. A thirty-minute drive from Carie's tiny home will get you to either downtown San Francisco, some fabled redwood forests, or the Pacific Ocean. It is a real Bay Area gem. The building itself is nested into the edge of a hill with spectacular views of Mount Tamalpais. Carie lives here with her husband and son, and the three of them share the building with her parents, who live on a separate floor. It's a funny little home. It feels like someone took a shrink-ray gun and blasted a full-size house to make it pocket size. The place has just enough room for everything this busy family needs, including two bedrooms and a walk-in closet—an astonishing find in a miniature home.

Carie is an interior designer by trade, so scaling down was not a huge challenge for her. Having seen the clutter that clients have accumulated over the years, Carie understands all too well that a minimalist approach to design can maximize the efficiency of a space and allow her brain to be quiet. She looks at designing her home like putting together an outfit, mixing new with vintage finds. Her Smeg fridge takes center stage, and she swears by the benefits of a minioven, which she cooks everything in. The hardest thing for Carie and her family is keeping all their stuff in the right place. Raising a family in a full-size home is anything but easy, so our hats go off to Carie, who is killing it with her sweet little spot on the mountain.

 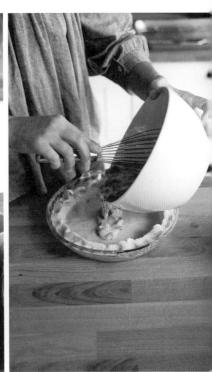

KITCHEN SINK QUICHE

To us, this quiche is the epitome of tiny mess cooking. It is prepared in one bowl and uses up all those wilted and leftover vegetables that are kicking around in your fridge or cooler. Also, you will need an oven for this one. However, we want to challenge Sonya (see page 139) to try to make this on her stovetop in a Dutch oven—we'll keep you posted.

MAKES ONE 9-INCH QUICHE

2 cups chopped vegetables and greens

Salt and pepper

4 eggs

2 egg yolks

¾ cup heavy cream

1 cup crumbled soft cheese or grated hard cheese, plus more for topping if desired

½ cup fresh herbs, finely chopped

Dough for 1 piecrust (see note)

Preheat the oven to 350°F.

Begin by sautéing your vegetables and greens in a medium skillet. A light cook will do before putting them to the side. You need to cook out some of the moisture before adding them to the quiche! Season lightly with salt and pepper.

In a large bowl, whisk together the eggs, egg yolks, cream, cheese, and fresh herbs. Season with salt and pepper if you think it needs it. It can be hard to gauge salt amounts in raw egg recipes, so we just dip a pinky in and taste it.

Grease a 9-inch pie dish and lay down your premade or homemade pie dough into the dish, pinching or crimping the overhanging dough. Using a fork, pierce the dough gently multiple times to prevent it from ballooning during baking. Alternatively, line the dough with parchment paper and fill it with dried beans. Bake the dough for 15 minutes.

Remove the crust from the oven. Stir the vegetables and greens into the egg mixture and pour into the crust. Sprinkle with extra cheese, if you please, and bake for 40 minutes, or until the custard is just set when you gently shake the pan. Allow to cool for at least 20 minutes before serving.

ON PAGE 158 THERE'S A PHENOMENAL PIECRUST RECIPE THAT WOULD BE PERFECT FOR THIS.

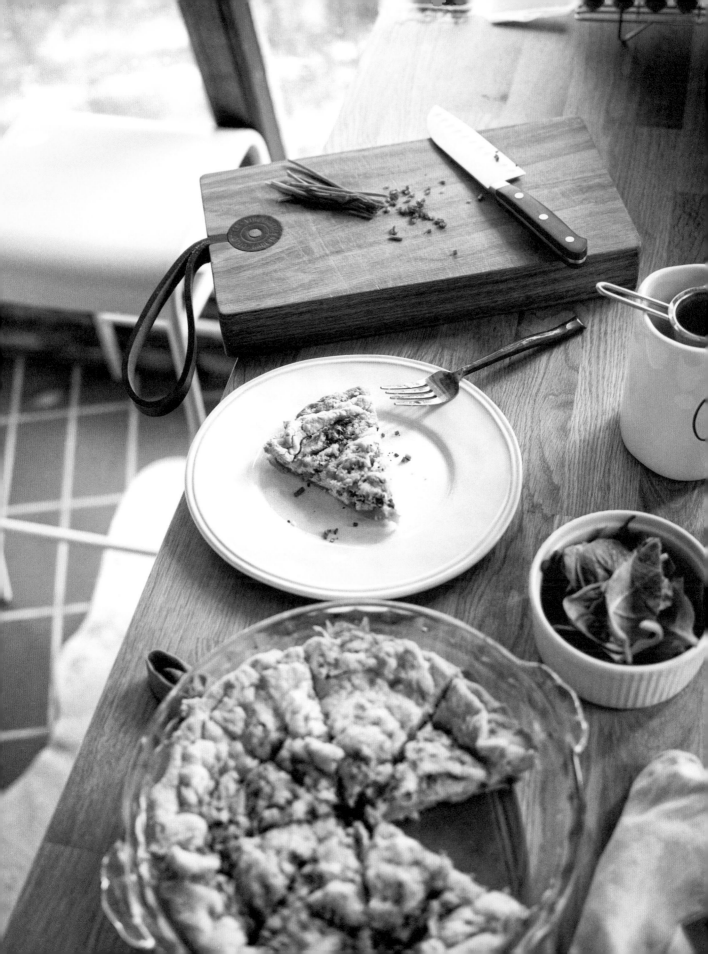

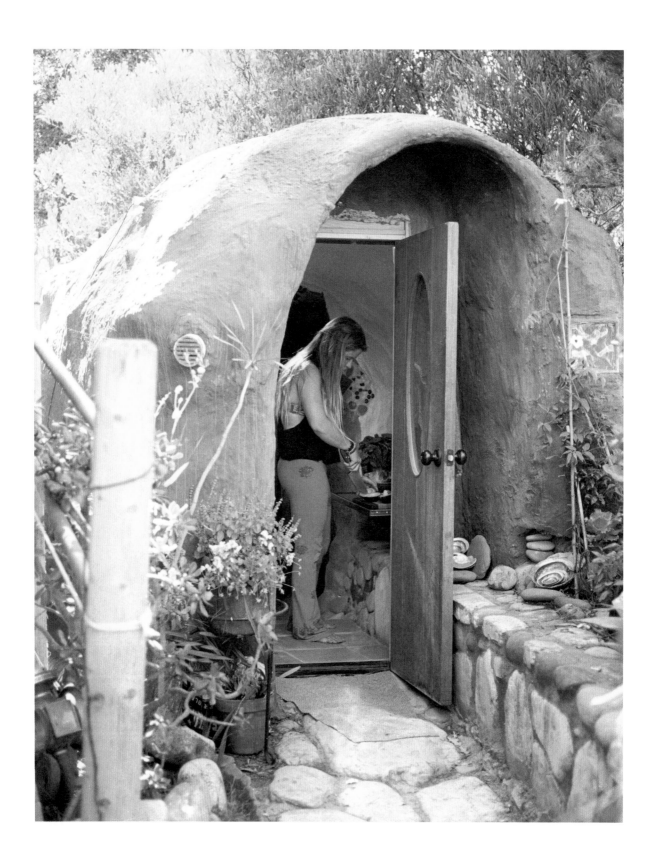

JAZMIN, GAVIOTA, CA

Mary met Jazmin through our local farmers' market here in Santa Barbara and became fast friends with this yoga-teaching wonder woman. When we found out she lives in a 185-square-foot "rock dome," we couldn't believe it and had to find out more. Turns out, the dome is not actually rock, but instead is made out of "papercrete," a mix of concrete and paper around a wire-mesh frame. It feels a bit like Disneyland with its real stone look and an experiential feeling that is anything but. The inside is super-funky and fun and essentially consists of six connected mini rooms/spaces. You walk in through the 55-square-foot kitchen, a late addition to the original dome, which was built in the 1980s. The kitchen leads into a hallway of sorts that is also home to the fridge. The bathroom and a larger central room lead off the hallway. The bedroom is encapsulated in its own minicave with a huge window that essentially opens up onto the beach. Despite being a glorified cave, there is actually quite a bit of natural light in Jazmin's home thanks to skylights, and enough headroom for 5-foot-1-inch Jazmin to do a headstand!

As for the kitchen, it is one of those cooking spaces where you can stand in one spot and just pivot around to reach everything. There is a small countertop on one side and a sink along the opposite wall. There is no cabinetry, as there isn't really any overhead space to use in a dome, but Jazmin has open shelving beneath the counter and storage under the sink where she keeps her beloved juicer and Vitamix. There is a little pullout drawer for utensils, which does double duty as additional prep space when a perfectly sized cutting board is placed on it. She has a two-burner electric stovetop that sits on the counter, an impressively seasoned cast-iron skillet, and a quiver of stackable pans that she uses often and keeps on the stove between uses. The room extends beyond each side of the door jamb just enough that Jazmin has been able to slip in a tiny toaster oven that fits snugly in what would otherwise be "dead space." She bakes up vegan and gluten-free sourdough bread in it weekly. Her kitchen reminds us of a Smart car; it's miniature and funky looking but works like a dream.

Besides the regular homemade loaves of bread, what else comes out of this cave kitchen? Jazmin is a vegan who prefers her food vibrant, alive, and local and her cooking is a chance to showcase this. The spring rolls she made for us were exploding with life—fresh stone fruit, kelp noodles, julienned vegetables, mint, rice paper, and Thai basil all rolled up in wraps. She served them with a satay-inspired dipping sauce using raw, local honey and creamy peanut butter. The perks of working the farmers' market mean she gets a bountiful supply of organic produce to cook with every week for dishes like her signature veggie tacos, which are made up of layered sautéed veggies, wilted greens, beans, cultured cashew cheese, local chipotle hot sauce, avocado, and nutritional yeast, all served hot in soft corn tortillas. When we think of Jazmin and her foodie habits, we can't help but think of the agricultural Shangri-La that California provides us all. Jazmin really is the essence of our state.

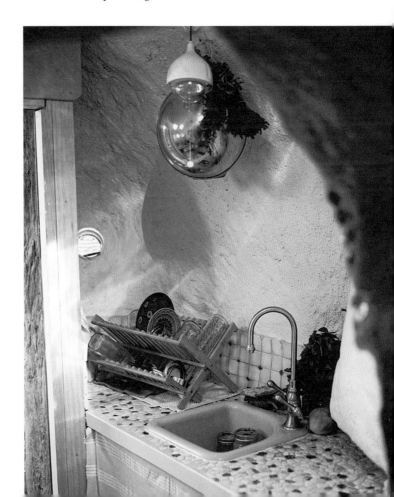

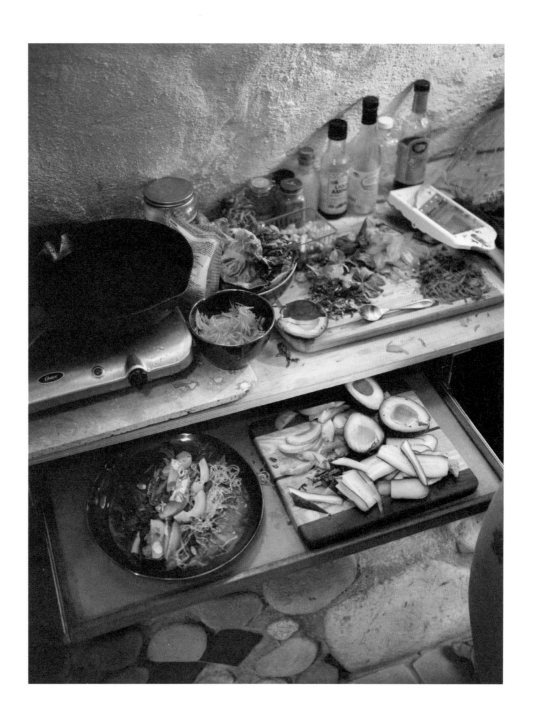

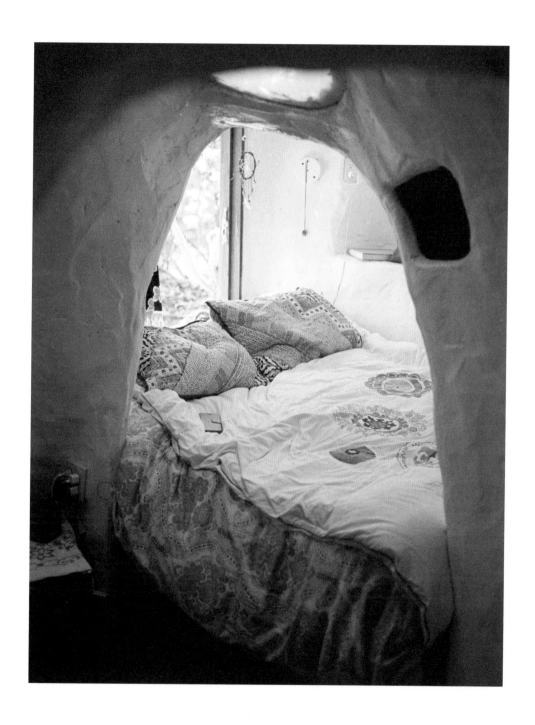

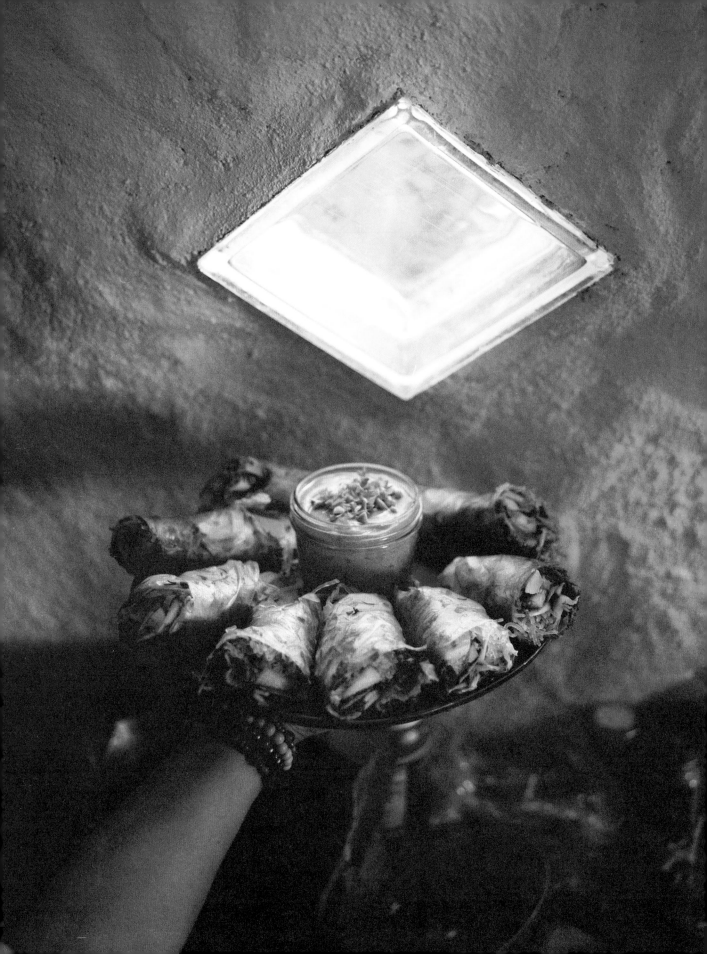

PEACH & MINT SPRING ROLLS
WITH HONEY-PEANUT DIPPING SAUCE

These spring rolls are so fresh and crunchy. The wrappers are translucent, too, so you get to see every bite! As for the sauce, it is salty and sweet and seriously addictive. You will want to pour it on everything. Rice bowls? Yep. Burgers? Hell yeah. Pizza? Ridiculous. Most kelp noodles are sold ready to eat, but check your package to be certain.

Spring rolls

MAKES 18 HALF ROLLS

1 cup each of loosely packed Thai basil, mint, and cilantro,

9 rice spring-roll wrappers

3 peaches, thinly sliced

4 Persian cucumbers, julienned

3 avocados, thinly sliced

4 carrots, julienned

Mixed salad greens

1 cup kelp noodles, ready to eat

Honey-peanut dipping sauce

MAKES 1¼ CUPS

½ cup peanut butter

2 tablespoons olive oil

2 tablespoons sesame oil

1 tablespoon rice vinegar

2 tablespoons cider vinegar

2 tablespoons ume plum vinegar

3 tablespoons soy sauce or tamari

3 tablespoons raw honey

2 cloves garlic

One 1-inch piece fresh ginger, peeled

4 tablespoons water

To make the spring rolls: Finely chop the herbs and set aside.

Fill a shallow dish that is larger than your rice wrappers with warm water. Dip a rice wrapper in the water, let it sit for 15 to 20 seconds, and remove. Lay it on a cutting board and start layering your produce in the bottom third of the wrapper, followed by the noodles. Try not to overstuff the roll; it might be tricky at first but you'll figure out the limits of stuffing. Once you've layered on the fillings, tuck the side closest to you over the filling quite tightly, then fold in the sides like a burrito and roll away from you, keeping those sides snugly tucked in as you do so.

Repeat this step until you've used up all the filling, then slice each roll in half on the diagonal and arrange them on a serving dish.

To make the sauce: In a high-speed blender or food processor, combine all of the ingredients for the sauce and blend until it's thick and creamy. Serve alongside the spring rolls.

TRY USING DIFFERENT COLORED CARROTS AND FRUITS OR EVEN EDIBLE FLOWERS WHEN FILLING THE ROLLS FOR A LITTLE EXTRA FLAIR.

LANDON & FRIENDS, CARPINTERIA, CA

Often, a well-loved trailer can become a time capsule of effort as collections of decades-old décor and furnishings and DIY projects accumulate alongside heavy scents of musk and dust. As we made our visits to assorted tiny kitchens, what never failed to interest us was the process by which this happens and the transformations and upgrades that can go down in a trailer over time. Invariably, they all seem to have the intention of creating more space, and yet they all seem to take a different path to get there. It is fascinating and incredibly helpful stuff to explore, no matter the size of your home.

In short, it seems people have one of two options when approaching their remodel: accentuate your retro roots or modernize, minimize, and whitewash in your quest for extra space. Landon's canyon home is absolutely the former, a true time-travel experience to a sweeter, soulful, and markedly more psychedelic time.

This 35-foot trailer is tucked into the side of a coastal canyon with sweeping views of the Pacific Ocean and is a thirty-minute drive on curvy dirt roads to the nearest town. The trailer actually showed up second to this dreamy location and was pulled straight into an existing barnlike structure in the 1970s. The trailer was sealed into place by some more barn/cabin building shortly after its arrival and has sat snugly on the hilltop ever since. Landon added big windows to the cabin once he moved in, effectively creating a workshop for his carpentry as well as a chill spot that serves as a second living room. A couple of keen cats work to keep the rats away.

As for the trailer itself, it is almost entirely in its original structural state, except for some epic kitchen upgrades Landon has made. He knocked out the old, impractical built-ins to free up more prep space and ripped out the

existing countertops. A large, curved countertop has been installed instead; sharp edges are no fun when you're shuffling around a small kitchen with sizzling-hot skillets of deep-dish pizza. He also built some shelving for sprouting seeds, nuts, and beans—presumably to throw over his favorite kale and roasted beet salad.

Though he has since moved on from this canyon hideout, and relocated up the coast about a hundred miles to a three-acre property with a 300-square-foot house. Landon recalled his old home with fondness, "It was the isolation that I cherished most." Like many of the homes we visited for this book, Landon's living space is a direct expression of the life he wants to live. He can choose when he participates in society and when he doesn't. He can be a hermit and hide out for days on end, making art and music without needing to explain it to anyone. Or he can invite a couple dozen friends over for dinner to munch on some local scallops and uni brought home from the commercial dive boat he works on. Either way, his home proves to be the perfect spot.

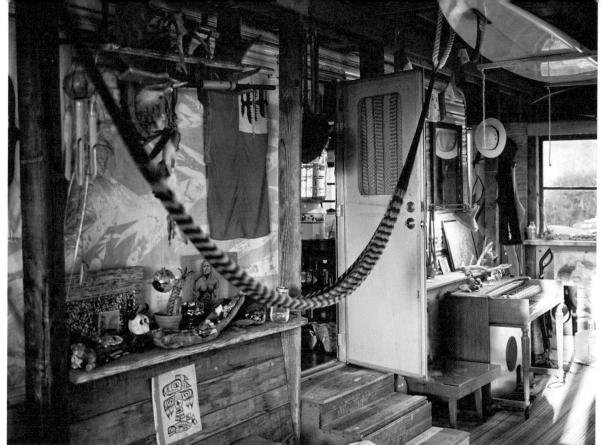

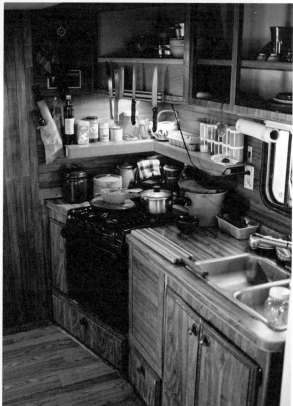

HIPPY DIPPY

This curry, avocado, and sunflower seed dip tastes like a steaming-hot summer spent dancing in meadows, smoking joints in paisley bell-bottoms, and listening to Canned Heat circa 1969. We don't know why it tastes like this, but it does. It takes us back to a place we've never been, and we love it. Chances are you will, too. This dip was created by Landon's pal Kristen in his mini-kitchen for a dinner party we attended, and we couldn't get enough of it.

MAKES ABOUT 2 CUPS

1 cup raw sunflower seeds, soaked in water for 2 hours and drained

½ cup water

2 avocados

2 cloves garlic

1 tablespoon peeled and finely chopped fresh ginger

1½ teaspoons tamari, plus more as needed

3 tablespoons fresh lemon juice

1 tablespoon raw honey

1 tablespoon plus 1 teaspoon curry powder

1 teaspoon paprika

Sea salt

Alfalfa or other fresh sprouts, for serving

Sesame seeds, for serving

In a blender or food processor, combine the sunflower seeds and the water and blend until creamy. You'll probably need to stop and scrape down the sides a few times throughout this process, but it will get there. Add the avocados, garlic, ginger, tamari, lemon juice, honey, curry powder, and paprika and blend until everything is visibly combined and smooth. Taste and season with salt or more tamari.

Transfer the dip to a serving dish and top with sprouts and sesame seeds. Serve with retro crudités, flax crackers, or sourdough toast and prepare to time travel.

IF YOU DON'T HAVE A HIGH-SPEED BLENDER OR A FOOD PROCESSOR, YOU CAN SWAP THE RAW SUNFLOWER SEEDS FOR PREMADE SUNFLOWER BUTTER, BUT IT WON'T BE AS SMOOTH. IT'S REALLY GOOD SMOOOOOTH!

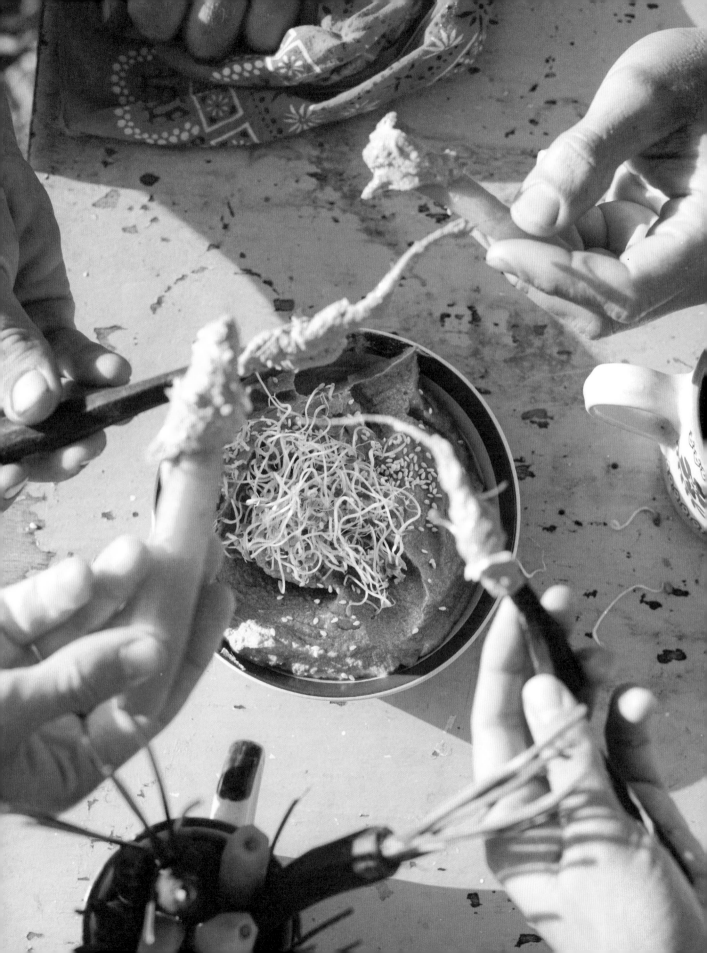

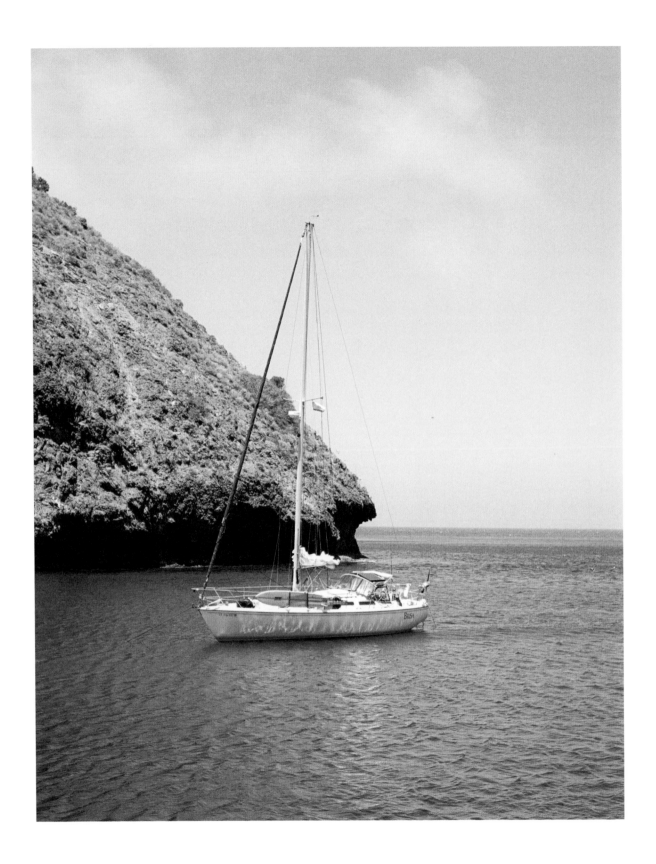

TREVOR & MADDIE, SANTA BARBARA, CA

We are two-thirds of *The Tiny Mess* and live full-time aboard our 36-foot Catalina sailboat, *Brisa*. Both of us grew up sailing in our respective homelands. Trevor gallivanted around the Channel Islands off the California coast year-round with his family, first in their 30-foot Catalina and later aboard powerboats before finally settling upon a 52-foot Cheoy Lee motorsailer named *Endeavour*. I grew up in England hiking half a mile out in knee-deep mud to a 24-foot double-keeled sailboat, *Lucy-Kate*. We'd wait eagerly for the tide to lift her, then bob up and down the murky waters of the English Channel.

Galley navigating and cooking, however, was relatively new to us as full-fledged grown-ups living on our own. Not only is our galley of the smallest proportions, but it's moving, too, which presents problems of its own. First, one must find their sea legs. For fresh liveaboards, this is not as simple as it sounds. Nearly a year after the purchase of *Brisa*—and many cruises later—I could finally make a channel crossing without my stomach somersaulting and can now happily get to work in the galley and throw together some finger-licking food for the captain and any hungry crew while under way.

(I swear the trick to overcoming uneasy queasiness while at sea is to mindfully find my sea legs. I treat my body like a gimbal, anchoring my feet firmly, bending each knee simultaneously to offset the rocking of the boat and keeping my upper body still and centered. So far, so good.)

If your kitchen is moving, then your stuff should not be, which introduces us to the second set of problems we face: stashing and storing. *Brisa*'s galley is most certainly functional but definitely belongs to liveaboards. You won't

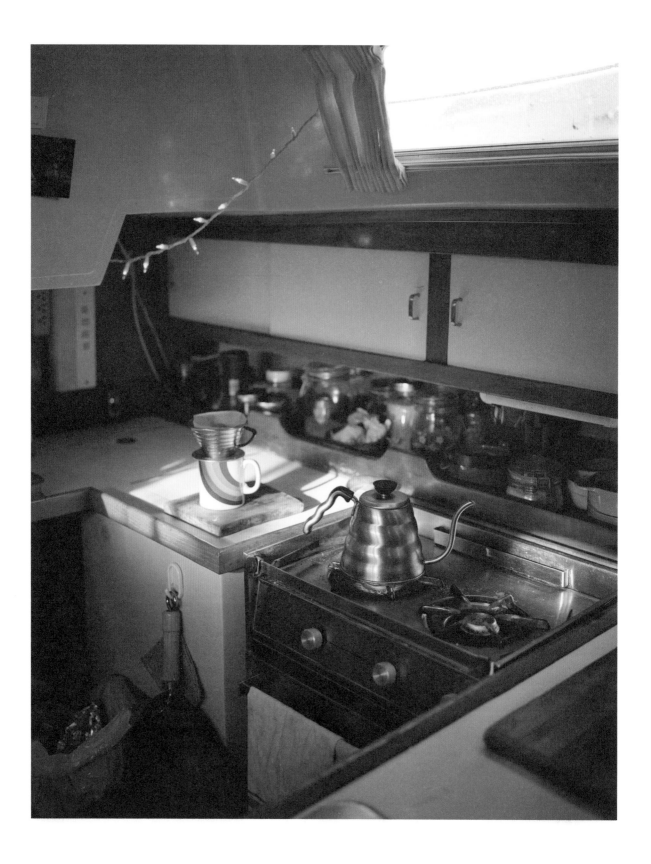

find stacks of outside-friendly acrylicware on board; instead we use ergonomic, stackable ceramics exclusively. For us both, eating off of ceramics and using real cutlery and mugs cannot be compromised. Before the dock lines are dropped, everything must be stacked in the cubbies, glassware nested in the sliding cabinets, and any appliances buried in a crammed and unorganized hole beneath the countertop.

Brisa holds 72 gallons of fresh water and has a saltwater pump that we use to rinse dishes when cruising. We're hooked up to shore power when docked at our home in the Santa Barbara Harbor but run off batteries, charged efficiently by 180 watts of solar power, when we are away from the dock. The galley is a sort of U shape and there's just enough room for two to prep meals if we stick to our own sides of the U. Obviously, a tangle of limbs and curse words are inevitable when there are too many cooks in the kitchen, so we usually take turns. Plus, I'm kind of a kitchen control freak, so Trevor often just stays out of my way, and I don't blame him. A two-burner Hillerange propane stove and oven takes center stage, and a cavernous hole of a top-loading fridge sits in the countertop to the right of it.

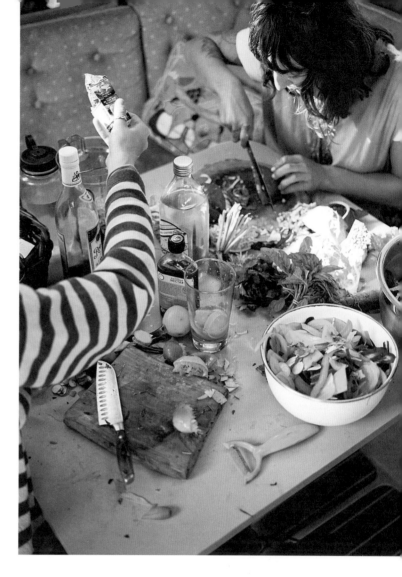

For the most part, it is pretty plain sailing in *Brisa*'s galley, until, of course, the boat breaks—and we all know boats break. They're often damp, have too many moving parts, and need regular care, or else. Once, we were without an oven for over a year while we tried to figure out what was causing it to malfunction. Twelve months of boiled, steamed, and stir-fried food took their toll on us and we wish we had already learned the Dutch oven tricks that we discovered later on during this project. Don't take crispy edges and caramelized crunchiness for granted, folks. The struggle is real! The fridge can be problematic, too. It keeps food cold but has no real structure to it. It is essentially a big hole with an unattached floating shelf that moves of its own accord. We're currently working on that, trying to figure out a way to turn the existing fridge into a fridge-freezer hybrid so we can freeze fish when we catch them.

We cruise mostly in the summer and fall, exploring the 160 miles of Channel Islands just offshore here in Southern California. The islands and surrounding waters provide us with seemingly unlimited fishing opportunities. Hefty bonito, 20-plus-pound yellowtail, and sabiki rigs jiggling with feisty mackerel are among our favorite sights when cruising and provide us with welcome protein-rich provisions. Ceviche spiked with tequila and fresh pineapple, calico bass tacos with fruity salsa, and smoked mackerel a hundred different ways are a few of the things you might find at our dinner table if you hop aboard around sunset. Just make sure you bring a bottle of wine to wash it all down.

We keep what little storage we have crammed with olive, coconut, and sesame oils, as well as lashings of salty seasonings, piquant sauces, and fruity vinegars. We eat a mostly grain-free diet, munching instead on root vegetables, including a thousand preparations of ever-versatile sweet potatoes. When grains are in the cards, it is usually sourdough pancakes, pizza, or homemade 24-hour fermented 100 percent rye bread. My starter, Nigella (named lovingly after the curvaceous and saucy British TV chef Nigella Lawson), sits on the countertop waiting eagerly for her daily feed. The undercabinet storage is crammed with spices, herbs, fresh garlic and ginger, and my favorite Maldon sea salt. The fridge is packed with pasture-raised eggs (we get a bit panicked when we're running low), vegetables, and things we can eat for breakfast. We turn to Asian food a lot because it's usually quick to cook and we love the balanced flavors, savory sauces, and tangy dressings. We keep the undercounter dry storage full of canned goods, including Thai curry pastes, coconut milk, fish sauce, and yam noodles. It's amazing how quickly an incredibly tasty dish can be thrown together with some fresh cilantro, ginger, garlic, lime, fish sauce, and noodles. Crack an egg on it, and dinner is ready.

What we enjoy most about living on a boat, however, is the option to get up and leave should we feel like it. We're beating the rising rent of the city while also planning our great escape, a long-distance cruise toward warmer anchorages. We will definitely need a freezer for that trip, though, as well as a pressure cooker to speed up cooking time and to can fish. Trevor has big plans to rig up a cold-smoker as well as a solar dehydrator for additional preservation of foods. A watermaker would be ideal as well and is on the list for us. We want to try our hand at curing fish, too. The list always seems to be growing.

The Tiny Mess has been an eye-opening and inspiring kick-up-the-arse for us. Visiting with other sailboat-dwelling couples and sharing stories and cruising plans has encouraged us to make plans of our own. Perhaps the most influencing visits, however, have been those with master food preservers like Brooke and Emmet (see page 8). Although we are without a garden and livestock, the ocean and all her offerings are at our fingertips every day, so figuring out ways to harness and, most important, preserve those offerings are our biggest and most exciting

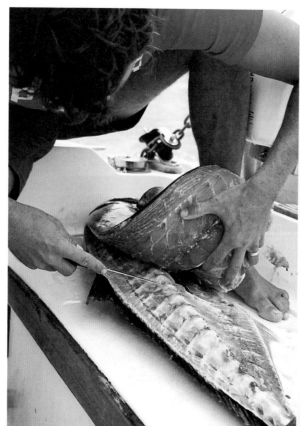

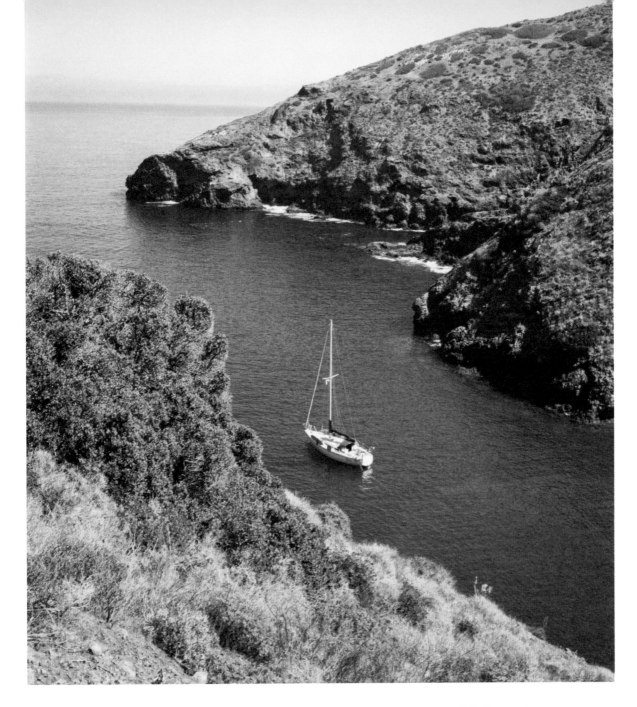

challenges. Learning hot- and cold-smoking techniques, how to build dehydrators, and the limits of pressure canning provides imperative lessons when provisions and morale are low.

Truly, this project has been life-changing for us. Nothing has been more humbling than sharing meals, lovingly prepared in kitchens that, while lacking in size and stature, have it all and more. The generosity and overwhelming knowledge that the folks featured in these pages possess are both refreshing and deeply encouraging to us, especially in a time when "stuff" holds more value for the mainstream than company and experience. We look forward to seeing what *The Tiny Mess* will unearth for everyone involved and hope that the tiny kitchen, big food revolution will continue to inspire people to find the time and space for soulful meals.

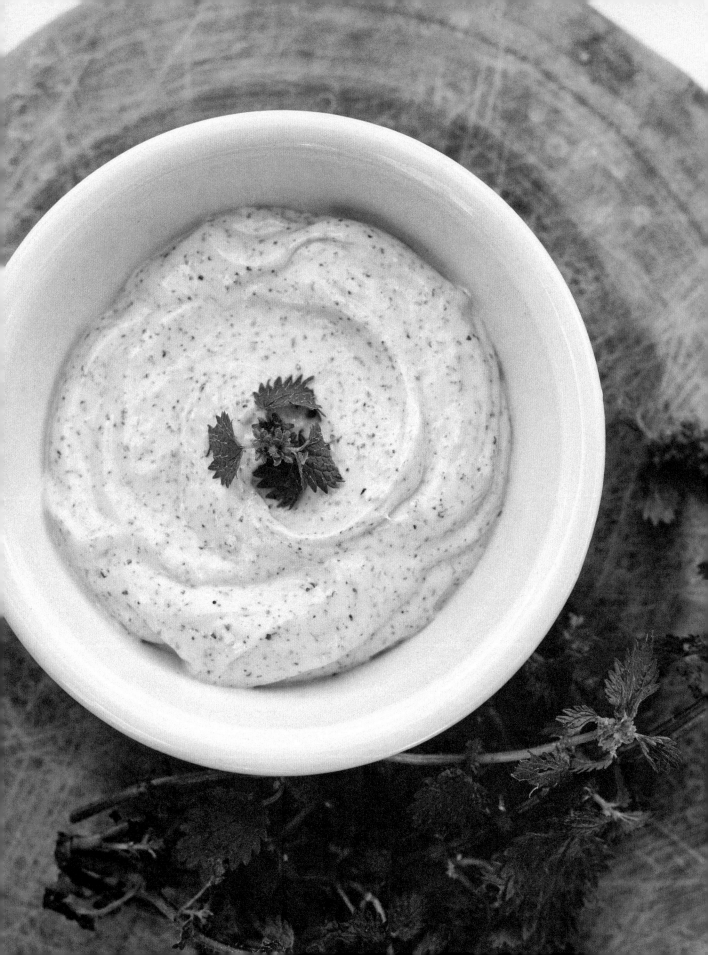

STINGING NETTLE MAYONNAISE

Store-bought mayonnaise is nearly always made with unhealthy vegetable oils, unless you pay top dollar for those primal avocado oil brands. Luckily, it is easy and cheap to make your own—and, dare we say, nutritious! This takes about 3 minutes in total, and we swear you'll never go back to store-bought. Note that you will be eating raw eggs so buy the best you can find.

MAKES 1½ CUPS

2 cups nettles or other wild greens

1 egg

1 egg yolk

2 tablespoons fresh lemon juice

½ teaspoon sea salt

1 cup sunflower oil, avocado oil, or other neutral-tasting nut/seed oil, plus more as needed

Optional seasonings: garlic, spices, herbs, or horseradish

If you are using nettles, make sure to use only tender green leaves. Wearing gloves, wash them well, blanch in boiling water for a minute, then strain and run under cold water. Squeeze the water out of the nettles and set aside. You can also blanch any other greens using the same method to retain the bright color.

In a blender, combine the egg, egg yolk, and lemon juice and blend on low speed for 10 seconds. Continue blending on low and add the salt, then very slowly trickle in the oil. When all the oil has been added, the mayonnaise should be thick. If it hasn't thickened completely, try adding up to another ¼ cup oil.

When it is properly thickened, throw in your nettles and any other seasonings and give it one final whizz on high speed. The end result should be really thick.

This mayo will keep in an airtight container in the fridge for up to 3 days.

CARROT-COCONUT SLAW
WITH MACADAMIA & CHILE DRESSING

In this unusual slaw, grated carrot and shredded coconut are tossed in a creamy macadamia nut dressing. It's packed with vibrant Southeast Asian flavors like lime, chile, garlic, and fish sauce. We often eat this salad by itself, but it is exceptionally tasty in a pulled pork roll with some barbecued pineapple, too.

SERVES 4 AS A SIDE

Dressing

1 cup raw macadamia nuts, soaked in water for 12 hours, drained, and rinsed

1 cup water, plus more as needed

2 cloves garlic

Medium fresh red chile, stemmed and seeded.

1½ teaspoons fish sauce

2 tablespoons fresh lime juice

1 tablespoon soy sauce, plus more as needed

1 tablespoon raw honey

Pinch of sea salt, plus more as needed

Salad

5 cups shredded carrots

1½ cups unsweetened shredded coconut

¾ cup fresh cilantro leaves, coarsely chopped

To make the dressing: In a high-powered blender, combine the macadamia nuts, water, garlic, chile, fish sauce, lime juice, soy sauce, honey, and salt. Blend until the mixture is thick and seems to be able to blend no more, then pour in additional water until the mixture can freely move in the blender, up to 1 cup more. It should be smooth and the consistency of mayonnaise. Taste and season with more salt or soy sauce. The dressing will keep in an airtight container in the fridge for a few days.

To make the salad: Toss the shredded carrots and coconut with most of the cilantro, reserving a sprinkle or two of cilantro for garnish. Dress the salad right before serving, as the dressing draws some moisture out of the carrots. Drain any liquid before refrigerating leftovers in an airtight container for up to 3 days.

FOR A FISH-FREE VERSION, REPLACE THE FISH SAUCE WITH 1 TABLESPOON OF RAW MISO.

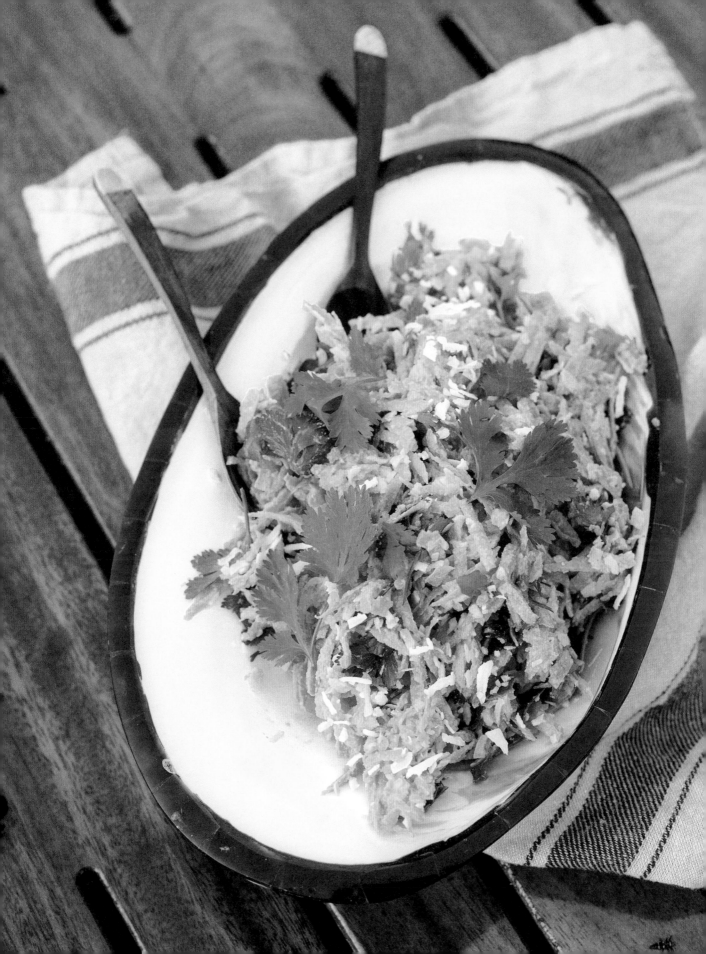

SOURDOUGH TEMPURA ROOT VEGETABLES
WITH PONZU DIPPING SAUCE

This recipe is such a good way to use up surplus sourdough starter while showcasing the best of local seasonal vegetables. We love to switch this one up, too, using a variety of warm-hued roots in the winter and crispy, crunchy spring vegetables when the seasons start to change. The dipping sauce is bright, vibrant, and versatile, and any leftovers make a killer marinade or dressing. Your starter need not be recently fed, though it's fine if it is. It really doesn't matter too much for this particular recipe.

SERVES 4

Ponzu dipping sauce

1 tablespoon fresh lime juice

2 tablespoons fresh lemon juice

1 teaspoon lemon zest

1 teaspoon *sambal oelek*
(chile-garlic paste)

2½ tablespoons soy sauce

3 tablespoons rice vinegar

2 tablespoons fresh orange juice

1 tablespoon maple syrup

¼ teaspoon sea salt

Tempura

A good selection of colorful vegetables (we used beets, purple sweet potatoes, heirloom carrots, green onions, and green beans)

1 cup sourdough starter
(see page 188)

½ teaspoon sea salt

½ teaspoon baking soda

Sunflower oil, coconut oil, lard, or tallow, for frying

To prepare the sauce: Combine all of the sauce ingredients in a jar, put the lid on, and shake well. Pour into a shallow dish for dipping and set aside.

To make the tempura: Prepare your vegetables by washing them thoroughly and cutting off any tough ends; if they are not organic, be sure to peel them. Use a rainbow of vegetables and cut them into different shapes. It's fun to combine long green beans with thin disks of bright red beets, spears of parsnips, and little squash crescents. Go wild and experiment! You really can't go wrong.

For the tempura batter, mix the sourdough starter with the salt. Slowly pour in water while stirring until your batter reaches the consistency of heavy cream. Mix in the baking soda.

Heat at least 4 inches of sunflower oil or the fat of your choice in a large, heavy pan over medium heat. To check the oil temperature, gently drip some tempura batter into the pan; if it sizzles immediately, your oil is good to go. At this point, turn the heat down to medium-low. Coat each vegetable piece well with batter and wipe them gently on the side of the bowl to remove any excess before you fry. Lower the vegetables gently into the hot oil, making sure to not overcrowd the pan. They are done cooking when golden brown. Remove them from the oil with a slotted spoon and place on an old towel to soak up excess oil before serving with the dipping sauce.

ANY LEFTOVER BATTER CAN BE MADE INTO SKILLET CRUMPETS, JUST BLOB LIKE PANCAKES INTO A HOT, OILED SKILLET AND FLIP WHEN IT'S BUBBLY.

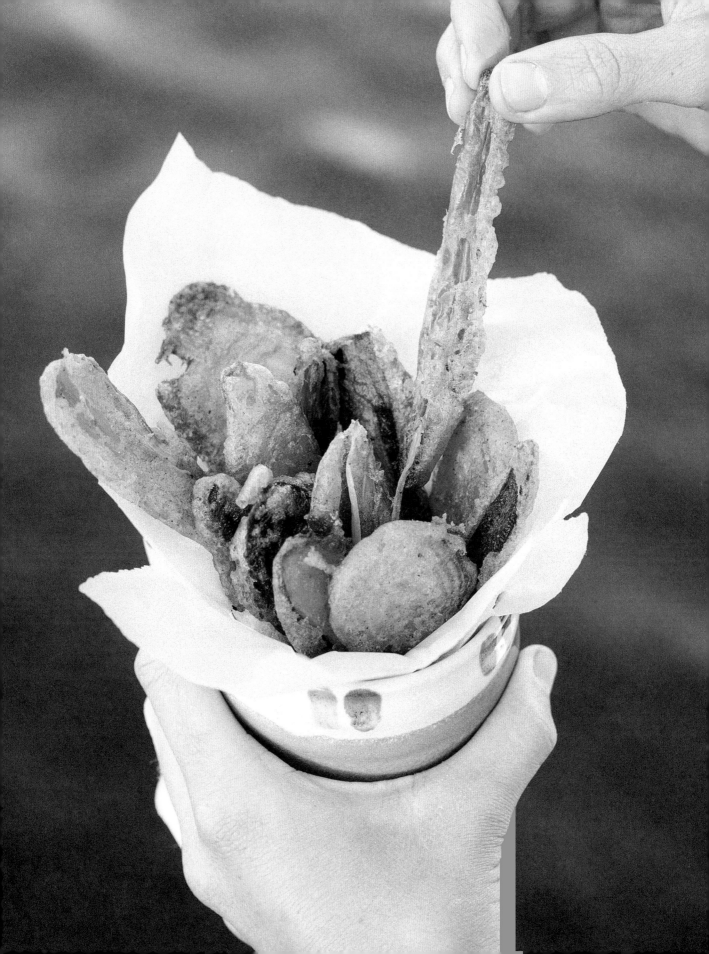

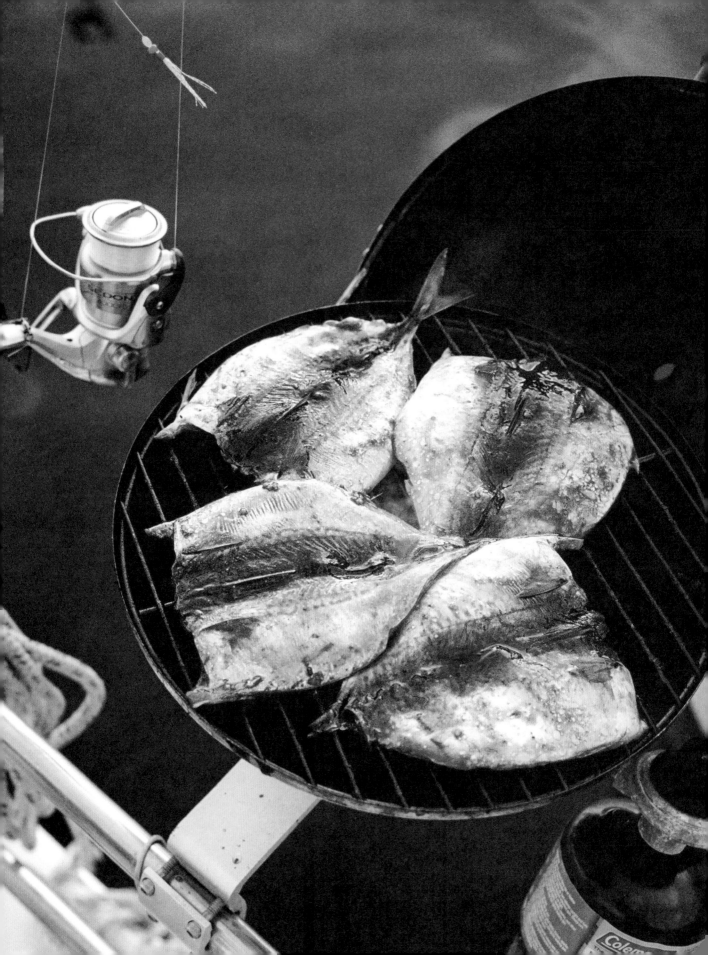

MARINADE FOR LOW-IN-THE-FOOD-CHAIN UNDERRATED SUSTAINABLE FISH

This is our all-time favorite marinade for mackerel, bonito, and other oily fish. We catch a lot here along the coast of California, and we love it. Bonito could be passed off as tuna if prepared right! It's a real shame that here in the States we are ignoring these sustainable options. We pay top dollar for halibut, endangered cod, and overfished salmon while our neighbors in the UK are having some kind of "fish revolution" thanks to smart, environmentally conscious TV chefs like Hugh Fearnley-Whittingstall. He's a god on our boat. The key to enjoying this seldom-celebrated yet delicious fish is definitely in the preparation. As with all oily, low-in-the-food-chain fish, time is of the essence. The longer the fish sits unbled, unfilleted, and uncooled, the fishier it's going to taste. However, if you get these suckers fresh, they are some of the best fish you'll ever eat. This marinade tenderizes the fish beautifully and adds great Asian flavor. It also lends itself terrifically to hot-smoking, which is always a great way to prepare mackerel.

MAKES 2 CUPS, ENOUGH TO
MARINATE 3 POUNDS OF FISH

½ cup soy sauce

¼ cup ponzu

¼ cup avocado oil, sunflower oil, or other cold-pressed nut/seed oil

One 2-inch piece fresh ginger, peeled and grated

3 cloves garlic, minced

2 tablespoons brown sugar

1 fresh red chile, finely chopped

Whisk together all of the ingredients in a bowl or container. Add the fish about an hour before you wish to cook it, making sure the marinade covers each piece entirely.

Need a makeshift hot smoker for your grill? Fill a disposable aluminum baking tray with cherry or alder wood chips. (Hickory tends to be a little strong for fish.) Cut a piece of metal mesh the same size as the baking tray and sit it on top. Preheat it in a grill until the chips are beginning to char and smoke, then turn the heat down. If your grill runs hot you may need to soak your chips in water for 30 minutes or so first. Ours does not . . .

Add the marinated fish to the grill, shut the lid, and let it smoke for at least 20 minutes or up to 1 hour for mackerel. We recommend slow and low for best results. It's pretty hard to overcook oily fish like this in a smoker.

IF YOU CAUGHT THE FISH YOURSELF, MAKE SURE TO BLEED IT BEFORE FILLETING. THE DIFFERENCE IN TASTE IS NIGHT AND DAY.

SMOKED MACKEREL EMPANADAS
WITH SOURDOUGH CRUST

Smoked mackerel is a wildly popular ingredient in Europe and the UK but remains underappreciated here in the United States. Maybe these empanadas will help tip the scales. The sweet beets and smoky chiles go incredibly well with the salty fish, and the creamy Stinging Nettle Mayonnaise on page 53 is the perfect accompaniment. If you can't get ahold of smoked mackerel, any hot-smoked fish can be used instead. The empanada dough is also really versatile and can be used for pizzas, pastries, and flatbreads.

MAKES 9 EMPANADAS

½ cup active sourdough starter, (see page 188)

¼ cup olive oil

¾ cup warm water

1 teaspoon sugar

1 teaspoon sea salt

2 cups all-purpose flour, plus more as needed

2 large red beets, diced

1 large red onion, finely diced

3 cloves garlic, minced

1 teaspoon ground dried chile

1 teaspoon smoked paprika

1 teaspoon ground cumin

½ teaspoon ground coriander

1 teaspoon sea salt

2 tablespoons red wine vinegar

¼ cup olive oil

¼ cup fresh dill, finely chopped

¼ cup fresh parsley, finely chopped

8 ounces hot-smoked mackerel fillet, flaked

1 egg, beaten

In a large ceramic or glass bowl, combine the sourdough starter, oil, and warm water. Mix in the sugar and salt, then stir in the flour. Bring it all together into a soft dough, using your hands if it's easier. It shouldn't be too sticky and should be easy to handle, so add more flour if needed. Cover with plastic wrap or a tight-fitting lid so that the dough does not dry out, and leave on the counter for a minimum of 8 hours. Overnight/all day is best. Afterward, pop it in the fridge until you are ready to cook.

Preheat the oven to 400°F. In a large bowl, toss the beets, onion, garlic, spices, salt, vinegar, and oil together. Pour onto a baking sheet and bake until tender, about 40 minutes. Be sure to shake often to get all of the edges crispy and caramelized. Remove from the oven and toss with the fresh dill and parsley. Transfer filling to a large bowl and fold in the mackerel. Leave the oven on for the empanadas.

Dust a work surface lightly with flour and turn out the dough. Sourdough acts very differently compared to other dough, so you might well find that your dough is already extremely pliable, which is great! We often find that we don't need to do much with our dough.

Using a rolling pin or your cheapest bottle of plonk (we use the bottle of the most insipid rum we can find), roll out the dough to about ⅛ inch thick. We like to cut our dough out like a cookie rather than make balls, but that is totally your call. We find that we have more uniform sizes when we cut them out. We use a 5-inch plate and a sharp knife to make 9 pieces. Gather the scraps and repeat this process until you have no usable dough left.

Flour your cut-out pieces well and lay them out on a large cutting board, ready for filling. Lightly grease a baking sheet.

(Continued on the next page . . .)

WHEN FERMENTING THE DOUGH, USE GLASS OR CERAMIC IF POSSIBLE. PLASTIC AND STAINLESS STEEL SHOULD BE AVOIDED AS THEY CAN POTENTIALLY REACT WITH YOUR FERMENTED GOODS AND CAUSE THEM TO TASTE FUNNY.

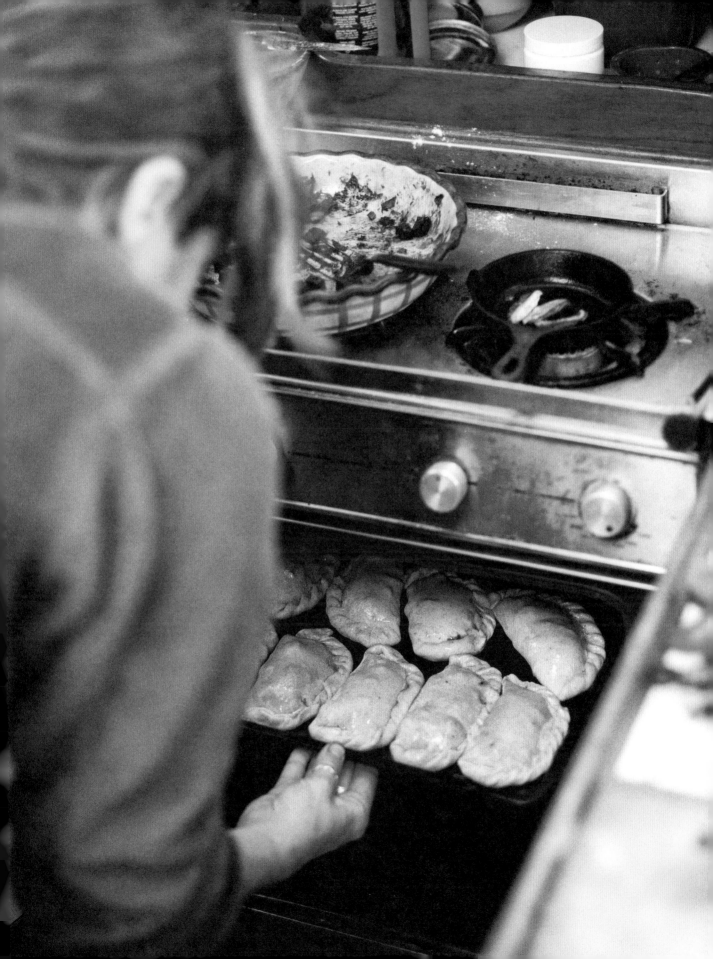

Fill half of each circle of dough with the filling, making sure to leave about ½ inch uncovered around the edge of the dough circle. Fold the unfilled side over and, using either a fork to crimp the edges or your favorite fold-and-twist technique, seal those little puppies up. Lay each empanada on the prepared baking sheet, brush with the beaten egg, and bake for about 30 minutes or until golden brown.

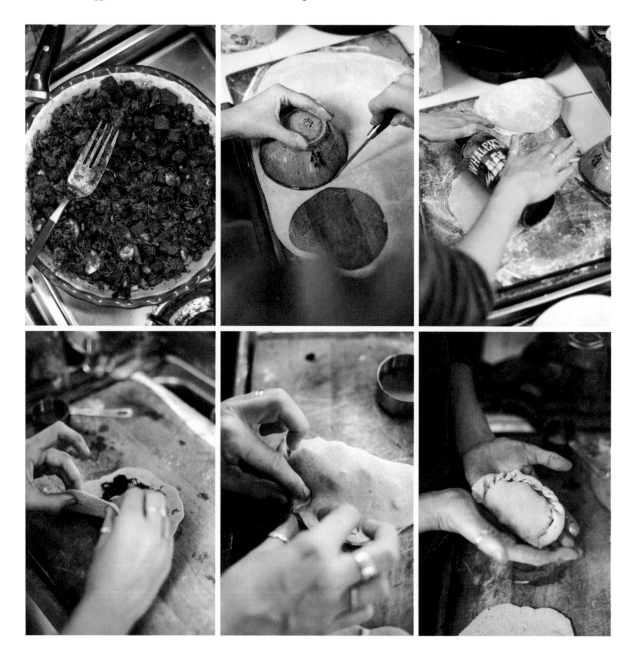

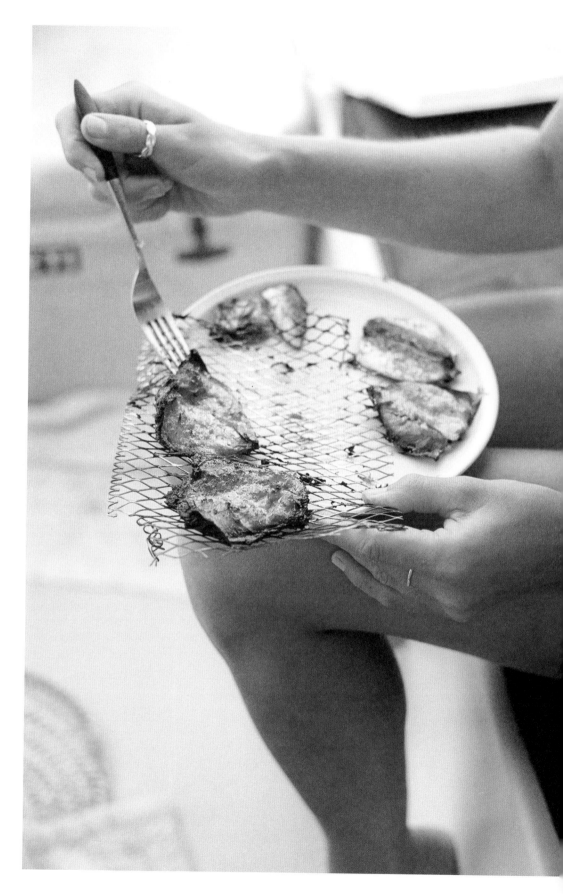

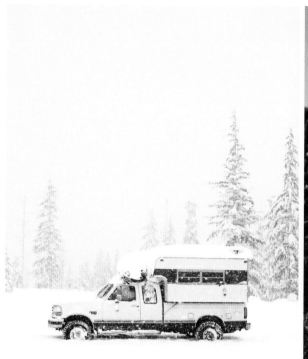

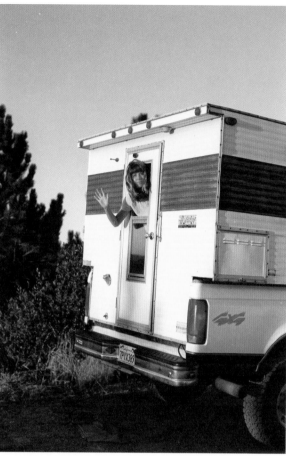

When we, Trevor and Maddie, aren't aboard our sailboat, *Brisa* (see page 47), we're likely out in our 1970 cab-over Holiday camper that rests atop a 1997 Ford F250 diesel pickup. We snatched the camper up for a couple hundred bucks on Craigslist and fell in love with its nostalgic '70s-era vibe. It has a sage-colored three-burner stove with a matching hood that's opposite a little sink with a freshwater hand pump. It has some serious storage, maybe more than the boat, so we ripped out a useless coat locker and installed a miniature woodstove we found on eBay. Complete with marine-grade parts, it heats the camper up well, even with a couple feet of snow on the roof. Nothing beats waking up in the morning and warming up the camper with a hot drink—English breakfast for Maddie, coffee for Trevor—and mixing up our favorite sourdough pancake recipe.

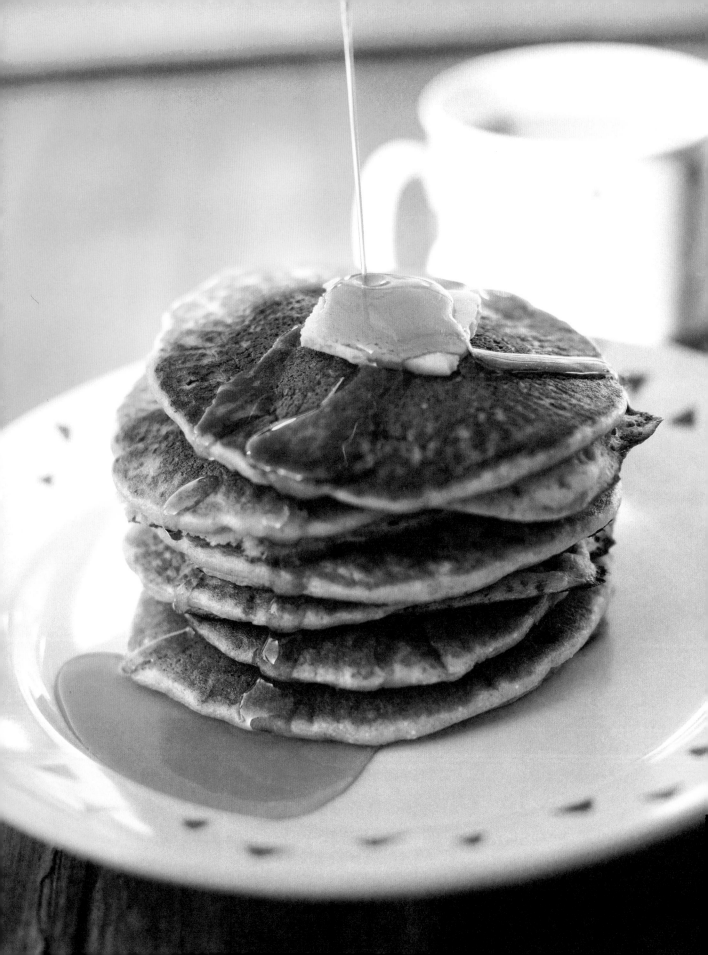

SOURDOUGH PANCAKES

These pancakes were discovered while questing to find the perfect sourdough pancake. We tried numerous popular overnight sourdough pancake recipes and were never totally happy with their gummy texture. We wanted to make a pancake that was fermented and nutritious but didn't want to ferment any "extra" flour overnight. Eventually, we came up with this simple mix, and we knew our search was over. These pancakes are so damn delicious—and fluffy, too. The recipe uses just 1 cup of active starter and zero additional wheat flour. (For this recipe it is important that your sourdough starter is active and bubbly.) It takes minutes to whip up and produces pancakes that are tangy, light, and fermented! Hurray!

MAKES EIGHT, 3-INCH PANCAKES

1 cup recently fed sourdough starter (see page 188)

2 eggs

Zest of 1 lemon

1 teaspoon vanilla extract

Pinch of sea salt

1 tablespoon maple syrup

2 tablespoons coconut flour

½ teaspoon baking soda

In a bowl, gently whisk together the sourdough starter and eggs until just combined. Add the lemon zest, vanilla, salt, and maple syrup and then fold in the coconut flour. Add the baking soda right before cooking, as you will want the batter to be bubbly and light.

Heat a well-seasoned cast-iron skillet or pan over medium heat. (If using a nonstick pan, add butter before cooking.) Pour ⅛ of the batter into the skillet and cook until bubbles are visible on the surface, about 1 minute. Using a spatula, flip and cook for another minute. Remove the cooked 'cake to a plate, and repeat with the remaining batter.

BEST SERVED WITH PLENTY OF GOOD, GRASS-FED BUTTER, HOMEMADE PRESERVES, AND YOGURT. EVEN BETTER YET, ADD A SUNNY-SIDE-UP EGG ON TOP AND SOME QUALITY MAPLE SYRUP.

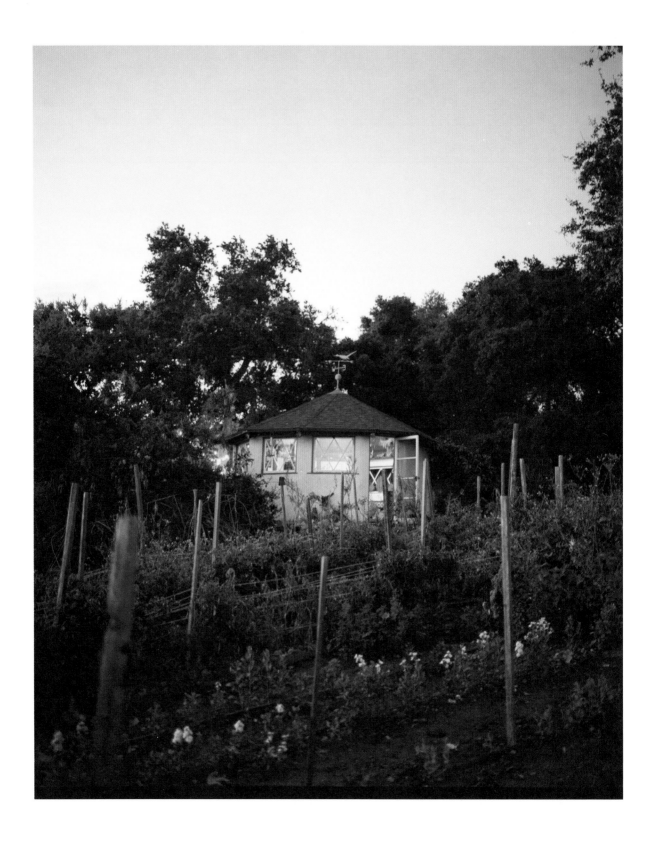

SESPE, SANTA BARBARA, CA

Sespe grew up backpacking with his father, learning how to pack in as little food as possible. Perhaps you could say that this has inspired his interest in primitive skills and wild food. Sespe lives in a hand-built eight-sided home on his folks' property. The house began as a tipi in the 1970s before becoming a palm-clad palapa and finally the solid structure that Sespe calls home today. Out front sprawls a tangled garden of vegetables, greens, and weeds all growing harmoniously together. At the back of the home, an outdoor kitchen and patio are surrounded by wild weeds and native greens—nasturtium, mallow, mint, chickweed, and nettles, to name a few—which provide Sespe with a seasonal selection of nutritious foods to include in his next meal.

Nestled beneath coastal oaks is a covered kitchen, complete with a combination minifridge and freezer, a sink, and a rusty two-burner propane stove. He has nothing fancy at his fingertips but he has everything he needs to create delicious grub. It's not unusual to find something hunted or gathered on Sespe's plate and neither is it unusual to find carcasses and drying hides scattered in the grass and trees around his home. Evidence of his deep knowledge of primitive skills can be seen everywhere, from the handcrafted tools he uses and his handwoven foraging basket to the vast collection of carved, whittled, and found objects that are strewn throughout his little home.

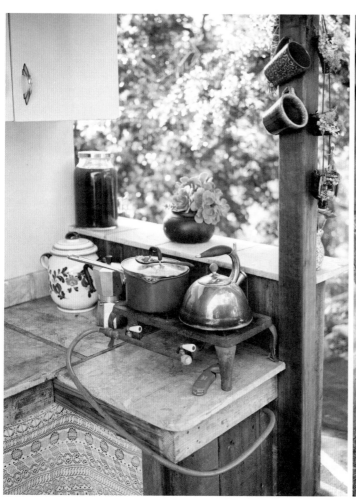
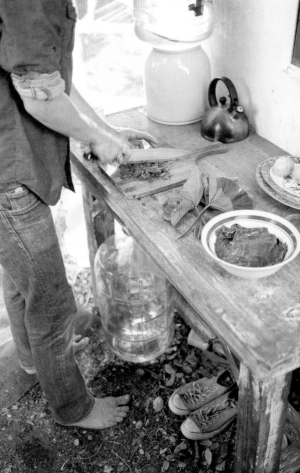

MALLOW DOLMAS
FILLED WITH FRAGRANT RICE & FRESH HERBS

It's pretty empowering to be able to take advantage of the wild edible foods in your area. Of course, Turkey and Greece are famous for taking their native mallows and stuffing them with rice to make a traditional dolmas, but many species of mallow are eaten all over the world. Sespe's garden was a springtime dreamscape when we paid him a visit, and the mallow, amid the other wild greens, was impressively tall, with leaves as big as our hands. The mallow leaves are prepared just like grape leaves and can be stuffed with all kinds of grains, herbs, and even meat. Sespe has used buffalo meat with great success.

MAKES 20 DOLMAS

20 large mallow leaves (at least 5 inches wide; see page 72)

1½ cups extra-virgin olive oil

¼ cup lemon juice

1½ cups wild rice

3 cups water or broth

½ cup diced roasted tomatoes (canned is fine, fresh is great)

½ teaspoon paprika

¾ cup diced yellow onion

1 teaspoon sea salt, plus more as needed

2 cloves garlic, minced

¼ cup pine nuts

½ cup fresh parsley, finely chopped

¼ cup fresh dill, finely chopped

¼ cup fresh mint, finely chopped

The night before: Bring a large pot of water to a rolling boil. Turn off the heat and drop your mallow leaves in for 2 minutes. While these are blanching, fill a large bowl with ice and water and, using tongs, gently transfer the mallow leaves from the hot water to the cold, essentially shocking them and halting the cooking process. This step is important, as it'll prevent soggy dolmas!

In a large, shallow dish, combine 1 cup of the olive oil and the lemon juice. Spread out the leaves in the dish and make sure they are covered evenly by the marinade. It doesn't matter if they overlap, but you want them to lay flat. Cover and let marinate on the counter overnight.

On the day: Combine the rice, water, tomatoes, and paprika in a heavy pot and bring to a boil. Reduce the heat, cover, and simmer for 45 minutes or until done. Turn off the heat and leave the rice covered for 5 minutes. Fluff with a fork.

While the rice is simmering, heat the remaining ½ cup olive oil in a large pan over high heat. Add the onion and the sea salt and sauté until translucent and browned. Stir in the garlic and remove from heat.

Lightly toast the pine nuts in a hot, dry skillet. Combine the nuts with the cooked rice, sautéed onion mixture, and herbs in a large bowl and set aside.

Lay each mallow leaf out flat, smooth-side down, so that the veins and the bottom of the leaf are facing you. Fill each leaf with about 2 tablespoons of the rice filling. Fold the two sides over the filling, kind of like a burrito. Starting with the edge closest to you, pull the leaf over the rice and tuck it tightly before rolling it into a taut cigar shape. Do this with all of your mallow leaves and save any leftover filling for dinner! Store in an airtight container in the fridge for up to 3 days.

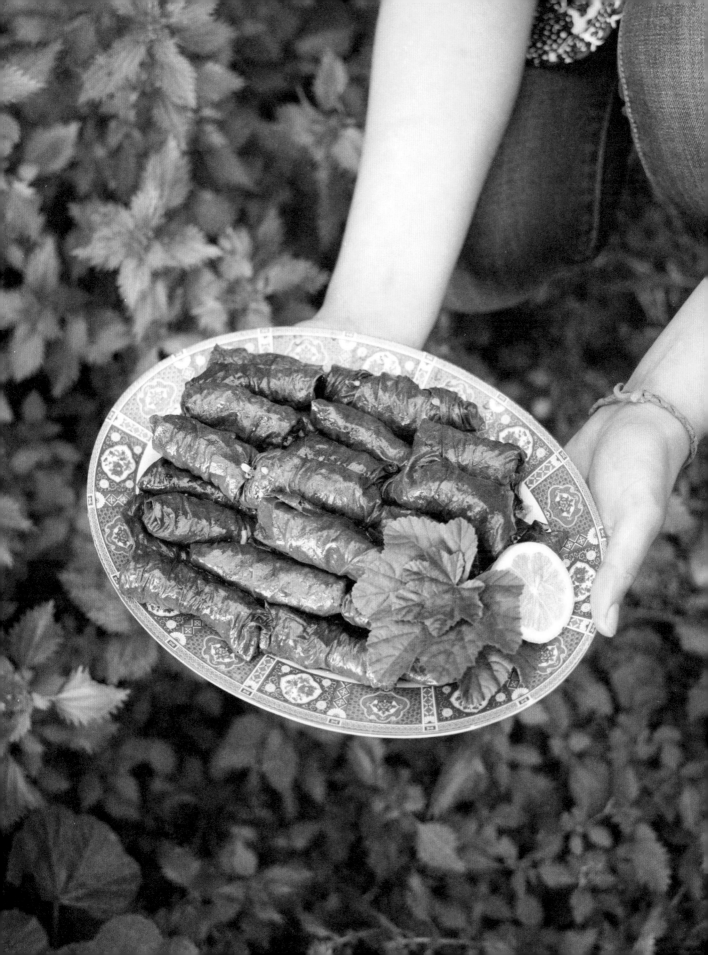

Identifying mallow in the wild: Mallow is a tasty weed that can be used interchangeably with most other leafy greens. It grows just about everywhere, but make sure that you harvest it from a clean, unpolluted place. Identifying this plant is simple, but you **must** be 100 percent sure of your identification before eating it. There are lots of resources online and in print that should be used in addition to this book to help you confirm the plant's identity. Mallow pops up in Central California in late winter and spring. It has geranium-like leaves that are circular to kidney shaped and rough to the touch, with five to seven lobes per leaf. The entire plant is edible but be sure to harvest bright green young mallow, free of orange scale.

IF YOU DON'T FANCY YOURSELF A FORAGER JUST YET, YOU CAN EASILY MAKE THIS RECIPE WITH EITHER FRESH GRAPE LEAVES PREPARED IN THE SAME MARINADE OR PREMARINATED GRAPE LEAVES. YOU CAN FIND THOSE AT YOUR LOCAL EUROPEAN MARKET.

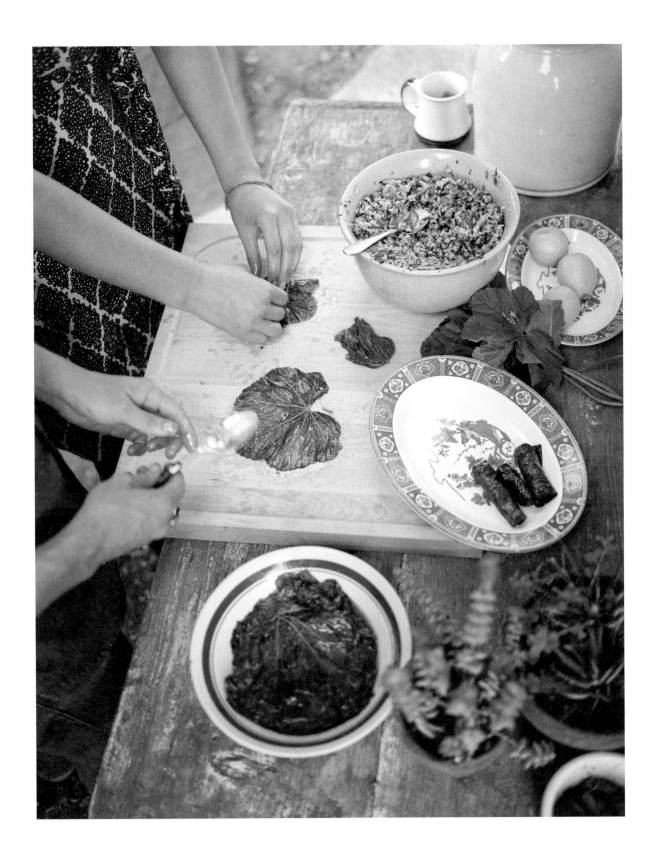

MARIE & DEAN, SKAMANIA COUNTY, WA

The Tiny Mess might not have ever happened without Marie and Dean. Though they currently call a more traditionally sized house their home, this couple spent half a decade living out of a combination Vanagon and school bus and provided us with endless inspiration when we first visited them during the early stages of this project.

Washington is wet and cold for much of the year, so Dean and Marie installed an ever-crucial wood-burning stove within the first week of owning their bus. Three months later, they added running water, and six months after purchasing the school bus, they added the "second-story" sleeping loft—a 1985 Volkswagen Vanagon that they cut in half horizontally. The old VW was fatally wounded with a terribly delinquent motor, so they cut it off it just above the wheel wells, rented a forklift to move it into place on top of the school bus, welded a new undercarriage, and bolted it into its new home. The bus itself remained intact, and the entry for the sleeping space was through the existing emergency exit in the roof of the bus. The heat from the wood-burning stove below kept the piggyback bedroom warm and dry, and the panoramic VW windows let in plenty of natural sunlight.

Dean and Marie's creative problem solving and resourcefulness did not stop there, and it was on full display in the kitchen of their rolling home. Set up along the rear driver's side of the bus, the kitchen was hiding ingenuity everywhere with ample storage and long, workable counters. Standing humbly in the center was the aforementioned wood-burning stove, providing both heat and a secondary stovetop. The cabinets were cherrywood and were custom made by Marie's grandpa Dale, and hold a lot of sentimental value to her. The drawers were also a custom job and fit quart-size canning jars perfectly, which Marie and Dean used for storing nonperishable food and canned goods. As a self-professed "pie nut," Marie stashed a pull-out marble pastry board as well as a slide-out maple breadboard under the counter. But perhaps the most practical addition to their van-bus mash-up was the "cellar"—underfloor storage containers welded beneath the bus but accessible from the inside. Located in the wasted space created by the bus's undercarriage clearance, these containers kept goods cool, dry, and dark, and provided perfect storage for nonperishables and hardy winter vegetables.

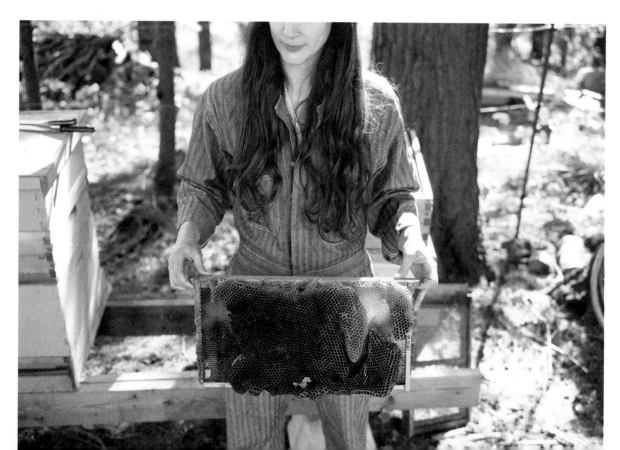

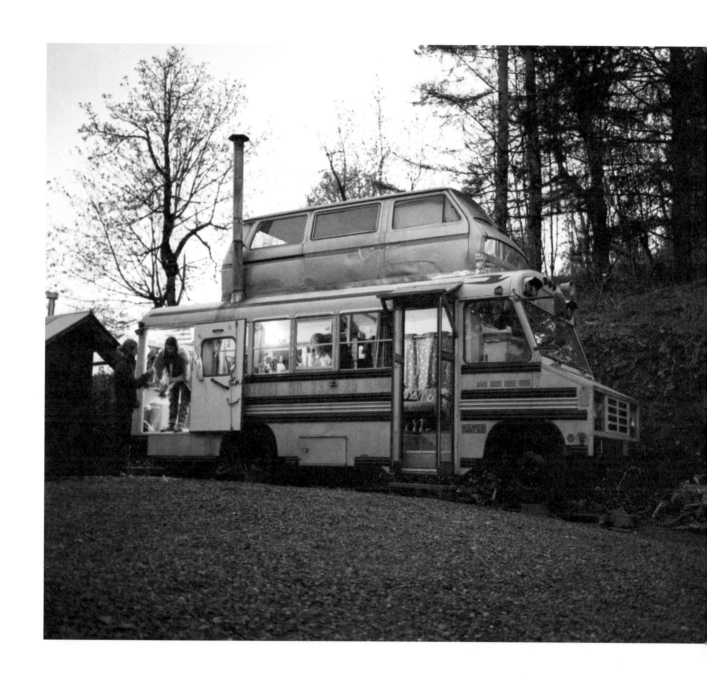

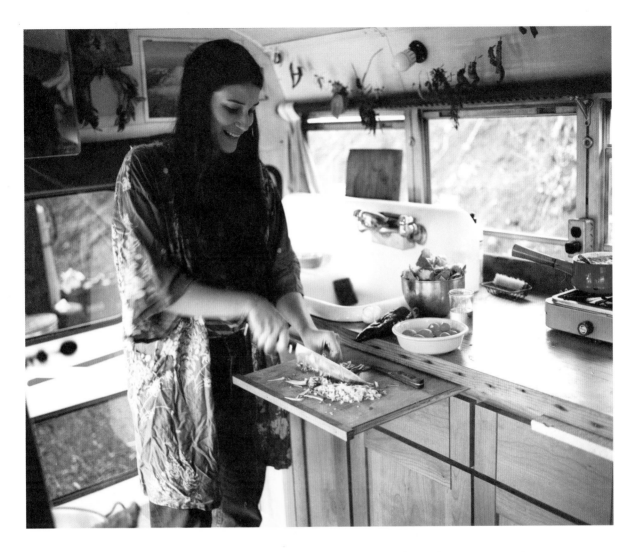

Marie's tips for creating a tiny kitchen that is both useful and beautiful: A clean countertop. An easy-to-access compost bin. Well-organized spices in labeled glass jars. Take advantage of beautiful and useful things and ditch the ugly crap. Toss the gimmicky and nonessential appliances and tools (who really needs a melon baller?). A sharp spatula—clean out pans by scraping out the leftover food first and fling it in the compost. It'll save you water and you won't have to pull soggy, rancid food out of the sink. A small collection of sharp knives, emphasis on sharp. One measuring cup that includes all measurement increments. Design your kitchen around your "work triangle," a three-sided shape where you think you will spend the most time (such as between the stovetop, fridge, and sink). Be safe with your wood-burning stove: have it correctly installed with a heat shield.

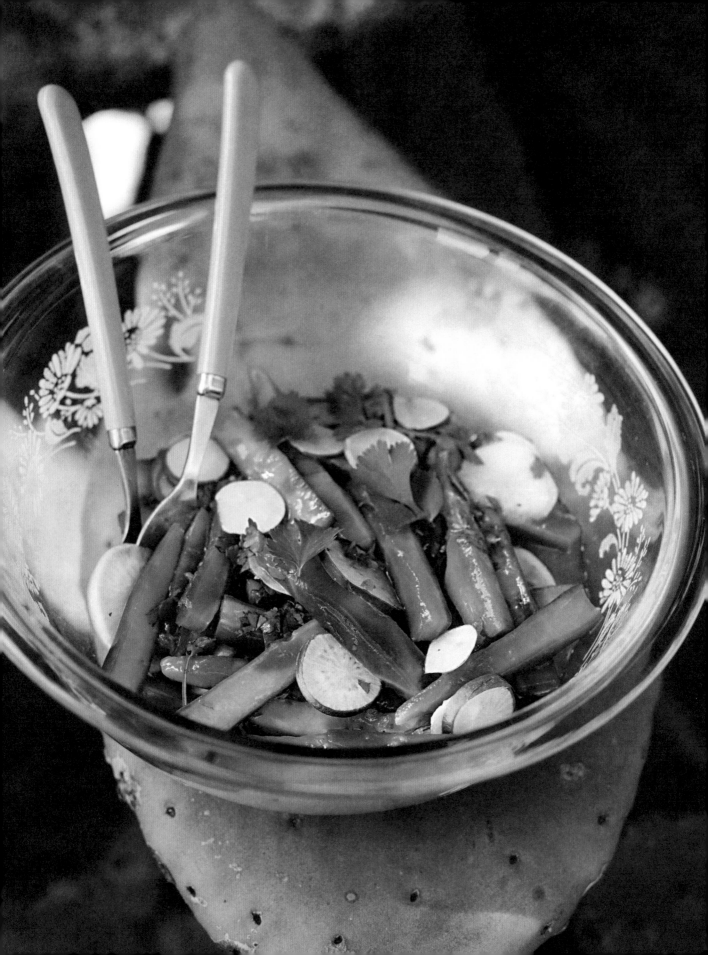

NOPAL CACTUS SALAD
WITH RADISH & JALAPEÑO

If you like okra, then nopales are for you. They're simply the roundish and lumpy paddles of the prickly pear cactus. If you live in an area where these are growing wild, foraging is a great way to acquire them. Remember to use gloves when harvesting, as those spines hurt and they will get everywhere fast. If you can't harvest them yourself, check your local Hispanic market. In a pinch, you could substitute Persian cucumbers, green beans, or even green bell peppers for the nopales.

SERVES 4 AS A SIDE OR IN TACOS

1 nopal paddle

8 radishes, thinly sliced

½ cup fresh cilantro, finely chopped

¼ jalapeño, finely chopped

Juice of 2 limes

Pinch of sea salt

Take a large knife and slice off the spines of the nopal under cool running water. Slice the nopal into French fry-size pieces. In a large bowl, toss together the nopal, radish, cilantro, and jalapeño. Add the lime juice and season with the salt. Serve the salad as an appetizer, or as an accompaniment for the rabbit tacos on page 80.

SLOW-STEWED RABBIT TACOS
WITH RED WINE, MOLASSES & SMOKY DRIED PEPPERS

This is a recipe we adapted from Marie's "wood-burning stove" stewed rabbit. We're unable to hunt our own, but we do have access to good-quality frozen rabbit. You can add whatever herbs and spices you wish. We wanted this particular rabbit stew to be warm, rich, and almost sticky, so we stewed it slowly with red wine, dried chiles, and molasses. It's perfect for tacos, with a texture reminiscent of pulled pork. According to Marie, the key to tender rabbit is to cook it slow and low, never above 350°F. Marie stewed hers on her woodstove, which is perfect for slow stewing, although temperature control can be difficult so you have to remain very attentive. She recommends getting hot coals built up and then throwing a big chunk of green wood on. This will drop the temperature and give you that nice, constant heat needed for slow stewing. Alternatively, just use a regular stove.

SERVES 4

2 red bell peppers

3 dried chiles (we used dried pasilla, California, and guajillo), rehydrated for 1 hour in warm water

6 shallots

4 cloves garlic

2 sprigs each of thyme and oregano

One 3-pound rabbit

One 750ml bottle jammy red wine

1 cup water or broth, or enough to just cover the rabbit

4 tablespoons grass-fed butter

1 tablespoon smoked paprika

1 teaspoon ground coriander

3 tablespoons molasses

Sea salt and black pepper

Corn tortillas, for serving

Nopal Cactus Salad (page 79), for serving

Yogurt, for serving

Toasted fennel seeds, for serving

Under the broiler or directly on a gas stovetop burner over high heat, roast the bell peppers whole until the skin is blistered and blackened. Slice the peppers and remove the seeds.

Drain and finely chop the rehydrated chiles.

Line the bottom of an enameled Dutch oven with the shallots, garlic, thyme, oregano, bell peppers, and chiles. Lay the rabbit on top of the veggies, pour over the wine and water, top with the butter, smoked paprika, and coriander, then drizzle with the molasses. Finally, season well with salt and black pepper. Cover the pot and braise over low heat for 3 to 4 hours, until the meat is falling off the bone.

Remove the rabbit from the braising liquid and let it rest for 15 minutes. Pull the meat off the bones. Rabbit has a lot of tiny bones, so be extra vigilant when deboning it, especially around the tailbone and the bottom of the rib cage. Cook the liquid left in the pot over medium-high heat for 30 minutes to reduce it, then return the rabbit meat to the pot and cook for 10 minutes more to heat through. Taste and season with salt and black pepper before serving.

Serve in warm corn tortillas with Marie's nopal salad, a dollop of yogurt, and a sprinkle of toasted fennel seeds.

TIPS FROM MARIE ABOUT BUTCHERING YOUR OWN RABBIT:
LET IT HANG, GUTTED AND SKINNED, FOR 1 TO 3 DAYS IN A COOL, DRY, AND DARK PLACE. THE MEAT WILL BE MUCH MORE TENDER AFTER HANGING, UNLESS BOOT-LEATHER TACOS ARE YOUR THING. HANG IT IN A PILLOWCASE OR BREATHABLE FABRIC BAG SO THAT FLIES DON'T GET TO IT.

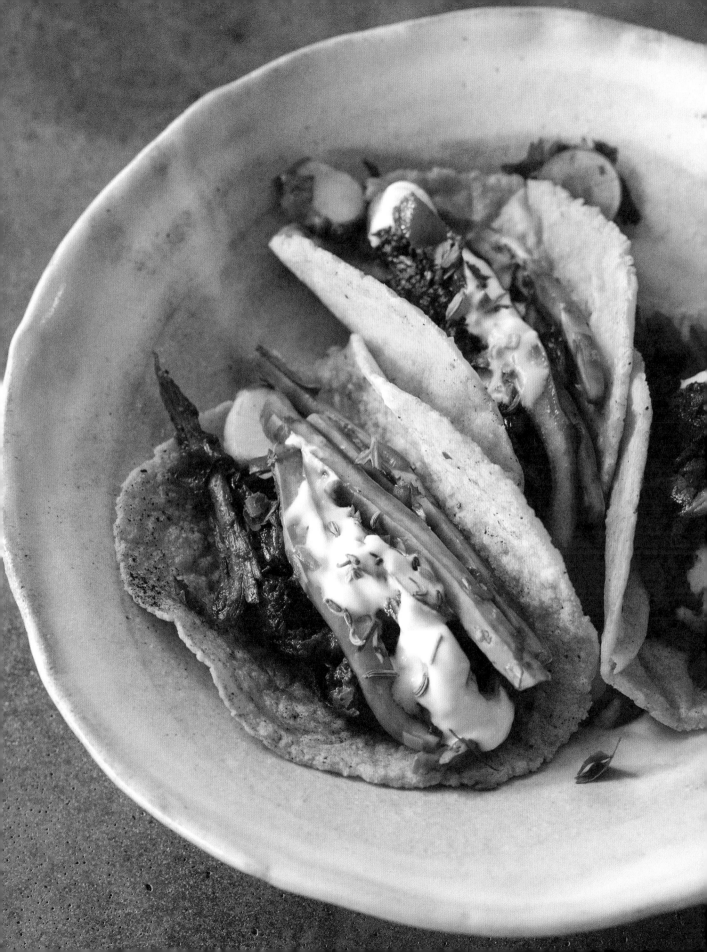

Sleeping Willow Farm is the affectionate name that Hannah and Jessie have given their tiny homestead. They share their home with their children, two little pups, and a small flock of hens. They started their family of five in this very cottage some years ago but quickly uprooted and moved to a family farm—where they built and eventually lived in a yurt for quite some time. It was their years in that yurt that primed them so well for life in their miniature cottage when they eventually moved back to it. Their home is one of those places that is styled just enough while still maintaining a well-lived-in and practical feel. Hannah scours antiques malls, flea markets, and thrift stores for vintage housewares. The kitchen is chockablock with elegant but useful tools, pots, and pans. Making their home both comfortable and functional is a constant work in progress at Sleeping Willow Farm.

The kitchen is tiny but in proper proportion thanks to the petite vintage stove in the middle. Salvaged-wood shelving clads the walls on both sides, making the kitchen feel light and organic. It's easy to imagine how much smaller the kitchen would feel with traditional overhead cabinetry. Of course, the shelves are full of gorgeous enamelware, antique copper pots, and heavy cast-iron pans from Hannah's thrifty hunts. The kitchen spills into the living room with a rainbow of retro Pyrex stacked on mobile shelving, and a nearby coat closet has been turned into a pantry. It is anything but traditional, but it works.

Initially, it was Hannah's wild selection of brightly colored kombucha and fuchsia pink pickled eggs that begged us to get in touch with her, not her impossibly cute kitchen. She is seriously creative with her kombucha flavors and enjoys experimenting with fruits available to her seasonally. Her go-to combinations are vanilla-peach in the summer, chai-pear in the fall, honey-kiwi in the winter, and strawberry-mint in the spring.

When we showed up to Sleeping Willow, the kitchen counter was covered in bowls overflowing with crunchy homegrown vegetables, all prepped and ready for cooking. Their yard is just over a third of an acre, with about

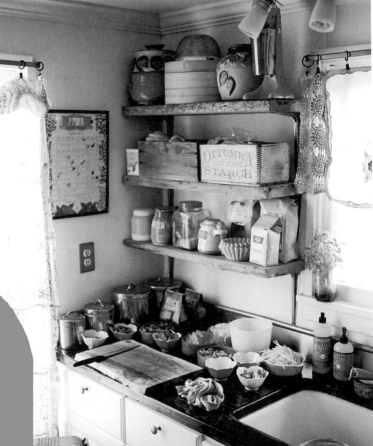

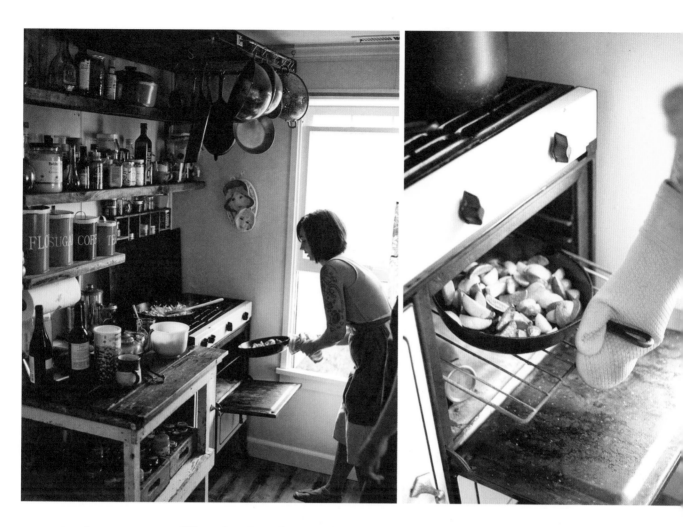

a quarter of an acre set up as edible gardens. It reminded us of one of those idyllic old paintings of a farm allotment exploding with life—chickens perched on beanpoles and shimmying blissfully in the dusty soil, sleepy cats taking naps in the late-afternoon sun, ripe tomatoes hanging heavily on the vine, and hot peppers glistening in their waxy skins. With all these ingredients at his fingertips, Jessie served us up the pad Thai to end all pad Thais. He tossed purple wild rice noodles with crunchy snow peas, tomatoes, and fresh mint, basil, and cilantro. He spooned a sweet-and-salty peanut sauce over the top and served the dish with some of the best potatoes we've ever eaten.

While they plan for eventual upgrades like a four-season greenhouse and root cellar, Jessie and Hannah are already aces at the home-preserving game, with nearly everything that comes off their land eventually being a candidate for canning, pickling, preserving, or freezing. Sun-ripened tomatoes end up as rich sauces for pizza and pasta, sweet berries become preserves, and even their eggs get popped into a pickle jar.

As impressive as the food and facilities are at Sleeping Willow Farm, what we loved most about our time with Hannah and Jessie was seeing how they had adjusted to "city life"—albeit a small city—after all their years in the yurt. It was clear that they adored life in their old yurt and on the surrounding farm, but they have moved on and have created a sweet life in a new spot where they can still carry on those homesteading traditions on a smaller scale. It just so happens that this new scale is perfect for them. Their garden is lush and bursting with color, and their kitchen a place where nourishing fare is on the menu.

OVERNIGHT VINEGAR POTATOES

These tangy potatoes are wonderfully reminiscent of salt-and-vinegar potato chips but chunkier, and they make a way more substantial snack. Hannah and Jessie served them with a bright purple pad Thai (as picutred), and they paired perfectly. We took one bite of these morsels and couldn't stop thinking about all the other things we wanted to serve them with.

SERVES 4 TO 6

6 or 7 medium potatoes, unpeeled, diced

1 cup water

3 cups cider vinegar

1 tablespoon sea salt

1 tablespoon garlic powder

1 tablespoon black pepper

1 tablespoon dry mustard

2 tablespoons coconut oil or olive oil

Put the potatoes in a large bowl of cold water. Using your hands, swirl them around to rinse off excess starch. Drain the water and repeat this step one more time or until the water runs clear. Put the potatoes into a gallon-size ziplock bag or a glass or ceramic bowl. Pour the 1 cup water and the vinegar over the potatoes, add the salt, garlic powder, pepper, and mustard, and combine well. Cover and place in the fridge to marinate overnight.

Preheat the oven to 400°F.

Drain the marinade from the potatoes and pat off excess moisture. Put the oil in a large roasting pan. If using coconut oil, pop this in the heated oven for a minute to melt it. Add the potatoes, toss with the oil, and roast for 45 minutes. Shake the pan periodically to brown the potatoes evenly. When crispy and browned to perfection, remove from the oven and serve. These are just as good as leftovers as well! Store in an airtight container in the fridge for up to 3 days.

THESE WOULD BE GREAT PAIRED WITH CARIE'S KITCHEN SINK QUICHE ON PAGE 34.

PICKLED EGGS

Welcome to the 1970s. You're in a pub and choking on the haze of cigarette smoke. Luckily, you've noticed that jar of suspicious-looking eggs floating in vinegar sitting on the bar. You kind of want one, but you're scared. Well, don't be. Firstly, these are not even comparable to those anemic-looking unidentified floating objects found in pubs of old. Not only is this a great way to preserve all your extra eggs, but it's a really tasty way to eat them, too. The pickling brine is highly seasoned, slightly spicy, and just sweet enough. The hard-boiled eggs essentially marinate in the brine, absorbing all that amazing tanginess. Chop these up into salads, slice them for cheese sandwiches, or just pop them right into your gob.

MAKES 12 EGGS

1½ cups distilled white vinegar

3 cups raw cider vinegar

3 cups water

1 beet, peeled and quartered

⅓ cup sugar

1 teaspoon sea salt

4 cloves garlic

1 red onion, thinly sliced

1 teaspoon black peppercorns, crushed

1 teaspoon dry mustard

2 hot chiles, fresh or dried

12 hard-boiled eggs, peeled

Small handful fennel fronds

In a pot, combine both vinegars and the water. Add the beet, sugar, and salt. Bring to a boil, stirring to dissolve the sugar and salt. Reduce the heat to medium, add the garlic, onion, pepper, mustard, and chiles and simmer for another minute or two. Remove from heat and discard the beet quarters.

Wash and sterilize a ½-gallon glass jar.

Place the peeled hard-boiled eggs and fennel fronds in the sterilized jar and pour in the now-pink pickling brine, including the spices, to submerge them.

Cool, then store the pickled eggs in the refrigerator in the brine. The flavor will be best if you wait a few days before diving in.

IF PINK ISN'T YOUR THING, TRY SWITCHING OUT THE BEET JUICE FOR A TABLESPOON OF GOLDEN TURMERIC, FRESH OR DRIED.

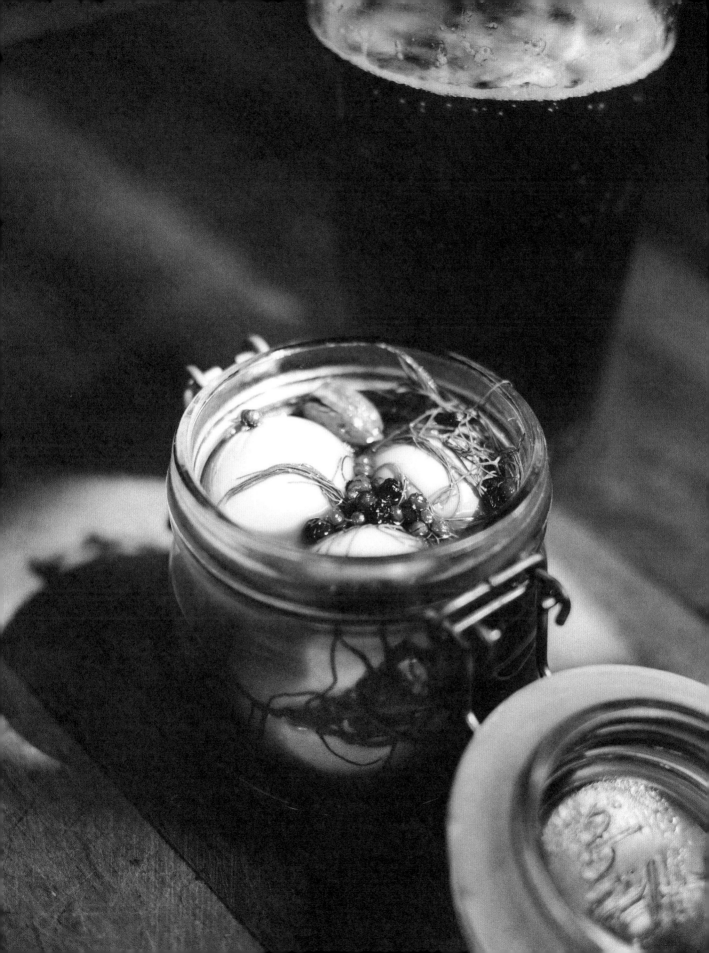

QUINCEY & MITCHELL, BERKELEY, CA

On a 32-foot sailboat in the heart of Berkeley Marina you will find Quincey and her husband, Mitchell, cooking up a storm in their little galley. They are full-time liveaboards on *Windrose*, a classic 1976 Fuji Ketch. The boat is petite and teak-clad, and feels like a cabin on the high seas. That famous Bay Area breeze might have a nip to it but down below in the belly of the *Windrose*, it is cozy and always smells like one of Quincey's tasty creations.

Quincey is a graduate of the Bauman College of Holistic Nutrition, and she and Mitchell eat a mostly plant-based diet, which they supplement with free-range eggs, occasional organic dairy, wild-caught sustainable seafood, and— very occasionally—a small amount of pasture-raised organic meat. They are lucky to have access to a community garden in their marina, where they tend to a small plot of veggies and fresh herbs. In fact, this duo became tiny kitchen boat dwellers primarily because of their commitment to the environment. All of their actions, both on board and off, focus on reducing their impact on the planet in one way or anther.

Mitchell and Quincey purchased *Windrose* back in June 2015 from a sweet couple in Sausalito, California, who loved her very much. For Mitchell, it was love at first sail after a special first date with *Windrose* that took him under the Golden Gate Bridge and back around again, past the skyline and sparkling lights of San Francisco. Soon enough the boat was all theirs.

They repainted the bottom, revarnished the galley, and gave the mast a new lick of paint. They replaced hardware, added new standing rigging and electronics, and drew up plans to swap out the pressurized water system for a more foolproof foot pump system. There's this thing that happens on boats where you fix one thing, and before you can put your tools away, something else gives out and it's project time all over again. With so many moving parts and lots of salty dampness, it's an endless fight with moisture, mold, rust, and upgrading outdated electronics and less-than-ideal plumbing. The work never ends for liveaboards, and Quincey and Mitchell know that well.

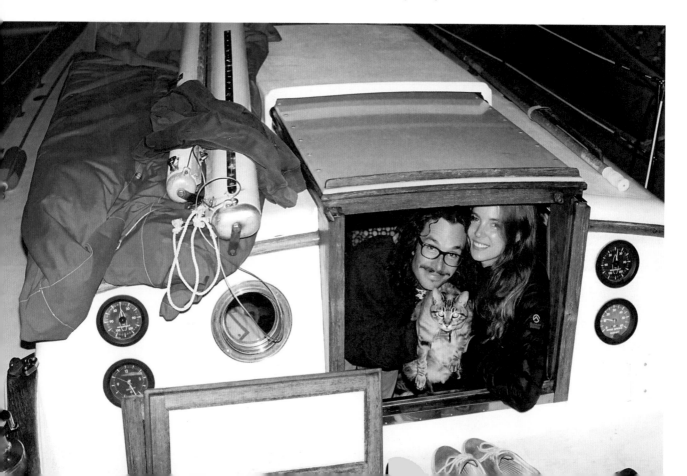

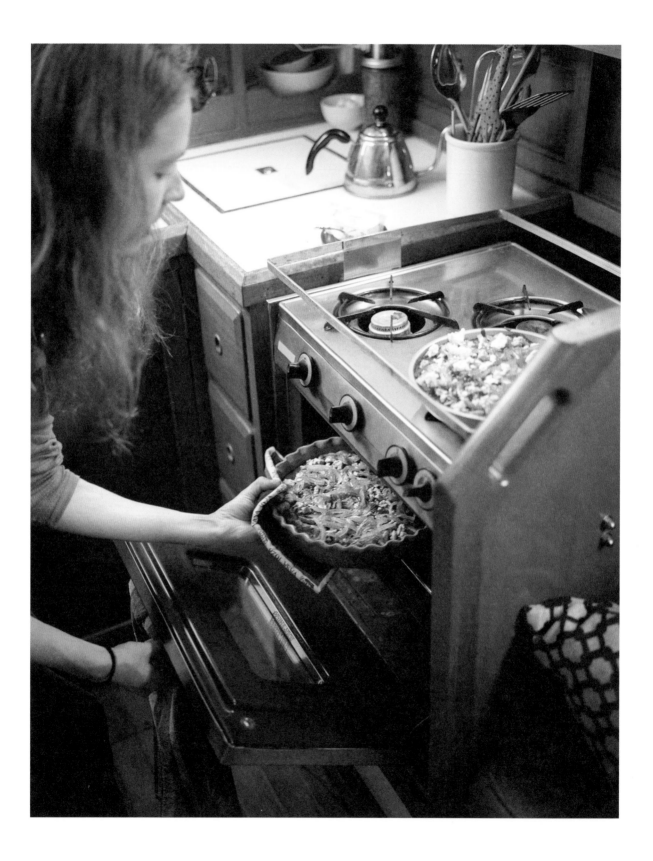

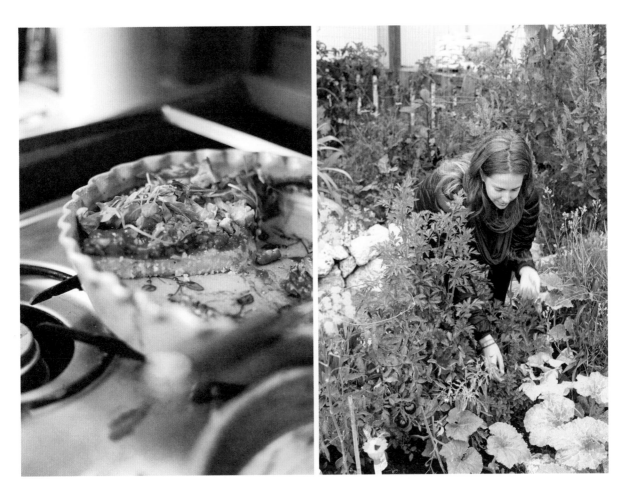

With the first phase of renovations complete and plans to set sail for southern points unknown in 2019, the couple has recently updated their kitchen with a state-of-the-art propane stovetop-and-oven combo. They are staying busy by regularly tinkering with and improving *Windrose*, particularly in the galley, where they spend most of their time. There aren't many options for places to hang out on a small sailboat when there are two people and a pirate cat. The galley also happens to be the living room, the dining room, the kitchen, and the office. Every inch of space needs to have a function or two . . . or three.

If you drop in on Quincey and Mitchell unannounced, you will likely find veggies fermenting on their countertop and the food processor whizzing up raw, vegan desserts. When your space is limited, you can either fill your kitchen with lots of small gadgets that don't really do the job, or a couple of big and burly ones like a blender or food processor that take up precious space but also make life a whole lot easier. We, of course, recommend the latter.

BOAT BORSCHT
WITH SOFT GOAT CHEESE & FRESH DILL

Quincey has nailed this lighter take on a traditional borscht. The beets and red cabbage make this soup an intense shade of magenta, and it gets a bit of a kick from the harissa chili powder. This earthy soup really hits the spot, especially when topped with a dollop of soft goat cheese.

SERVES 4

¼ cup olive oil, plus more as needed

1 yellow onion, cut into ¼-inch dice

2 medium carrots, cut into ¼-inch dice

3 stalks celery, cut into ¼-inch dice

3 large red beets, cut into ¼-inch dice

1 tablespoon dill seed

1 teaspoon ground cumin

1 teaspoon harissa chili powder

½ teaspoon cayenne pepper

6 cups water or broth

½ head red cabbage, thinly sliced

2 tablespoons cider vinegar

Sea salt and pepper

Soft goat cheese or goat's-milk yogurt, for garnish

Fresh dill, for garnish

In a large pot, heat the olive oil over medium heat and add the onion, carrots, celery, and beets. Cook until they begin to soften, 8 to 10 minutes.

Make a small well in the center of the pot and add a drizzle of extra oil if the pan is looking dry. Sprinkle in the dill seed, cumin, harissa chili powder, and cayenne and cook for 30 seconds more.

Add the water, cover, and simmer for 8 to 10 minutes. Add the sliced cabbage and simmer until the cabbage is tender. Add the vinegar and season with salt and black pepper. Taste and adjust the seasoning to your liking.

Ladle the borscht into bowls. Garnish each with a big dollop of goat cheese and fresh dill. This dish can also be served chilled.

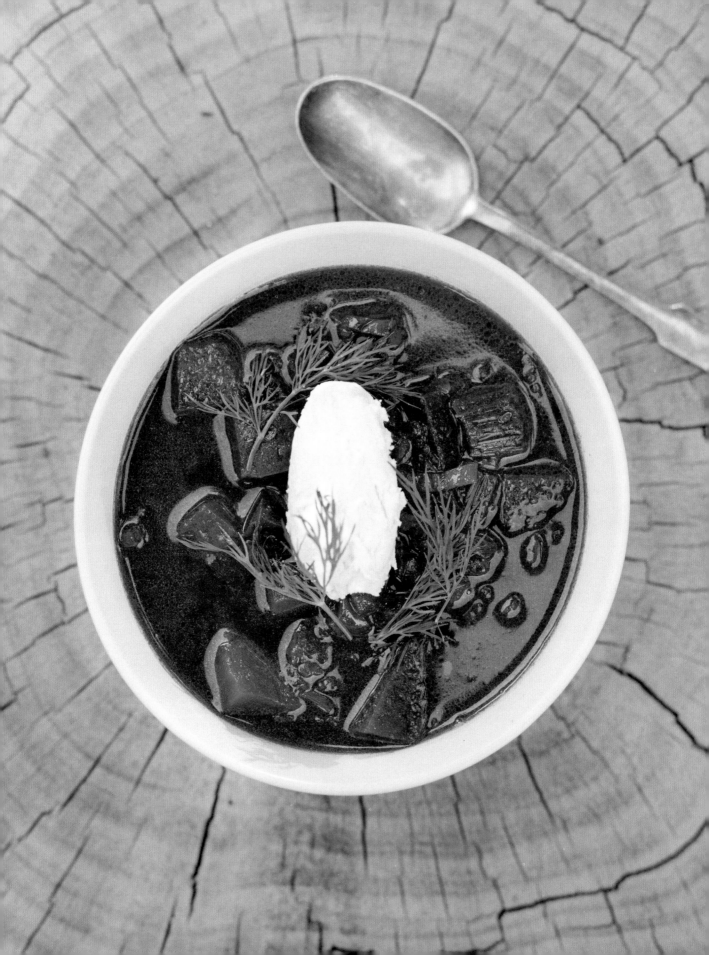

AIYANA, SANTA BARBARA, CA

Aiyana's father built their miniature home on a family-owned property nestled snugly in the foothills of the Los Padres National Forest. The place comprises three separate tiny buildings: a kitchen and living space and two tiny sleeping shacks. A sage-scented creek babbles beneath the home after the rain, which we were lucky to witness during our visit. The buildings appear so precariously placed, chiseled into the bank. It seems as though you might topple off into the creek below should you lose your footing. Aiyana's parents added an outdoor shower, a bathroom, and landscaping to the cliff edge. The buildings are constructed almost entirely from reclaimed materials—the cabinetry is built from walnut found on their property, and the windows and doors are thrifty finds.

The kitchen was built with the same care and attention as the rest of the home, using reclaimed marble left over from building jobs for the countertops and a boat-inspired approach to the whole kitchen design, which means minimal wasted space. The family gets their water from a well on the property, and their power is solar generated.

Years ago, the family of four, plus the occasional straggler and voluntary crew member, were full-time liveaboards on a 52-foot Hans Christian pilothouse sailboat. They lived out of the Santa Barbara Harbor until they eventually navigated their floating home south through the Panama Canal to its final resting place in Guatemala. The inspiration drawn from these years on a boat can be seen throughout their whole place, especially in the galleylike kitchen.

Speaking of the kitchen, it is most certainly the center of this home. Aiyana's parents raised her and her brother in a food-centered house, instilling in them an appreciation of the health rewards and socioeconomic benefits of eating organic food. From a young age, Aiyana has been aware of just how destructive industrialized agriculture is to the environment and our health. She works for a local farm and has plenty of access to the fresh and organic produce that she loves. "We have family meals a little too often," joked Aiyana. Family meals are nearly always accompanied by lots of yelling and, of course, top-quality nosh.

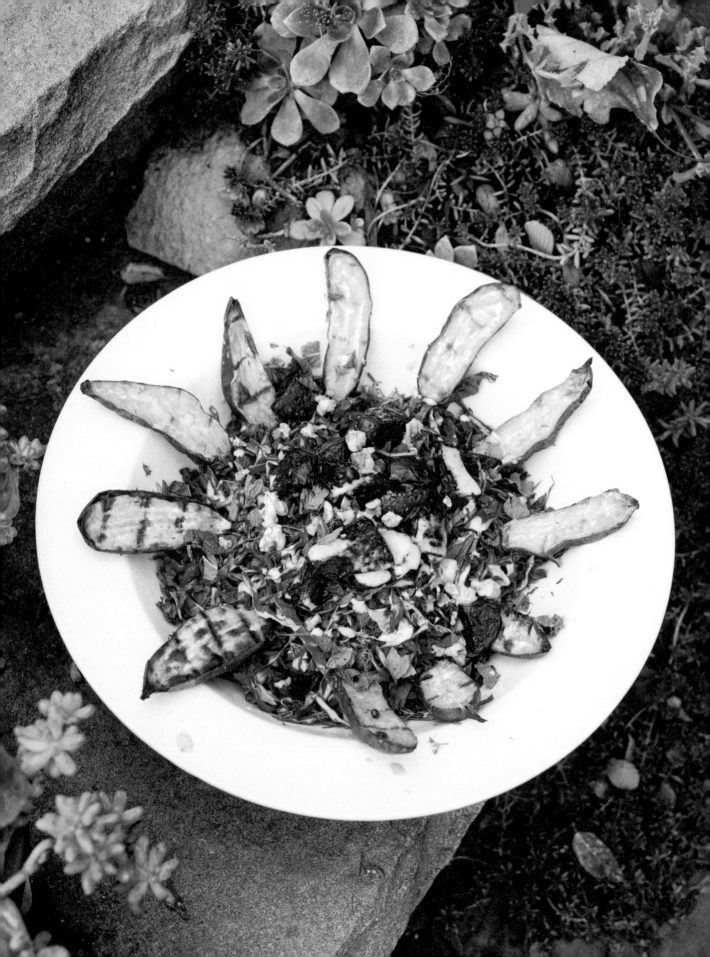

SWEET GINGER & DATE DRESSING

Aiyana served this fruity dressing over barbecued sweet potatoes and a salad, and we simply couldn't get enough of it. It's a pity we didn't barbecue even more sweet potatoes to mop up the rest of this sticky dressing!

MAKES ABOUT 1 CUP

1 tablespoon coarsely chopped fresh ginger

½ cup orange juice

1 tablespoon whole-grain mustard

3 soft dates, pitted

3 tablespoons cider vinegar

2 tablespoons lemon juice

Generous pinch of sea salt

¾ cup olive oil

In a high-speed blender or food processor, combine the ginger, orange juice, mustard, dates, vinegar, lemon juice, and salt. Blend until smooth.

With the motor running, slowly pour in the olive oil. This emulsifies the dressing and makes it super creamy! Store in an airtight container in the fridge for up to a week.

FOSTER, COLUMBIA RIVER GORGE, WA

Near the Columbia River Gorge, home to one of the biggest salmon runs on the West Coast, Foster lives 40 feet up in the air in two hand-built treehouses—complete with wood-burning stoves that never sleep. When we met up with Foster, we bought a whole Chinook salmon from just down the road, which we cut into steaks and tossed on the griddle for some juicy salmon burgers. We served them with Stinging Nettle Mayonnaise (page 53) and a side of roasted parsnip fries topped with lemon balm pesto.

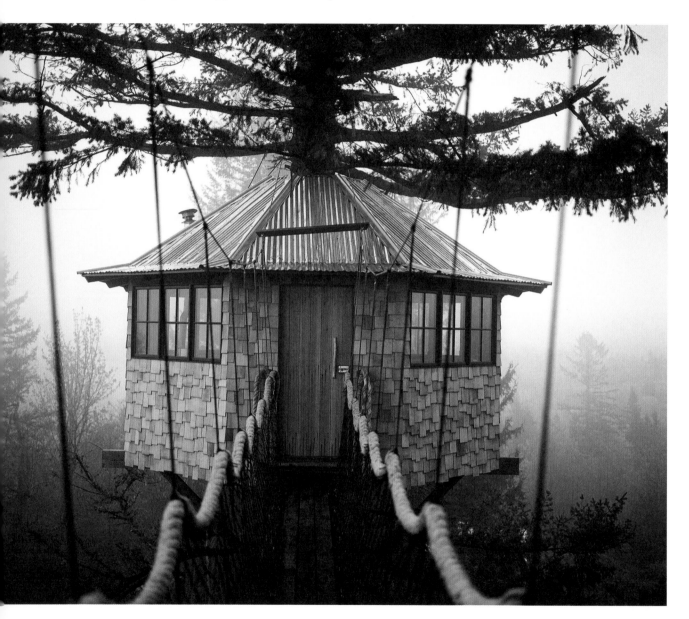

SIERRA & COLIN, SANTA CRUZ, CA

Sierra and Colin's square-footage-challenged kitchen was our first port of call on a trip north to shoot tiny kitchens for the book. All three of us were a little nervous as we pulled up to their home in Santa Cruz and wondered among ourselves just how successful this whole "rolling up to a stranger's house and sitting down for dinner" thing would actually pan out. Clammy handshakes and awkward introductions aside, we relaxed quickly and became fast friends with this creative and culinarily inspiring couple.

Colin and Sierra live in a completely renovated and rebuilt 1950s trailer located on their friend's fruit tree-studded property. Bought off Craigslist, the trailer needed some serious attention—a new roof, new walls and floors, insulation, and a complete kitchen reboot—before becoming what it is today. Luckily, Sierra had apprenticed under her father, a cabinetmaker, for over 35 years. She fell head over heels in love with the craft and eventually took over the family business. And, after six years in the bicycle industry, Colin joined her in the cabinet and carpentry game.

Together, they rebuilt their trailer, with special care paid to the kitchen area. They added a floor-to-ceiling pantry, a little breakfast bar, a long wall of exceptionally attractive and functional cabinetry, and ample counter space. Anyone with a tiny kitchen and who likes to cook knows that counter space and storage are everything, and Sierra and Colin have it in spades and then some. They added even more storage with custom drawers under their couch and a small weatherproof outside space for surplus food and equipment.

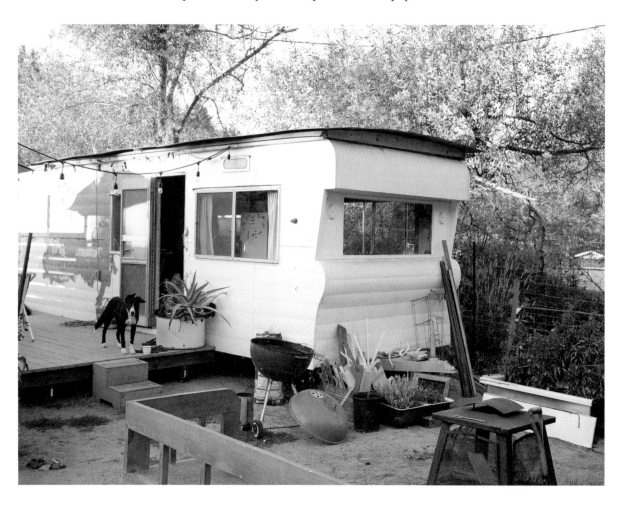

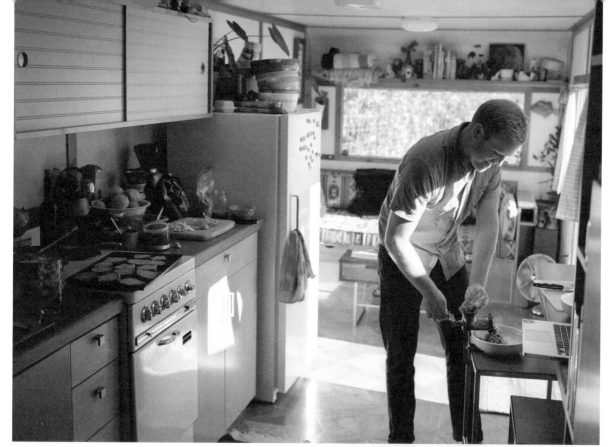

Colin and Sierra are both serious foodies and enjoy hosting meals and cooking for friends on a weekly basis. Colin likes to fish and spearfish and harvested the abalone for their meatball recipe (see page 104) from the waters around the Fort Bragg area. We had never had abalone prepared this way before. First, we watched Colin run the raw abalone through a meat grinder to tenderize and mince it before adding bread crumbs and plenty of herbs. Then he rolled them into small balls and panfried them before serving them with spaghetti and a rich cream sauce. It was truly delicious. We tell everyone about it.

Our food adventures with Colin and Sierra didn't end there. We also sampled their homemade tomato jam, made from their bumper crop of summer tomatoes. It's sweet, rich, and sticky, with plenty of tang, and pairs perfectly with creamy, stinky Brie. With mouths crammed full of delectables, we spotted some canning jars glistening with bubbly apples and inquired about their homemade vinegar, which we're excited to share with you.

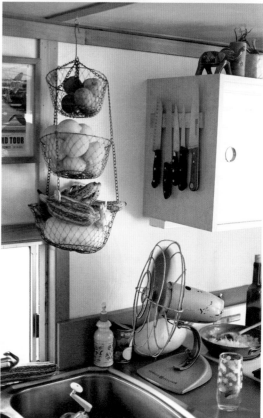

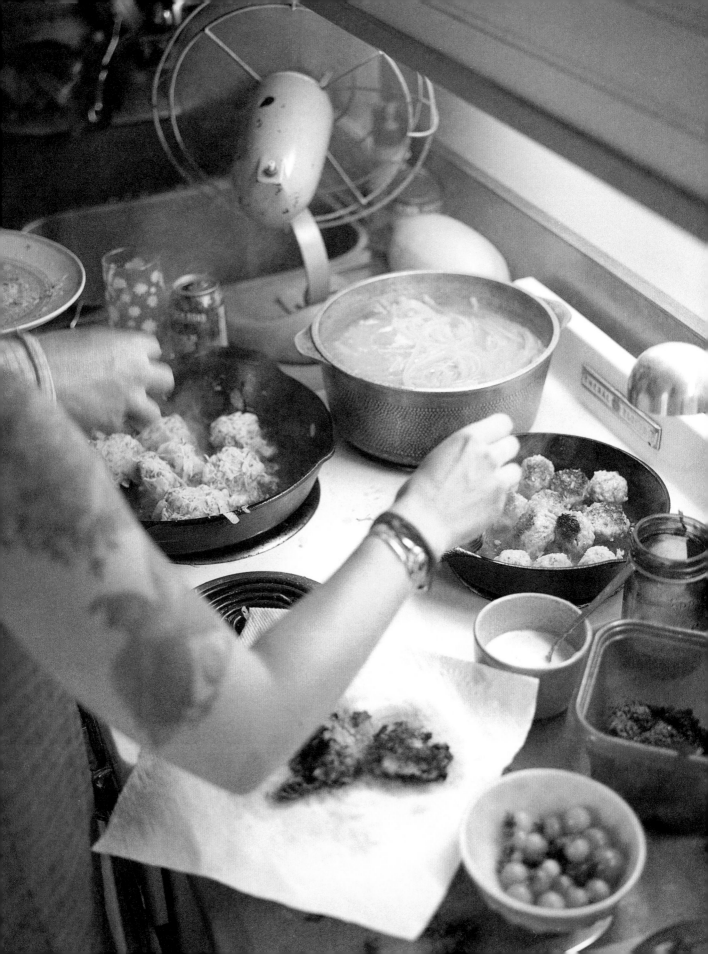

CIDER VINEGAR

Did you know that you can make your own raw apple cider vinegar? We didn't. Well, at least we didn't know how simple it can be. To reap all the benefits of this probiotic, mineral-rich, fermented vinegar, the toughest ingredient you'll need to find is patience. It's also a great way to use bruised and less-than-perfect apples.

MAKES 1 QUART

3 apples

1 tablespoon sugar

Wash your apples, leaving them unpeeled, quarter them, then cut those quarters into 3 pieces each. Pack them into a wide-mouth 1-quart glass jar until the jar is almost full. Add the sugar and top with water to submerge the apples. You might need to put a smaller jar inside the larger jar to keep the apples submerged. Cover the jar with cheesecloth and let the apples ferment in a cool, dark place for 1 month.

Strain the liquid after a month, discard the apples, and return the liquid to the jar. Cover with cheesecloth again and set aside to ferment for another month or two. Start tasting the tangy vinegar after a month. Once your desired flavor is reached, store in sterilized bottles or jars.

TOMATO JAM

If you have an abundant supply of sweet summer tomatoes, then this is a wonderful way to preserve them. Pair it with your favorite cheese, spread it on sandwiches, or stir it into sauces that just need "a little something."

MAKES JUST OVER THREE 1-PINT JARS

3 pounds cherry or plum tomatoes

2 tablespoons olive oil

1 yellow onion, sliced

2 cloves garlic, minced

½ cup packed brown sugar

¼ cup cider vinegar

1 teaspoon smoked paprika

½ teaspoon cayenne pepper

Sea salt and black pepper

Preheat the broiler. Place the tomatoes on a baking sheet and broil until blackened. In a large saucepan, heat the olive oil and add the onion. Cook, stirring occasionally, until the onions have browned and are well caramelized. Add the garlic and the tomatoes, breaking them up with a wooden spoon or spatula. Simmer for about 45 minutes or until the juices have cooked down, stirring often to prevent sticking.

Add the sugar, vinegar, paprika, cayenne, and salt and black pepper to taste and stir to incorporate. Simmer the jam for another 15 minutes. Once thickened, spoon the jam into sterilized jars and either can them or freeze them, or refrigerate and use within a month.

ABALONE MEATBALLS
WITH CITRUS-WHITE WINE CREAM SAUCE

We've had abalone before. We have even loved abalone before. But we never saw these meatballs coming. They're ridiculously good, packed with flavor, and served in a Meyer lemon-spiked cream sauce. You could also make these mini and they'd be a cracking tapas dish. If you can't find abalone at your local fish market and you live near the ocean, research abalone harvesting laws in your area and consider having a hunt, if possible. If you can't get hold of abalone, try this with calamari steaks. They are a great substitute in texture and taste.

SERVES 6

Meatballs

2 pounds fresh abalone

1 cup panko bread crumbs

1 egg

2 cloves garlic, minced

½ cup fresh parsley, finely chopped

Sea salt and pepper

Olive oil, for cooking

Sauce

½ cup white wine

8 tablespoons butter

1 large shallot, finely chopped

1 clove garlic, minced

Zest of 1 Meyer lemon

½ teaspoon red pepper flakes

2 cups heavy cream

Sea salt and pepper

1 pound of your favorite linguine

Extra-virgin olive oil

Juice of 1 lemon

Fresh parsley and Parmesan, for serving

Bring a large pot of generously salted water to a boil for the pasta.

To make the meatballs: Pound the abalone hard to tenderize it. A tenderizing mallet would be the perfect tool for this, but a hammer or rolling pin would suffice. Run it through a meat grinder into a bowl (or use a food processor or mince with a sharp knife as you would with garlic), then add the bread crumbs, egg, garlic, and parsley, and season generously with salt and pepper. Using your hands, combine everything really well and shape into 1-inch balls.

In a cast-iron skillet over medium-high heat, pour olive oil to a depth of ⅛ inch. Add the meatballs and cook, turning them often, until all sides are browned. Remove the meatballs carefully and set aside on a plate.

To make the sauce: While the pan is still hot, add the wine and stir to deglaze the pan. Simmer over medium heat until the wine has reduced by half, then add the butter. Once the mixture is bubbling, throw in the shallot, garlic, lemon zest, and red pepper flakes. When the shallot is translucent, about 10 minutes, reduce the heat to low and add the cream, whisking well to incorporate everything. Warm the sauce gently to prevent it from splitting. Simmer for 20 minutes or until reduced by half.

Remove from the heat and season with salt and black pepper. Return the meatballs to the pan and turn them to glaze with the sauce. Cover to keep warm.

When the pasta water is boiling, add the pasta and cook for 7 minutes, or until al dente.

Drain the pasta, tip it into a large bowl, and toss gently with a good glug of extra-virgin olive oil and the lemon juice. Serve the meatballs and sauce on top of the pasta and garnish with fresh parsley and grated Parmesan.

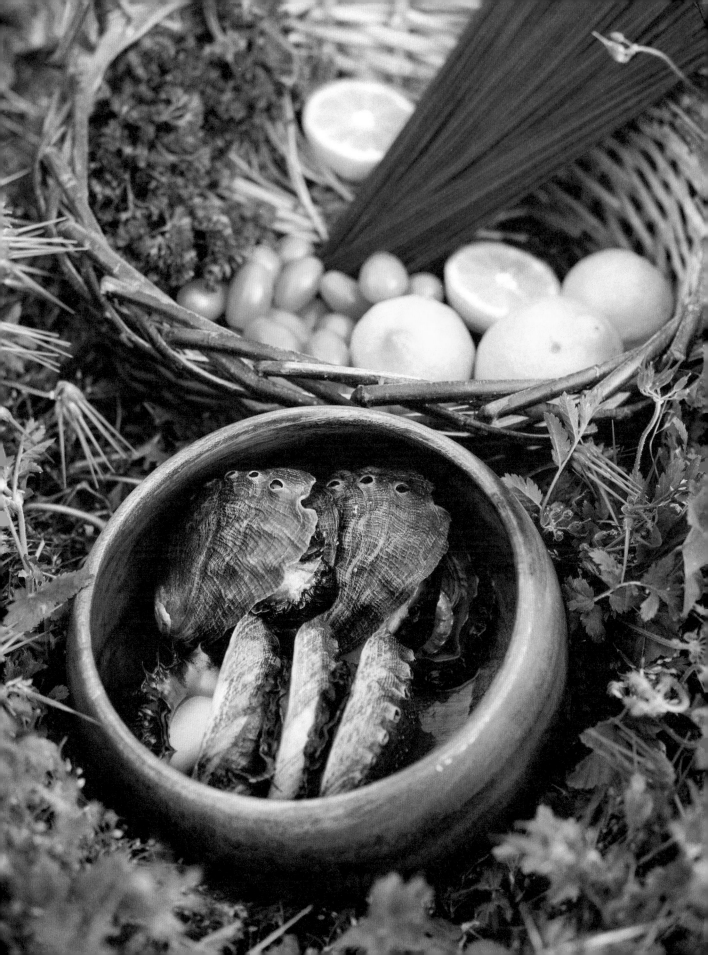

MONIQUE, SANTA BARBARA, CA

Monique lives aboard a 27-foot 1978 Watkins sailboat named *Seaway* in Santa Barbara Harbor. After traveling around in her bus and spending time in Austin, Texas, she decided she was ready to be back in Santa Barbara—breathing briny air and gazing at sage-covered mountains. She learned about *Seaway* and bought both the boat and slip off a long-term liveaboard before he moved away. She dove headfirst into boat life and purchased the boat without having even seen it! Three years later, she's still there, living a humble life on the sea and filling her belly daily with health-giving foods. The boat isn't rigged to safely sail and doesn't have a motor, but it is the perfect floating home for her and her miniature pup, Gizmo. It floats, it's dry, and she's got a 360-degree view of the Pacific Coast.

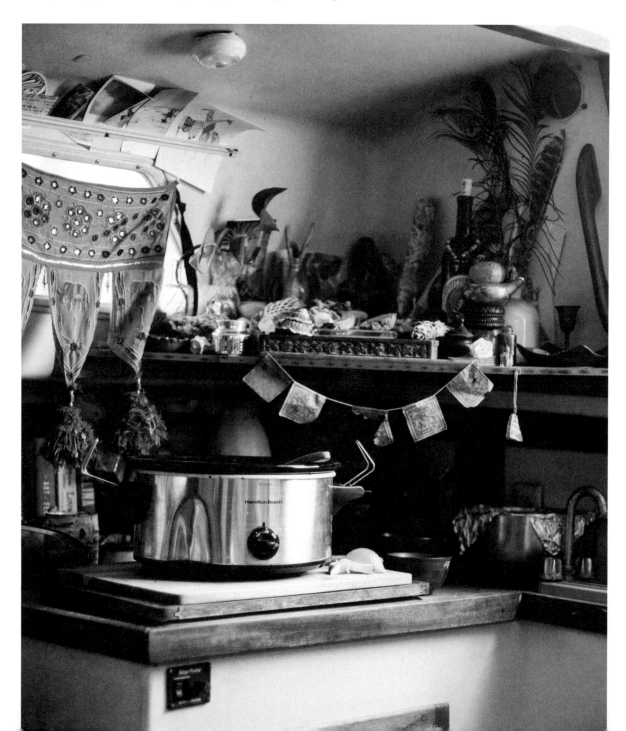

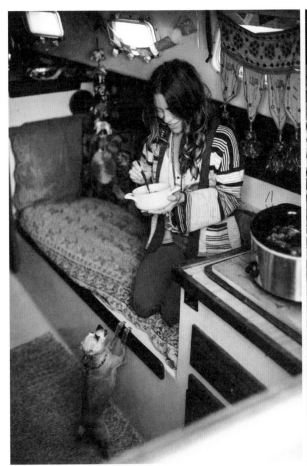

Seaway is small. We mean really, really small. Monique's kitchen space is restricted to a lone corner, filled with spices, produce, oils, and the olivewood utensils that she loves. It has no built-in stove so Monique cooks everything using either an electric slow cooker, an induction cooktop, a toaster oven, or—in the summer when the outside deck is an option—on a Coleman camp stove. She also has a rice cooker, which means she can set it and forget it, and a Vitamix for assorted potions, elixirs, and soups. All of her appliances fit in the little cabinet under the countertop, and the rest she stashes in baskets that she stacks around the boat. The sink is out of service, so covering it up gives her extra space to work. Dirty dishes go in a big tub with castile soap and water from the dock hose before being laid out to dry on the deck.

Despite some obvious limitations, Monique loves to cook aboard *Seaway*, creating wholesome one-pot dinners from fresh veggies and protein. She uses lots of healing spices and herbs to season her soups in the winter and makes huge crunchy salads in the summertime. Monique made us a savory bone broth packed with belly-warming ginger and turmeric and a sprinkle of medicinal mushroom powder. She is a great example of how living on the water doesn't have to be a big deal. Not a lot of sailing experience? No problem. You can still enjoy a life where the beach is literally your backyard, and Monique is proof.

24-HOUR CHICKEN BROTH

Monique's magnificent bone broth is as nourishing as it is tasty. If you are under the weather, this ancestral power food will have you feeling perky in no time. After 24 hours of simmering in its own juices, the chicken is not only tender beyond belief, but all those nutrient-dense minerals and fats from the bones and skin wind up in every sip of the broth. Monique's optional addition of medicinal mushrooms takes this broth to a whole new level of healthy. We tested this recipe in our own 4-quart slow cooker using a 3½-pound organic free-range chicken. If you have a larger slow cooker, good for you! You'll be able to cram that thing with a bigger chicken and more veggies. This recipe is very flexible, so be creative and try adding any vegetables and seasonings that strike your fancy (see note for more ideas).

MAKES ABOUT 3 QUARTS

1 onion, sliced

6 cloves garlic, coarsely chopped

1 serrano chile

1 sprig rosemary

10 grams medicinal mushroom powder, such as Chaga, Lion's Maine, or Reishi (optional)

One 3½ pound organic free-range chicken

½ bunch celery

3-inch piece fresh turmeric, peeled and thinly sliced

3-inch piece fresh ginger, peeled and thinly sliced

1 tablespoon cider vinegar

1½ teaspoons sea salt, plus more to taste

Juice of 1 lime

1 tablespoon maple syrup

1 large sweet potato, diced

1 bunch collard greens, stemmed and sliced

½ cup chopped fresh cilantro

In a slow cooker, combine the onion, garlic, chile, rosemary, and mushroom powder (if using). Add the chicken and fill the slow cooker with enough water to cover everything. Fill the gaps with the celery, turmeric, and ginger. Top with the vinegar. Cover and cook on low for 8 to 10 hours.

Pull the chicken out of the slow cooker. Take all the meat off the chicken, especially that rich brown meat that is so often overlooked. Put in a container and refrigerate. You can add this back to the soup at the end or use it any which way you please. Return the bones and skin to the broth, season with the salt, top off with more water, cover, and cook on low for 10 to 12 hours.

Strain the broth, discarding the solids, and season it with salt again if it needs it. Add the lime juice, maple syrup, and sweet potato. Leave out those leafy greens, though; those go in last. Cover and cook on high for 1 hour. Add the greens, cooked chicken, and fresh cilantro 5 minutes before serving. Season once more if needed.

MONIQUE'S MAGICAL COMBO: TURNIPS, CARROTS, SHALLOTS, GINGER, SWEET POTATOES, SERRANO CHILE, RED PEPPER FLAKES, TURMERIC POWDER, A SPRINKLE OF MASALA POWDER, A MUSHROOM IMMUNITY BLEND, KALE.

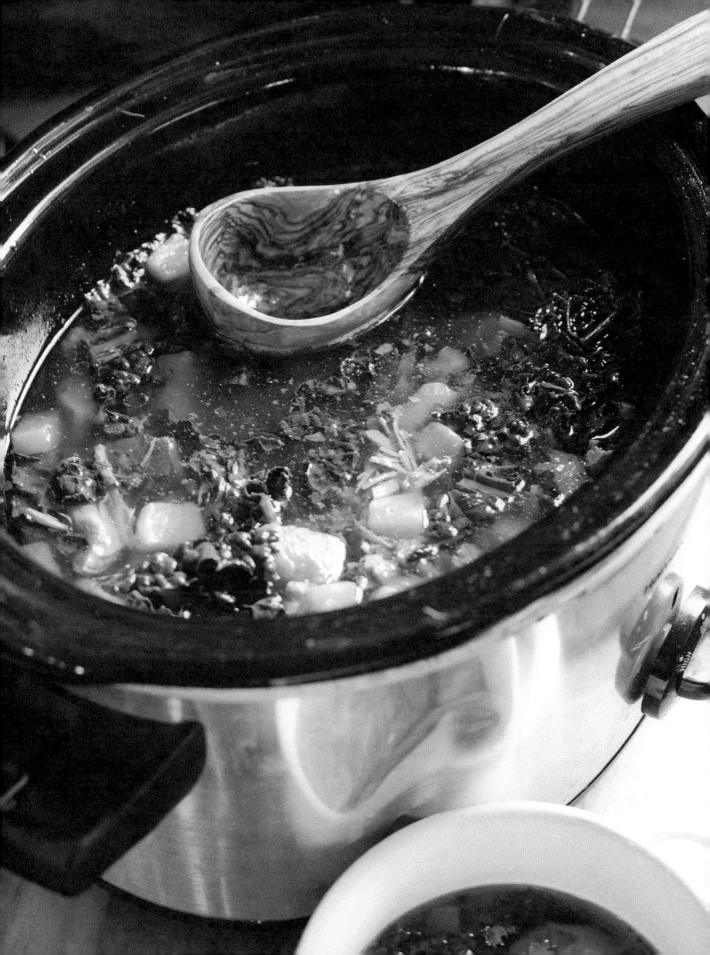

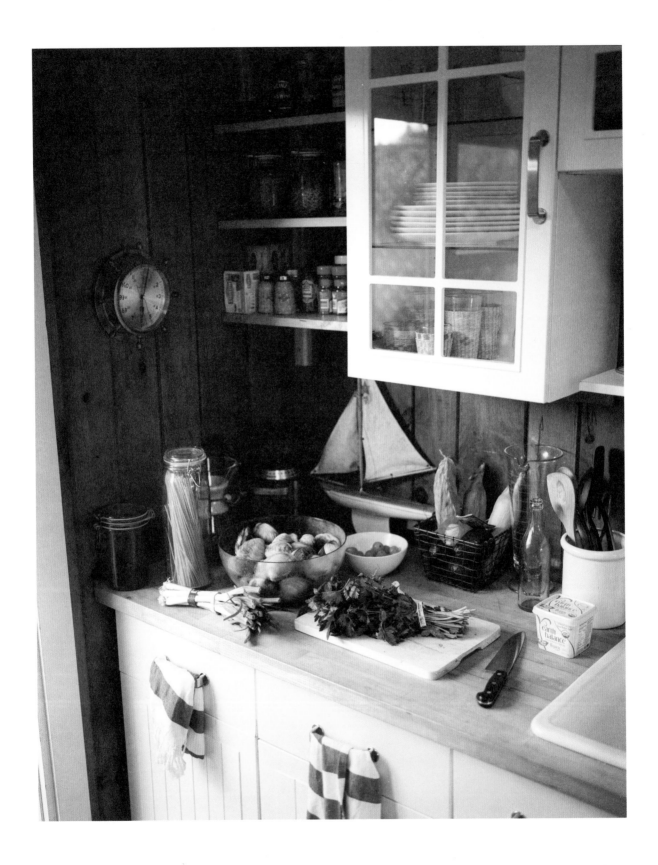

MIKEY & LISA, MONTAUK, NY

Mikey and his wife, Lisa, spend most of their time in New York City, but in the summer they pack their weekend bags and head out to Long Island to stay in their teeny-tiny second home in Montauk. It sits atop a one-car garage, so, as you might imagine, it is pretty darn micro. Despite the size, this place is fully equipped for a weekend of clam digging, beach antics, and chowing on good grub day and night. Mikey has been digging for clams since before he could swim and harbors nostalgic memories of wiggling his tiny toes in the low-tide mudflats. His father was a commercial clammer, so tossing together delectable dishes caught from the Atlantic Ocean is second nature to him.

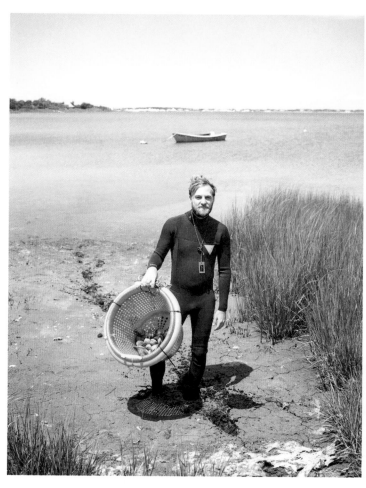
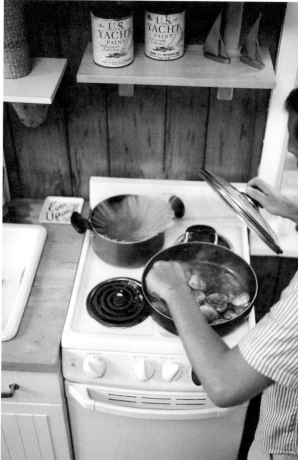

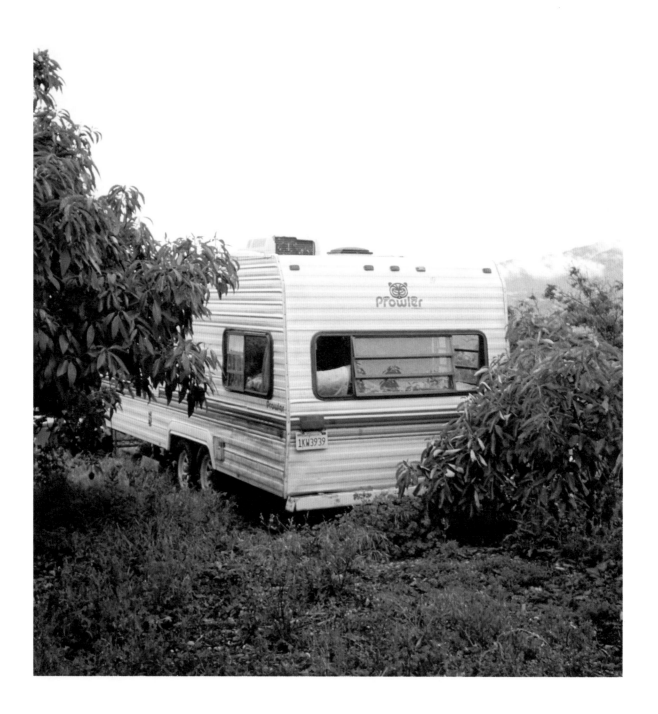

MARY, CARPINTERIA, CA

When the sleepy beach town beneath the mountain is socked in by fog, you will find me 1,800 feet above, in my sunny spot atop the clouds, pottering in and around my 22-foot Prowler travel trailer. As one-third of the team behind *The Tiny Mess*, I've really put my little home to the test while working on this project, throwing no end of culinary challenges at her as we explored recipes and worked on new dishes. She's not only been a home to me these past few years, but also a test kitchen, a daily challenge, a windbreak, a sunshade, and, of course, a zoo. Always a zoo. My little slice of the 1970s has come out the other side of this book with flying colors, proving to me that she's got this. We can handle it. And, most important, that a tiny kitchen in no way hinders my ability to cook delicious and nutritious food for myself and company.

I live on my family's 22-acre avocado farm and have tucked my trailer in a sun-kissed, north-facing spot by an orchard. We are in Carpinteria, California, where the trailer looks out over the Los Padres National Forest, but I can see the Pacific Ocean shimmering in the distance through a portal-like window in my "living room." I have a flat plot of land that I've designated as my very own vegetable and herb garden, and spend a lot of time playing in the dirt. I work up here every day growing food and fixing irrigation and water lines, but also clock hours at a local university, helping them with a small-scale food production garden. I love working with my hands and nurturing plants. I love knowing that the seeds I sow grow into plants that end up on my plate. Besides the farming, I also bake

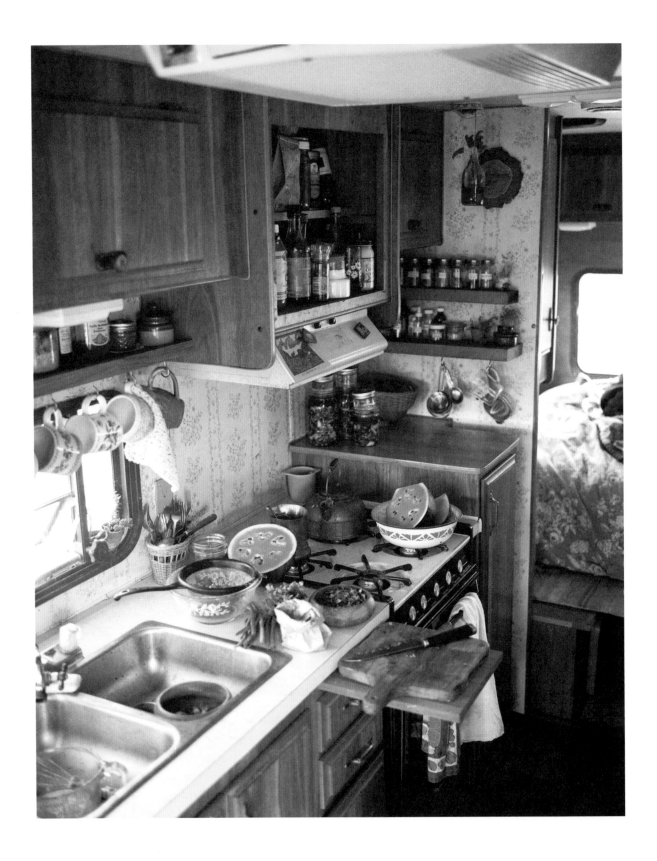

plant-based wedding cakes and sling avocados and lemons at the farmers' market, which, as it happens, is a very good place to meet people who live in funky little homes!

The trailer was sitting decrepit and dying on a friend's farm when I found it. She needed some real TLC, so I rose to the challenge and claimed her. With many hours put in and with the help of friends, I cleared out the rat droppings, bird's nests, spiders, and trash, ripped up the rotten floors, and added a wood-burning stove and a platform bed that sits snugly over two twin beds. But, to be clear, this trailer is not a total refit. She has more retro charm than I can handle some days.

Naturally, the kitchen was my primary focus for the upgrades, as it is where I spend most of my time when I am not sleeping or tending to my gardens. I added open shelving, pulled out the ghastly microwave that I swear was going to fry my brain while I slept, and added little hooks under the cabinets for my mugs, measuring cups, and pot holders. I mounted a spice rack at the far end of the kitchen, as it's really nice to be able to see everything that I have on hand. My oils, vinegars, teas, and assorted witchy brews have moved in where my microwave used to live, and if you ask me, they make much better houseguests. Once upon a time, the built-in fridge-freezer used to work, but not in my lifetime. Now, instead of it being a useless hole, it is the perfect pantry for all my baking supplies, legumes, nuts, and seeds. A couple of open boxes of baking soda keep the moisture and odors at bay.

Overall, the kitchen is great and plenty functional, but there is not as much counter space as I would like. Fortunately, there is a perfect pull-out cutting board hidden away that gives me a ton more room when I need it and three little drawers beneath it for utensils and kitchen linens. I also have a collection of olivewood cutting boards that I can set up on the stovetop and over the sink should I need even more prep room. I cook on a four-burner propane stove and bake everything in the single-shelf oven beneath it. I am a baker by profession so having an oven that works is crucial, and this little dynamo does the job!

There is a small fridge-freezer that I keep on wooden pallets along the side of the trailer, which has been a real treat. Coolers work great in small kitchens but changing out the refreezable gel ice packs is a pain, so I was glad to make the switch. I don't have a ton of storage space so I try to keep my possessions to a minimum. A good sharp chef's knife, a serrated knife, canning jars for just about everything, and professional measuring cups are key. A mini food processor takes the edge off cumbersome tasks and I should not need to tell you why I love my Vitamix. I have to blend soups on the floor and set the slow cooker up next to my bed, but heck, where else am I going to put it?

I've learned that the mess is always worth it. A tiny kitchen certainly keeps me on my toes but it also forces me to be clean and organized, and for that I am very grateful.

My ranch has full power, which is a welcome addition after the last place I lived. Completely wiping the solar-charged battery every time I used my Vitamix got old fast. I used to have to run across the property, blender in hand and foxtails in my feet, and plug it in outside the landlord's house to finish blending. Now I have an extension cord that goes into my trailer to run lights and appliances so I can blend to my heart's desire. The trailer could have plumbing if I hooked it up, but there is a massive leak somewhere under my bed so I go without. Instead, I poked a hose through my kitchen window and zip-tied it in place over the sink. There is no hot water but I can always boil water for extra cleaning power. I have a composting toilet in the orchard and a compost bucket that I keep right outside the door to fling food scraps into if they don't make it to my dog Rose's mouth first.

I have big plans for this little spot. Someday I will build a permanent home—something small and strong that can keep up with the dirt and the weather. I want to diversify my folks' avocado farm, too, perhaps growing row crops and more herb gardens and wildflowers. I'd eventually love to teach classes up here and share the wisdom that medicinal plants have taught me. Of course, cooking is a huge part of my long-term goal, be it teaching or simply

building a dream kitchen with a cob oven to accommodate all my culinary projects and give my family and friends a place to gather. I grew up one of five girls with a stay-at-home momma who cooked nearly all our meals. The kitchen was where we spent most of our time, helping her cook, hanging out, and learning to prepare food with love. This is a tradition that I am excited to continue.

So what exactly does my typical tiny mess look like? Well, if you were to swing by, I'd probably have something bubbling on the stove, or at least some homemade snacks on hand. I follow a plant-based diet so I cook a lot of quick and easy meals that pack a nutritional punch. Whole grains, legumes, fresh greens and herbs, ferments, and, of course, a tasty dressing are standards on my plate. Sunflower seed paté, sweet potato and black bean burgers, black rice and veggie hand rolls, and root veggie tacos with smoky cashew cheese are some of my favorite tried-and-tested recipes that I always come back to. I love to ferment food, too—eating fermented food is a quick way of getting a dose of gut-friendly probiotics. Fermenting is also great for tiny spaces since you can preserve your fresh produce without the need for bulky canning equipment. Don't get me wrong, canning is great, but it has a time and a place. I also love to take advantage of the wild food available here in my backyard for food, teas, and medicines. Elderberries, wildflowers, wild greens, and sages are but a few of my favorites.

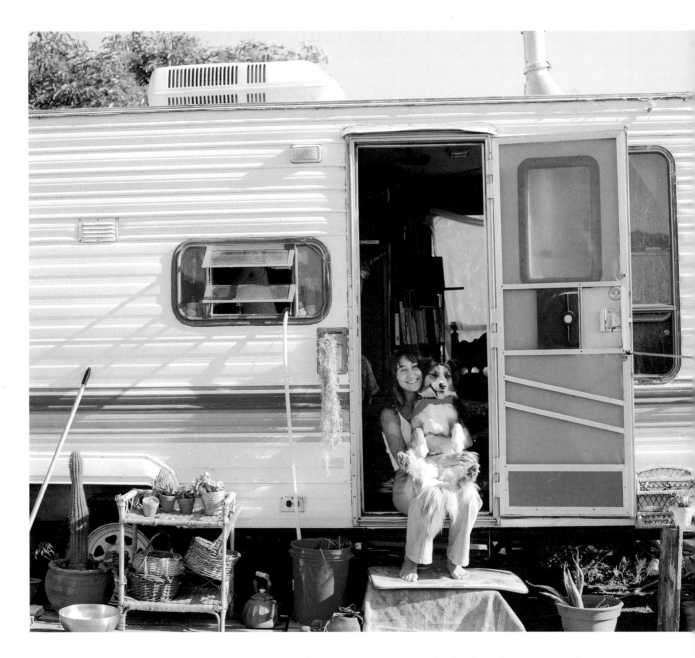

Who would have guessed a few years back that we would have met so many people who share the same core values that motivate us? Meeting people who are going above and beyond in making their tiny, humble kitchens work for them is an absolute inspiration. Working on *The Tiny Mess* has been a catalyst for me to move forward with my own kitchen dreams and dive deeper into transforming my own space up here. It is something that I will be forever thankful for. All the wonderful people you will find in this book are real-life proof that tasty and healthy food doesn't have to be made in a fancy kitchen!

WATERMELON POKE

This is a blow-your-socks-off vegan *poke* featuring watermelon in place of fish. It takes a little bit of preparation, but it's worth it. The melon adopts a meaty texture through cooking and combines with a sticky, salty marinade, fresh green onions, and cilantro. Serve alone or with coconut rice or crunchy raw vegetables. For best results, prepare the watermelon and sauce a day ahead and keep chilled.

SERVES 6

3 pounds seedless watermelon, rind removed, cut into 1-inch pieces

½ cup unseasoned rice vinegar

¼ cup toasted sesame oil

3 tablespoons soy sauce or tamari

2 tablespoons lime juice

2 tablespoons tahini

1 tablespoon agave nectar

1 tablespoon ume plum vinegar

Sea salt

2 green onions, white and pale green parts only, thinly sliced

1 cup fresh cilantro leaves

Place the watermelon pieces in a large resealable bag or bowl. In a blender, combine the rice vinegar, sesame oil, soy sauce, lime juice, tahini, agave nectar, and ume plum vinegar and blend until smooth, or shake vigorously in a jar. Pour over the watermelon, seal or cover, and chill for at least 4 hours or up to 1 day.

Heat a large skillet over medium heat. Remove the watermelon from the marinade; set the marinade aside. Cook the watermelon, tossing often, until firmer and lightly caramelized, 6 to 8 minutes.

Meanwhile, bring the marinade to a boil in a small saucepan. Reduce the heat to maintain a simmer and cook until thickened to the consistency of heavy cream, 12 to 15 minutes.

Chill the watermelon and sauce separately for at least 1 hour, ideally 12 hours. To serve, toss the watermelon with the sauce, taste, season with salt as needed, and top with the green onions and cilantro.

UME PLUM VINEGAR CAN BE FOUND AT JAPANESE MARKETS, NATURAL FOOD STORES, AND SOME SUPERMARKETS.

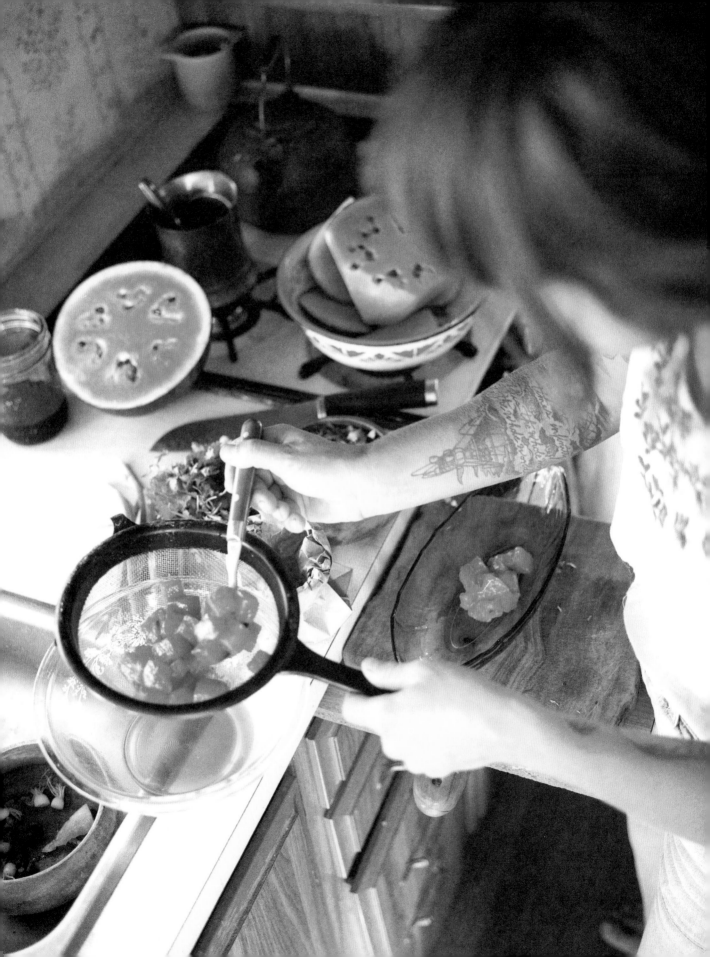

RAINBOW CARROTS
WITH BEET YOGURT & HERB OIL

Maddie and I created this recipe for a springtime dinner we hosted for some friends at my previous home. It was a splendid evening, spent in good company nestled in an avocado orchard. We dreamed up a vibrant spring menu featuring seasonal vegetables, including this intoxicating rainbow carrot dish. Drizzled with magenta-hued beet yogurt and herb oil, this side is a stunner and would complement almost any main dish.

SERVES 4

20 heirloom carrots, tops trimmed to about 1 inch

3 tablespoons plus ½ cup olive oil

1½ teaspoons sea salt

1 beet, peeled and grated

½ cup plain unsweetened yogurt

⅓ cup fresh dill

⅓ cup fresh parsley

⅓ cup fresh mint

Flaky sea salt

Preheat the oven to 350°F.

In a large roasting pan, lay the carrots out, drizzle with 3 tablespoons of the olive oil, and sprinkle with the sea salt. Massage with your hands to ensure the carrots are well coated. Bake for 40 minutes or until a carrot easily falls off a fork.

While the carrots are roasting, take the grated beet and squeeze it through cheesecloth or a fine-mesh sieve to separate the juice from the flesh. Keep the juice and save the flesh if you like for veggie burgers or a salad. In a small bowl, combine 2 tablespoons of beet juice and the yogurt. Cover and set aside.

In a blender, combine the remaining ½ cup olive oil and the dill, parsley, and mint. Blend until the herbs are well broken down and the oil is bright green. Pour through a fine-mesh sieve into a bowl, keeping the oil and discarding the solids.

Lay the roasted carrots on a platter, drizzle with the yogurt and the herb oil, and sprinkle with flaky sea salt.

WILD WEED SOUP

I left the name of this soup pretty open to interpretation. As we encourage throughout this entire book, switch out ingredients for your favorites and use what's available or seasonal to you. I used nettles and nasturtium in this creamy plant-based dish. The nasturtium adds subtle pepperiness and that garden-green hue, and nettles pack a nutritional punch. This soup is rich and velvety in texture thanks to the earthy celery root, and is best served with a swirl of something creamy and some crunchy toast.

SERVES 6

2 tablespoons coconut oil or butter

2 cups thinly sliced leeks

1 fennel bulb, thinly sliced

2 cloves garlic, finely chopped

3 cups diced celery root

2 teaspoons fresh thyme, finely chopped

2 teaspoons finely chopped fresh rosemary

3 cups vegetable broth or water

1 tablespoon cider vinegar

½ cup coconut cream or heavy cream

1 cup coarsely chopped wild weeds (nettle, young dock, dandelion, mallow, chickweed, mustard greens, watercress, and miner's lettuce are all great options)

1 to 2 nasturtium leaves (optional, for color)

Sea salt

In a large pan, heat the oil over medium. Add the leeks, fennel, and garlic and sauté until translucent, about 3 minutes. Add the celery root, thyme, and rosemary, and cook until slightly tender, about another 5 minutes. Add the broth and vinegar. Stir in the coconut cream, the wild weeds, and the nasturtium leaves, if using. Simmer for 5 minutes and then remove from the heat.

Using a tea towel or rag to hold down the lid and protect your hand from the heat, pour the mixture into a blender and whiz until smooth. Season to taste with salt. Serve garnished with whatever tickles your fancy. Perhaps a splash of cream or a drizzle of olive oil, some sunset-hued nasturtium flowers, or a sprinkle of toasted seeds. The choice is yours.

IF YOU PICK YOUR OWN NETTLES, AIM FOR THE YOUNG TENDER SHOOTS OR BRIGHT GREEN TOPS OF THE PLANT. IF IT'S GONE TO FLOWER, THE LEAVES CAN BE TOUGH AND BITTER.

TAMALES STEAMED IN AVOCADO LEAVES

This is a family recipe passed down from my Hispanic grandmother. I had to adapt it to suit my vegan diet and make these every Christmas with my mom and grandmother. My sisters always want to eat the vegan tamales despite the plates of meaty tamales on the table. I've learned long ago to stockpile these at family dinners! Despite the length of this recipe, it's actually just a couple of really simple processes: mix the masa, sauté the vegetables, and assemble and steam the tamales! Instead of corn husks, I use avocado leaves. Obviously, living on an avocado ranch means I have an abundance of these, so it just makes sense! I used Hass avocado leaves, but it's traditional in Mexico to use other varieties that have an anise flavor. They impart no overpowering flavor to the tamales and can be switched out with traditional corn husks.

MAKES 10 TAMALES

20 large Hass avocado leaves, or 10 corn husks

Masa

2½ cups masa harina

¾ cup sunflower oil

2 cups vegetable broth, at room temperature, plus more for steaming

1 tablespoon Mexican lime zest

Filling

3 tablespoons olive oil

3 cups sliced cremini mushrooms

1 medium onion, finely diced

2 cloves garlic, minced

2½ teaspoons chipotle chile powder

1 teaspoon smoked paprika

1 teaspoon ground cumin

1 tablespoon cider vinegar

2 cups chopped, stemmed Swiss chard

Sea salt

2 tablespoons vegan mayonnaise

Salsa and mole, for serving

If using avocado leaves, cut the stalks flush with the bottoms of the leaves. Do not destem them, though. If using corn husks, soak them in hot water for 20 minutes.

To make the masa: In a large bowl, combine all of the masa ingredients with a spatula. Set aside while you prepare the filling.

To make the filling: Heat the olive oil in a large cast-iron skillet over medium. Add the mushrooms and onions and sweat for 3 minutes, then add the garlic, chile powder, paprika, and cumin. Continue sautéing for 5 minutes, add the vinegar and chard leaves, and season with salt to taste. Cook until the vegetables are tender. Stir in the vegan mayonnaise and remove from the heat.

Nestle a steaming basket wide enough to accommodate your tamales without crowding them into a large pot. Fill the pot with broth to just below the bottom of your steaming basket. Bring the broth to a gentle simmer while you assemble the tamales. Be prepared to top off the broth when you add the tamales. The pictures are going to be really helpful for this step!

(Continued on the next page . . .)

SAVE THE CHARD STEMS THAT AREN'T BEING USED AND THROW THEM INTO JUST ABOUT ANY SAVORY DISH.

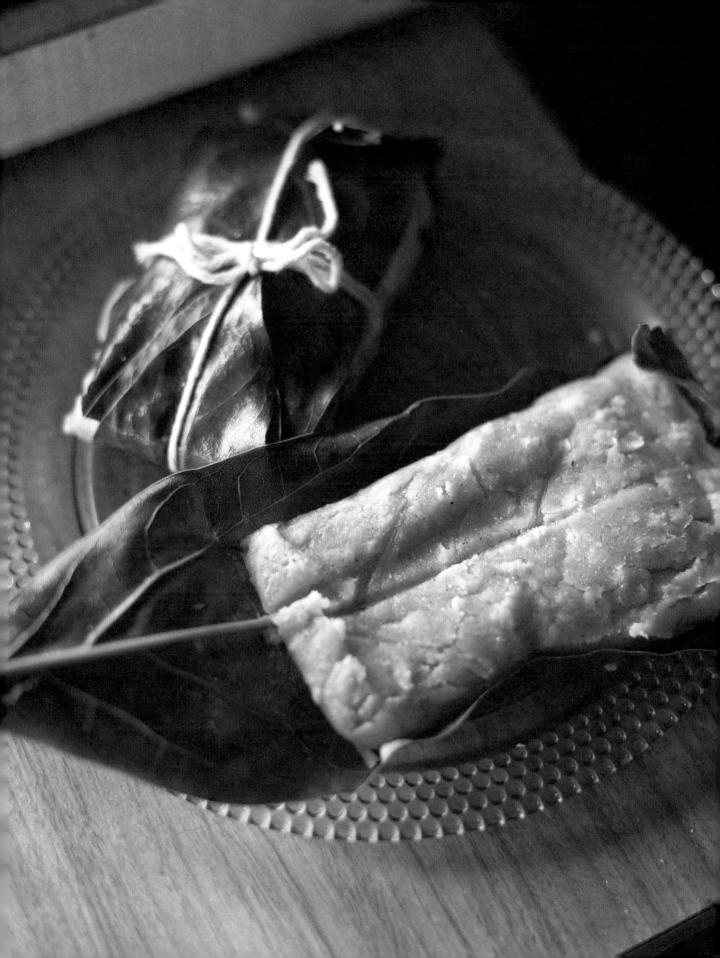

To make a tamale, lay out a large avocado leaf, shiny-side down so that the ribbed stem (underside) is facing you. (If using corn husks, fill them smooth-side down.) Using your hand, scoop about ¼ cup of masa and press it onto the leaf, leaving a ¼-inch perimeter. Top the masa with about 2 tablespoons of the filling, making sure it's in the center, leaving a little masa exposed on either side. Take another ¼ cup of masa in your hands. Roll it into a ball and pat it flat between your fingers, making a shape a little larger than the filling area of your tamale. Gently press the masa on top of the vegetable filling, making sure the filling is encapsulated in the masa. Top with the second leaf, shiny-side up, tucking the edges of the top leaf inside the bottom leaf. Take 16 inches of natural string, lay it over the top of the tamale, and wrap, like a parcel, bringing the string underneath, twisting, and then bringing it back up and finishing with a bow.

Repeat this step until all the masa is used up. You may have filling left over, lucky you!

Place the tamales in the steamer and steam for 40 minutes. You can check the doneness by removing a tamale, gently lifting the top leaf, and pressing the masa. If it's slightly firm, it's done. These can overcook, so make sure to check at the 40-minute mark.

To serve, unwrap the steamed tamales and top with salsa or mole.

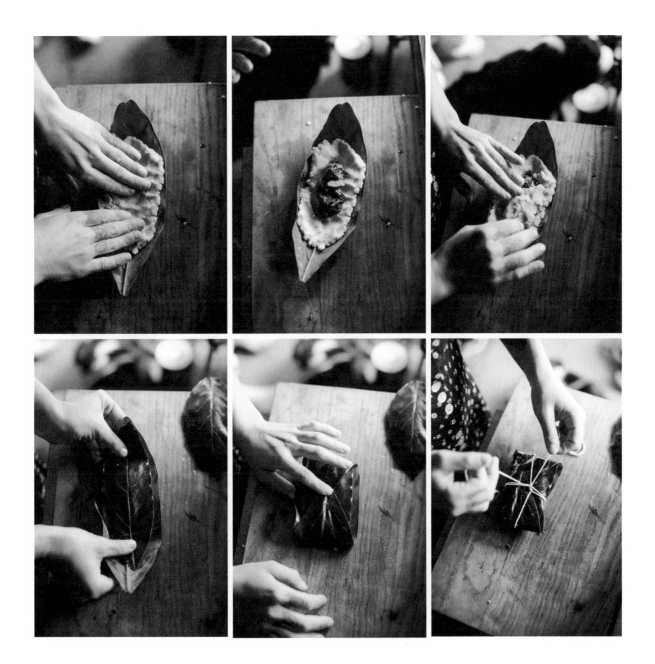

YERBA SANTA ICE CREAM

Yerba santa is a plant native to California and Oregon. Chumash Indians often referred to it as a "sacred herb." As well as its known medicinal properties, this little herb has an intriguing flavor comparable to sage with floral notes and lends itself wonderfully to creamy, sweet desserts. For this recipe, you will need an ice cream maker, a nut milk bag or cheesecloth, and a blender.

MAKES JUST OVER 1 QUART

2 cups raw unsalted cashews, soaked in water for at least 8 hours, drained, and rinsed

4 cups water

½ cup chopped fresh yerba santa leaves (see note)

1 cup canned full-fat coconut milk

½ cup honey

1 teaspoon vanilla bean powder

Bee pollen and raw honey (optional), for topping

In a high-powered blender, combine the cashews and water and blend until creamy. Pour into a nut milk bag and squeeze gently over a jar until you have extracted all the cashew milk. Hold on to the pulp if you like and use it in raw piecrusts (like Serena and Jacob's on page 163) or Superfood Balls (like Ally and Andrew's on page 169).

Pour the cashew milk into a saucepan and heat until steaming but not yet simmering. Remove from the heat. Add the chopped yerba santa and steep for 30 minutes. Strain the milk infusion and set aside to cool completely.

In the blender, combine the infused cashew milk, coconut milk, honey, and vanilla bean powder and blend well. Pour the mixture into your ice cream maker and follow the directions for your machine. To serve, top with whatever you fancy. A sprinkle of golden bee pollen and a drizzle of raw honey capture the summer wonderfully.

IF YOU CAN'T FIND OR FORAGE YERBA SANTA IN YOUR AREA, TRY SWITCHING IT OUT FOR 4 CALIFORNIA BAY LEAVES OR 6 CONVENTIONAL BAY LEAVES.

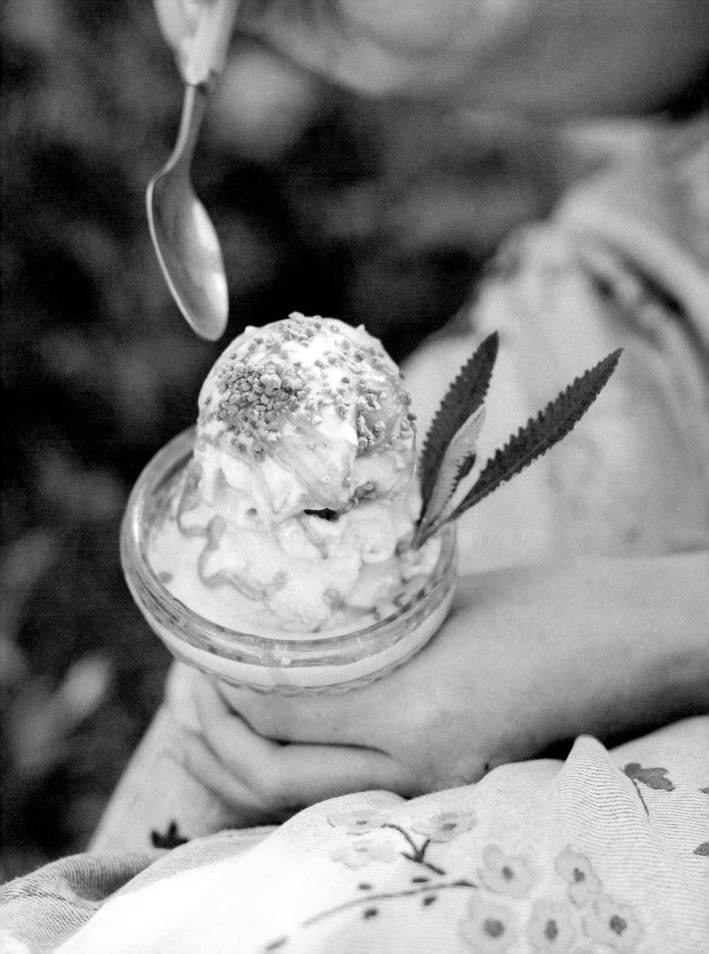

RICH CHOCOLATE JARS
WITH MULBERRY- CHOCOLATE GANACHE

There is no hiding it: we are millennials. This twist of birthday fate means we drink and eat everything out of glass canning jars. Besides being "supercool," these little jars and two-part lids are extremely helpful in a tiny kitchen. They play the roles of drinking glass, storage container, freezer bag, and spice jar, and are even oven friendly. All of which means that we can make more room for the stuff that matters, like chocolate chips. This dessert is baked and served in little 4-ounce jars because, let's face it, we haven't got room for a freakin' cupcake pan.

MAKES TWELVE 4-OUNCE JARS

Sunflower oil, for greasing

1 cup granulated sugar

Cakes

¾ cup unsweetened nondairy milk

2 teaspoons cider vinegar

1½ cups all-purpose flour, sifted

½ cup unsweetened cocoa powder, sifted

¼ cup packed brown sugar

1 tablespoon arrowroot powder

1¼ teaspoons baking powder

1¼ teaspoons baking soda

¾ teaspoon sea salt

¼ cup plain coconut yogurt

½ cup brewed coffee, cooled

¼ cup unsweetened tart cherry juice

1 teaspoon vanilla extract

¼ cup plus 2 tablespoons sunflower oil

Ganache

½ cup canned full-fat coconut milk

½ cup chocolate chips

½ cup mulberries

Preheat the oven to 350°F. Grease twelve 4-ounce oven-proof canning jars with oil and dust lightly with granulated sugar.

To make the cakes: In a small bowl, combine the nondairy milk with the vinegar and set aside for 5 minutes to curdle and thicken. This will be your buttermilk substitute.

In a large bowl, combine the flour, cocoa powder, brown sugar, arrowroot, baking powder, baking soda, and salt. Add the nondairy milk mixture, yogurt, coffee, cherry juice, vanilla, and oil and whisk until smooth.

Fill each jar with batter, leaving about ½ inch of room to allow the cakes to rise. Bake for 15 to 20 minutes or until the cake bounces back slightly when gently pressed with your fingertip.

To make the ganache: Heat the coconut milk in a pot until hot but not boiling. Remove from the heat and whisk in the chocolate chips. Stir in the mulberries. Set aside.

Allow to cool slightly. Spoon the ganache over the cakes and serve in the jar.

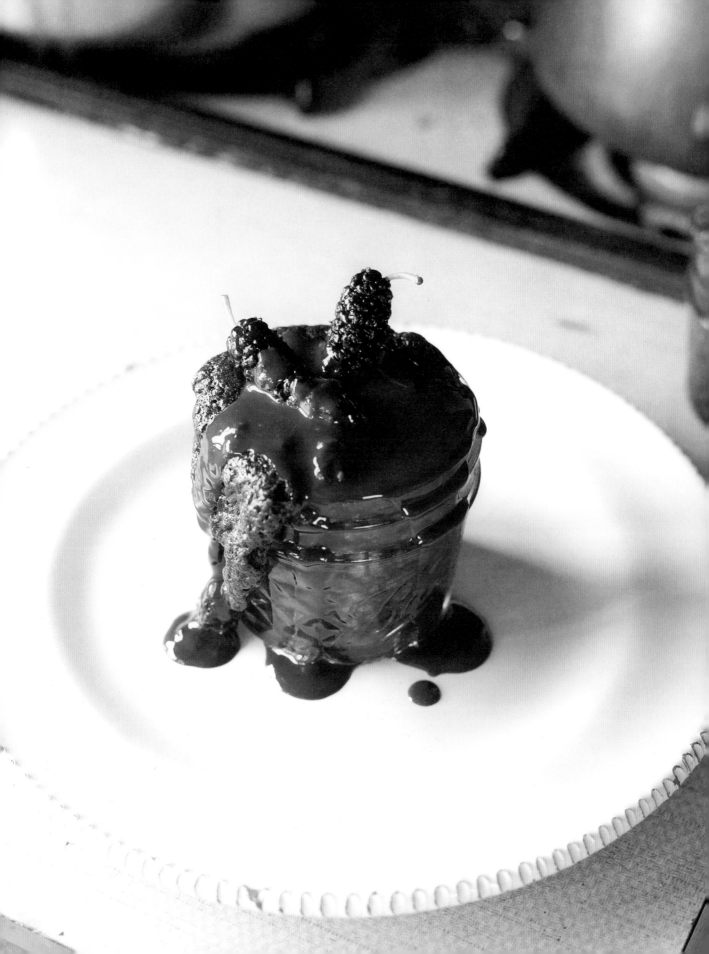

TOMMASO & EVA, OAKLAND, CA

If you happen to be visiting Jack London Harbor on a Thursday evening, there is a real chance that a plate will be thrown your way piled high with boat-made delicacies. Thursday night is "dockluck" night in the marina where Tommaso and Eva live, and their 35-foot sailboat home provides them zero limitations when it comes time for some high-quality galley cooking.

Their food is alive with Tommaso's Italian heritage, something that we quickly learned upon visiting and watching him slice guanciale through a curtain of freshly cut pasta. It was poetry in motion. Their small galley has plenty of flat counter space for rolling out pasta dough, and they keep a compact little pasta maker on board to make this job even easier. We asked Tommaso if he ever feels like his culinary projects get limited due to the minimal space aboard their boat and he replied, "Space limitations are, more often that not, limitations of our imagination." And we couldn't agree more.

Their potluck evening was really special. We've visited plenty of marinas up and down the West Coast, but this place will be forever etched in our memories. We admired the tight community in the marina, and according Tommaso, their weekly "docklucks" have now been extended to other marinas because folks were feeling left out. Just one visit and we could see why; we met some real characters that evening, including a gentleman who lived next door on a sailboat and was baking yeasted rosemary bread from scratch. We passed the loaf around the table, tearing off hunks and mopping up the savory, fatty sauce.

Unfortunately, the day we visited was the same day of a devastating earthquake in the Italian mountain town of Amatrice. In a show of solidarity, Tommaso and Eva's meal that night was prepared with a sauce from Amatrice.

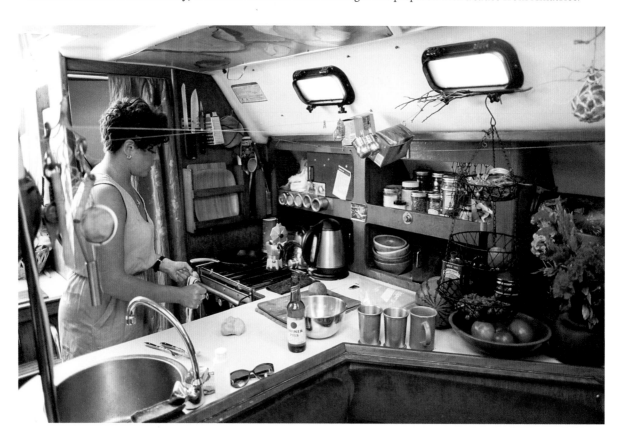

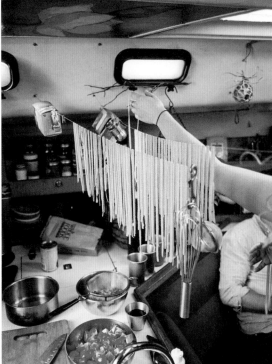

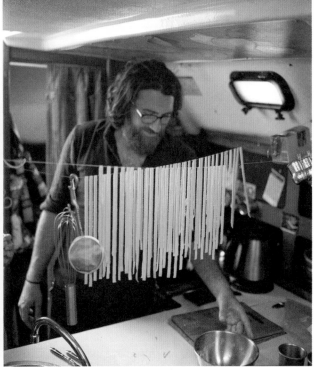

AMATRICIANA SAUCE

This traditional Italian sauce is rich and bold and will complement your pasta exceptionally well. It's no big deal if you can't find guanciale at your local deli—good bacon or pancetta will work fine. However, Tommaso explained to us that you might sacrifice both consistency and flavor should you decide to swap it out.

SERVES 2

½ pound guanciale

Olive oil

1 teaspoon red pepper flakes

½ cup dry white wine

One 14.5-ounce can crushed or diced tomatoes

Sea salt and pepper

Grated Pecorino Romano cheese

Cooked pasta, for serving

The traditional way to cut the guanciale is into strips about ¼ by ¼ by ½ inch, but you can slice it anyway you please. In a pan over medium-high heat, combine a touch of olive oil, the guanciale, and the red pepper flakes. Reduce the heat to medium-low and let the guanciale render and brown.

When the meat has browned nicely, add the wine to deglaze the pan. When the wine has mostly evaporated, add the tomatoes and simmer for 30 minutes. Season with sea salt, black pepper, and Pecorino. Serve tossed with your favorite pasta.

TRY THIS WITH LINDSEY'S PASTA RECIPE ON PAGE 156.

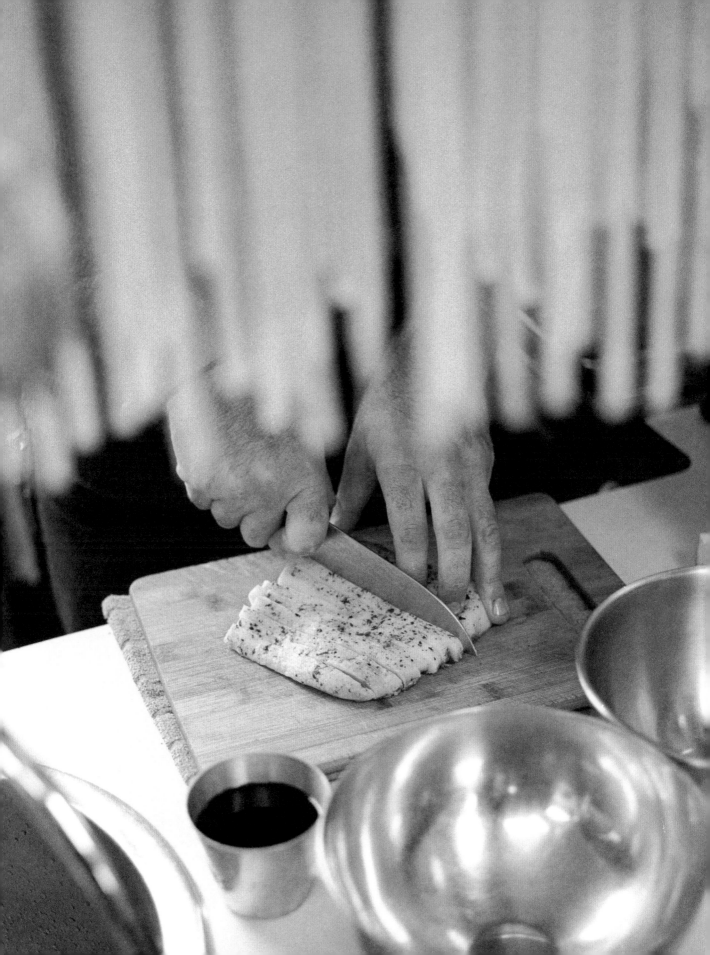

TATSUO, CENTRAL COAST, CA

Tatsuo is a Japanese surf photographer who has spent the last eight winters in his 1989 Ford Econoline van driving up and down the California coast, surfing and shooting for his book *Authentic Wave*. When we ran into him in the parking lot at Rincon (a famous Santa Barbara break), he was making a spicy tuna sushi roll out of the back of his van, with his surfboard underneath and his wetsuit dripping off the roof. He has a full-fledged electric rice cooker that he plugs into the car's battery and the coolest little sit-at kitchen. We've dabbled in sushi making here and there but Tatsuo is really good at it. He dips the tip of his knife in water, letting the drip slide down the blade before slicing the roll with restaurant finesse. This helps the knife glide smoothly through the sticky rice when cutting the rolls. His tricks for making great sticky sushi rice are to rinse the uncooked rice plenty of times to remove some of the starch and to use less water than commonly recommended when it comes to cooking it.

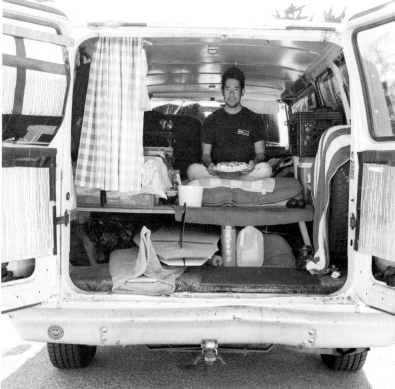

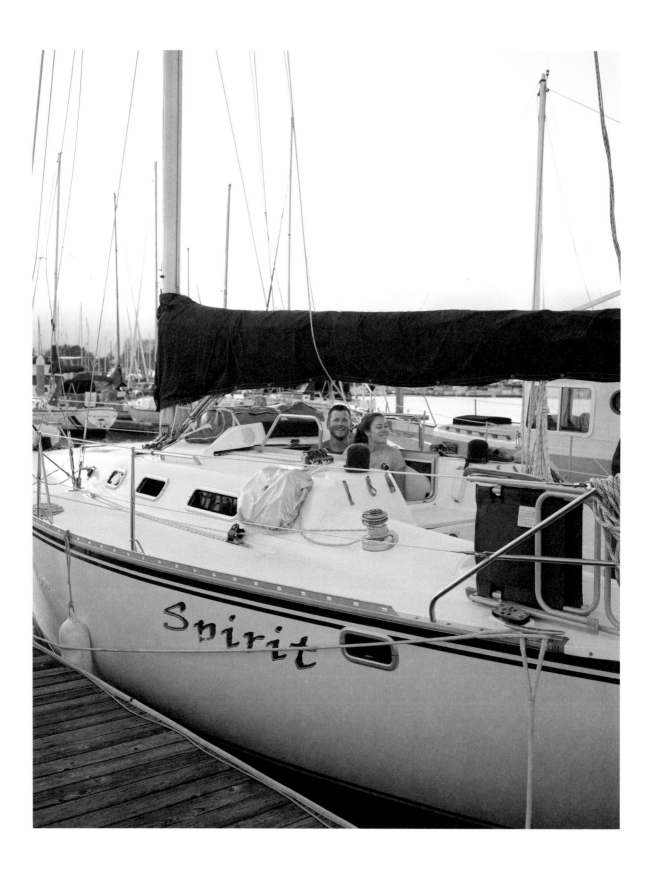

SONYA & JACK, BERKELEY, CA

The baking secrets Sonya and Jack shared with us will change your approach to tiny-kitchen cooking forever. This Bay Area couple blew our minds with what they could cook up on a boat with no oven. We kid you not, once you've learned their secrets, you will be thanking this crafty duo for years to come for their hard-earned Dutch-oven wisdom.

Sonya and Jack were the first liveaboards we visited for this book. The couple maintain boats for a living, so their personal vessel, a 37-foot 1987 Hunter Legend named *Spirit*, was meticulously kept. It was in an impressive state, considering they are actively getting ready for a big cruise south to Mexico and, hopefully, onward to the tropical South Pacific.

Both of them grew up sailing with family, Sonya in Uruguay and Jack on the windy waters of the Chesapeake Bay in Virginia, and it shows in both the form and function of *Spirit*. Their galley is a no-nonsense space purposely customized for the efficient creation of tasty food. They have a spot for everything and pride themselves on being able to covert the boat from a cozy floating home to a stealthy and seaworthy cruiser in twenty minutes flat. Anything that does not have a stow-away spot or a permanent home does not belong on the boat. Period.

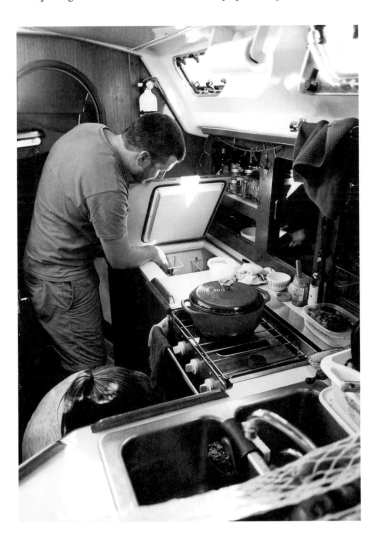

Sonya and Jack don't have an oven, only a two-burner propane stove. However, living an ovenless life doesn't seem to bother them too much. Instead of surrendering to meal after meal of soggy vegetables and boiled meat, they have figured out not only how to roast an entire chicken in a Dutch oven in about an hour on the stovetop, but also how to bake cakes, bread, and sourdough cinnamon rolls in the very same pot. It is absolutely inspirational.

Due in no small part to its versatility, Sonya considers her magic cast-iron Dutch oven to be the key to tiny-kitchen cooking. Below are just a few of the tips and tricks she has picked up over the years for getting the most out of her only "oven." We threw in a few of our own tips regarding maintenance at the end.

- Invest in a heat diffuser. This round of solid cast iron will evenly disperse the heat from your stovetop to the Dutch oven, preventing hot spots and cutting down on burnt, black-bottomed breads.

- Preheat both the base and the lid of your Dutch oven prior to cooking. A Dutch oven is essentially a minioven, and you

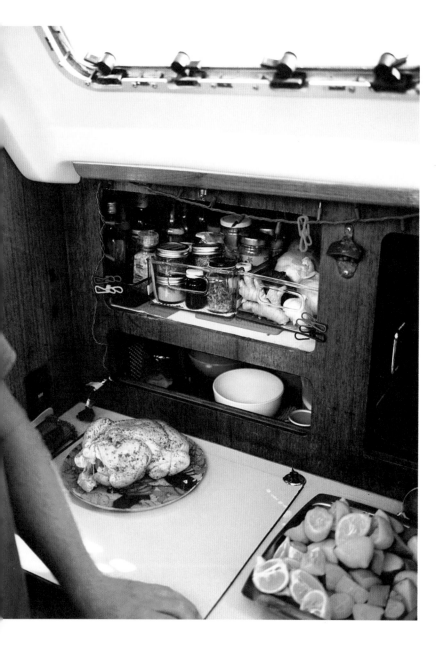

wouldn't ever think about putting a cake in a cold oven, would you? It certainly pays off to preheat it for stews and such, too, as it will significantly reduce your overall cooking time.

· Set the threaded piece of a Mason jar lid in the pot before placing any cake pans to lift them off the bottom of the Dutch oven. This helps the heat circulate as in a real oven.

· A lot of steam is created in a Dutch oven, so it can be hard to brown breads and toast the tops of cheesy dishes. Sonya uses a blowtorch to melt and brown the cheese on her lasagna and other casseroles.

· Slow and low is nearly always the key.

· Never, never, ever use soap (especially scented dish soap) on unenameled cast-iron pots and pans. They are sponges for flavor, which is a good thing until you suds up with some brightly colored dish soap and your next stew tastes like "Cashmere Breeze" or whatever the heck your soap was called. (Come to think of it, this goes for siliconeware, too. We've licked way too many soapy spatulas.) A coarse scrubber, some soaking, and some elbow grease are typically all you need. Whatever is left will just add more flavor to your next dinner!

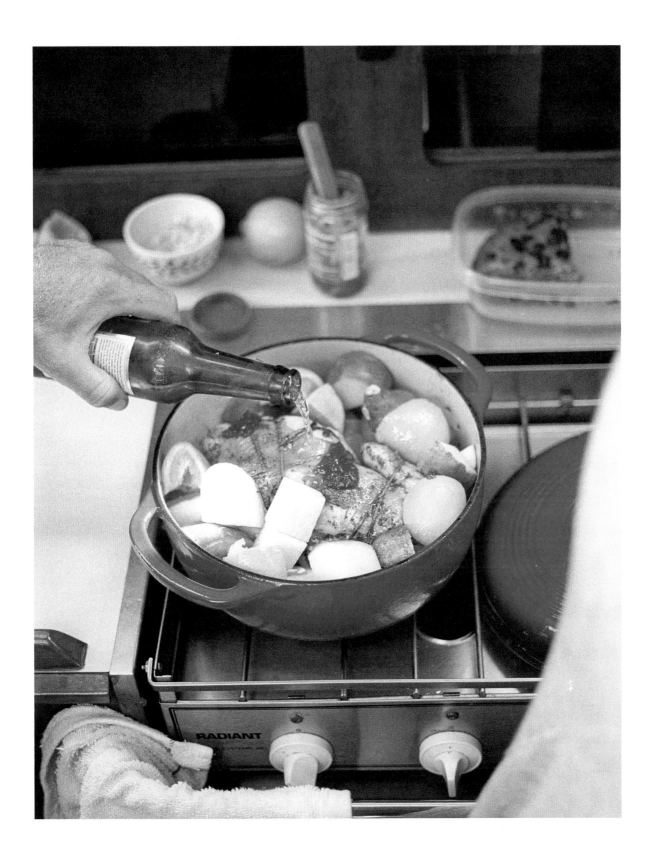

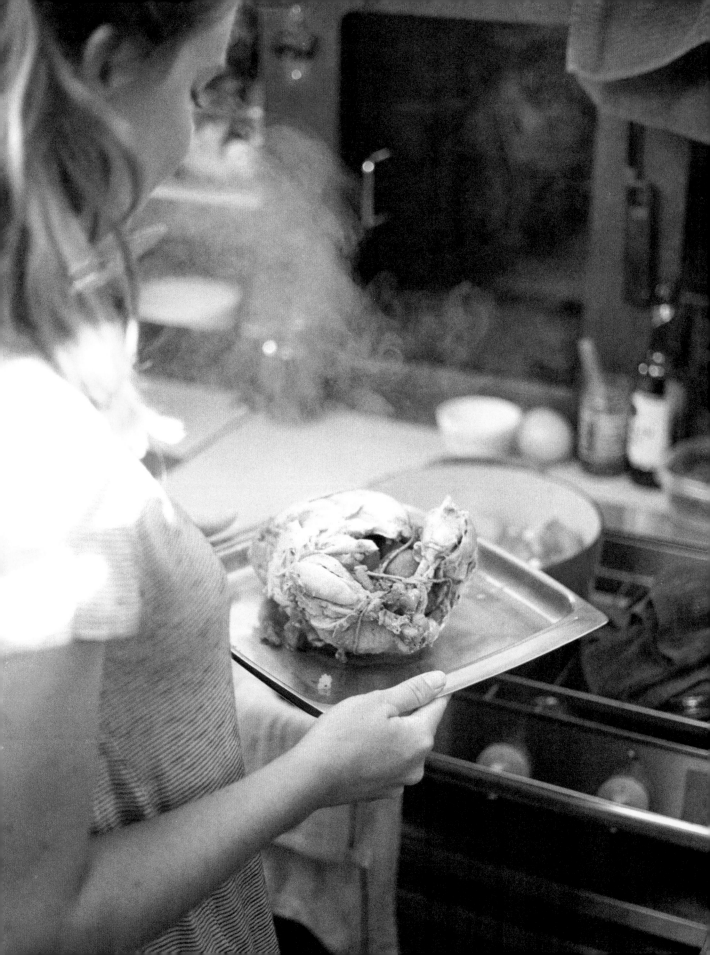

STOVETOP-ROASTED CHICKEN
WITH PILSNER & SWEET POTATO

We were so excited that Sonya and Jack shared this recipe with us. It is a secret that needs to be shared with the international tiny-kitchen community! Sonya and Jack don't have an oven but that doesn't stop them from essentially baking on their stovetop. You can cook an entire chicken on the stovetop in an hour and it's fantastic. This is a really juicy dish thanks to the Pilsner, and those sweet potatoes—wow, they sure soak up all of that chicken lickin' flavor.

SERVES 4

1 whole free-range organic chicken (about 3 pounds)

1 yellow onion, cut into eighths

1 large lemon, quartered

2 tablespoons finely chopped fresh rosemary

2 tablespoons fresh thyme, finely chopped

3 tablespoons olive oil, plus more as needed

8 ounces Pilsner beer

1 cup chicken broth or water

1 teaspoon sea salt, plus more as needed

Black pepper

9 cloves garlic

1 large sweet potato, peeled and cut into 1-inch pieces

2 large carrots, sliced

4 celery stalks, chopped

Lemon juice and zest (optional)

Begin by stuffing your chicken with the onion, quartered lemon, one tablespoon of the rosemary, and one tablespoon of the thyme. Close the cavity by tying the chicken legs together with some natural kitchen string. Pat the chicken dry and sprinkle with a little olive oil, salt, and the remaining rosemary and thyme, and set aside.

Heat the olive oil in a large Dutch oven on the stovetop over medium-high heat. When the oil is smoking, add the whole chicken and cook, turning often to brown the skin and seal in the juices, until lightly browned. Reduce the heat to medium-low, add the beer, broth, salt, and pepper to taste, and put the lid on. Cook for 35 to 40 minutes.

Remove the lid and add the garlic, sweet potato, carrots, and celery. Cover and cook for another 15 to 20 minutes.

When the vegetables are tender, turn off the heat. Using a meat thermometer, check the temperature between the thigh and the breast of the chicken. If it reads 185°F, it's done. Alternatively, check that the juices run clear when a sharp knife is inserted. Remove the chicken carefully and transfer it to a large shallow dish. Debone the chicken while it's still warm.

Taste the broth in the Dutch oven, season with salt and pepper, and cook for a few minutes more to thicken the sauce. Add a squeeze of lemon juice and a pinch of zest for a bright, citrusy flavor. Return the deboned chicken pieces to the pot and serve.

CHARLIE, MARIN COUNTY, CA

Charlie is a career woodworker, painter, and installation artist, and his home on the salty banks of a coastal mud flat in Marin County, California, is an eclectic and endlessly intriguing ode to intention. Art pieces, handmade furniture, tiny treasures, and trinkets are everywhere, and what's even better is that there is likely a story behind all of it. Within minutes of our arrival, Charlie fired up his La Pavoni manual espresso machine and poured little shots for us to sip on. It was a funny moment and a perfect introduction to the man and his aesthetic—the sleek and sexy espresso machine seemingly out of place sitting in this little rustic kitchen and perched next to a baby sculpture with a sea urchin head.

The kitchen was clearly the result of a loving rebuild, utilizing weathered wood for the cabinets and linen-lined boxes for tools and utensils. Art is everywhere, which makes it really hard to remove yourself both physically and mentally from Charlie's home. We walked from wall to wall taking in details and getting up close and personal with collections of stones and bones and the psychedelic painted sea urchins that Charlie creates.

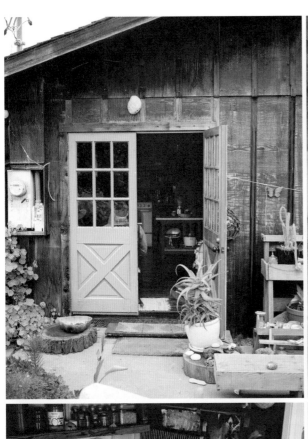
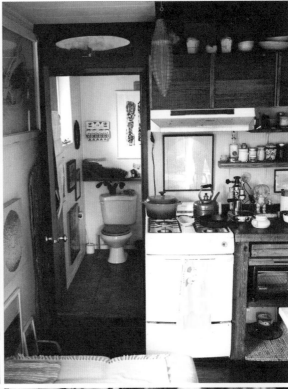

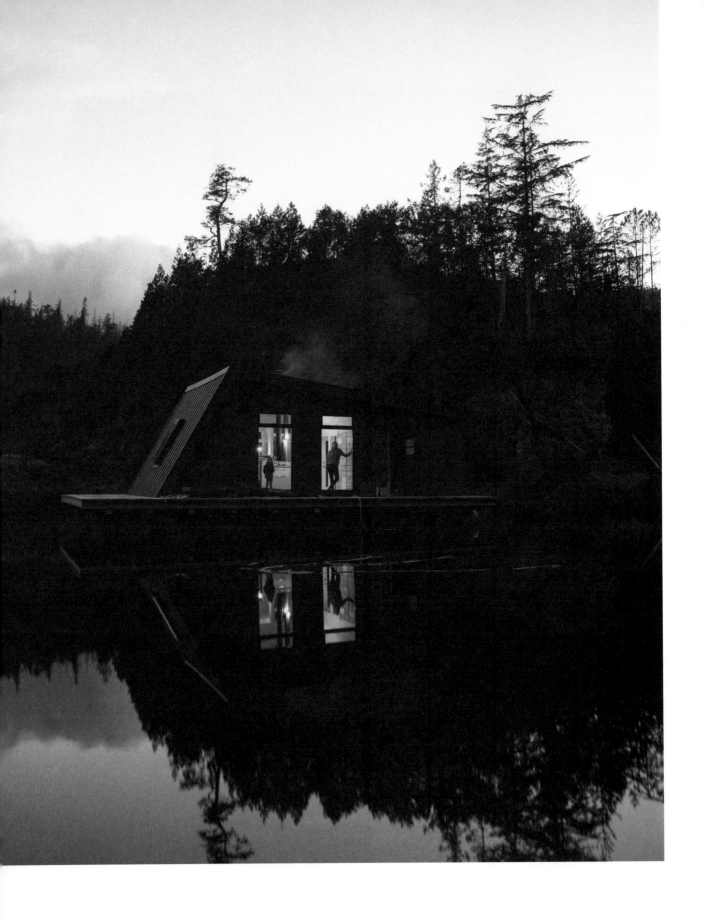

JEREMY & SARAH, VANCOUVER ISLAND, BC

Floating in a hidden inlet deep in a fjord in British Columbia, you might be able to spot Jeremy and Sarah's float house. Maybe. Blink and you might miss this quiet floating gem. It is seriously serene back in those sleepy inlets. In the summer, the ocean can reach temperatures in the high 70s and the only sounds are passing fishing boats, the wind through the trees, and the delicate trickle of the changing tides.

The float itself is 1,200 square feet, much of which is luxurious deck space. The actual home is only 400 square feet. There are beds set up against the back wall, and in the middle is a kitchen centered around a woodstove. The rest of the space is open plan with magnificent floor-to-ceiling windows. The entire float was built with locally sourced cedar and has a brilliant matte-black standing-seam roof that absorbs heat and helps keep the house surprisingly warm on chilly days. Anchored by five 2-inch-thick steel ropes, the whole thing sits behind a giant rock, which gives Jeremy and Sarah much privacy should a stray boat or dinghy putter by. It really is an ideal summer home for this couple and their daughter, Bella.

There's no power or potable water at the float house, so the family must boat in all their supplies. They have no fridge, but instead there is an outside cold storage space accessible from inside the home. It's essentially a cupboard with insulated doors on the inside but remains uninsulated on the exterior to let the cold come through. They cook most of their meals on a propane stove but enjoy using the woodstove when it's not a blistering-hot day. Jeremy and Sarah eat a ton of fish thanks to an abundance of local, line-caught, sustainable options, and best of all, they can harvest oysters and catch salmon, halibut, and crab right off the rocks by their home!

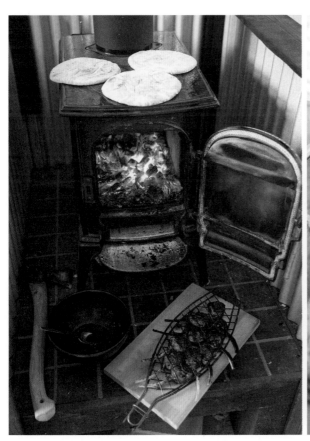

MARINATED LAMB COOKED ON COALS

Jeremy and Sarah are the masters of woodstove cooking. Using a grilling basket, they prepare all kinds of proteins and vegetables on red-hot embers, including the best tuna we've ever eaten. Jeremy says the marinade for that is top secret, so we happily settled for this instead. This succulent marinated lamb has warming Middle Eastern flavors and is paired with cool and tart cucumber yogurt. This dish tastes great with some wilted greens and golden turmeric rice or flatbreads.

SERVES 6

¼ cup olive oil

¼ cup pomegranate molasses

¼ cup balsamic vinegar

3 cloves garlic, minced

2 teaspoons baharat spice blend (see note)

¾ teaspoon sea salt

3 pounds lamb chops or cutlets

1 medium cucumber

¾ cup full-fat yogurt

¼ cup loosely packed finely chopped fresh mint

Squeeze of lemon

In a large bowl, combine the olive oil, pomegranate molasses, vinegar, garlic, spices, and salt. Add the lamb, making sure that each piece is covered with the liquid. Cover and refrigerate for up to 4 hours.

While the lamb is marinating, prepare the yogurt. Grate the cucumber into a bowl. Using your hands, take a huge handful and squeeze out as much liquid as possible into a separate bowl. Repeat this step if necessary until all of the cucumber has been squeezed. Reserve the cucumber juice. Mix the grated cucumber flesh, yogurt, mint, and lemon juice. Add a tablespoon or two of the reserved cucumber juice and stir until the yogurt has reached a consistency perfect for drizzling. Refrigerate until ready to serve (and throw the rest of that refreshing juice into a cocktail!).

When you're ready to cook the lamb, you have a few options. You can cook it in a cast-iron skillet, in a woodstove like Jeremy and Sarah did, or on a grill.

If using a skillet, sear the lamb over a medium-high heat in a glug of olive oil. How long you cook the lamb is entirely your personal preference. Giving a ½-pound lamb chop about 3 minutes per side will get you at the rare end of medium-rare.

If using a woodstove, allow the fire to burn down to flameless, red hot coals. Using a grilling basket (see photo on page 147), pop the lamb into the woodstove, turning it periodically and checking for doneness often. The lamb can quickly go from rare to medium and even well-done so stay on top of it!

Serve with the cucumber yogurt.

IF YOU CAN'T FIND BAHARAT SPICE BLEND, TRY MAKING YOUR OWN CUSTOM BLEND OF CUMIN, CORIANDER, GINGER, CINNAMON, PEPPER, CARDAMOM, CHILE PEPPER, CLOVES, AND NUTMEG.

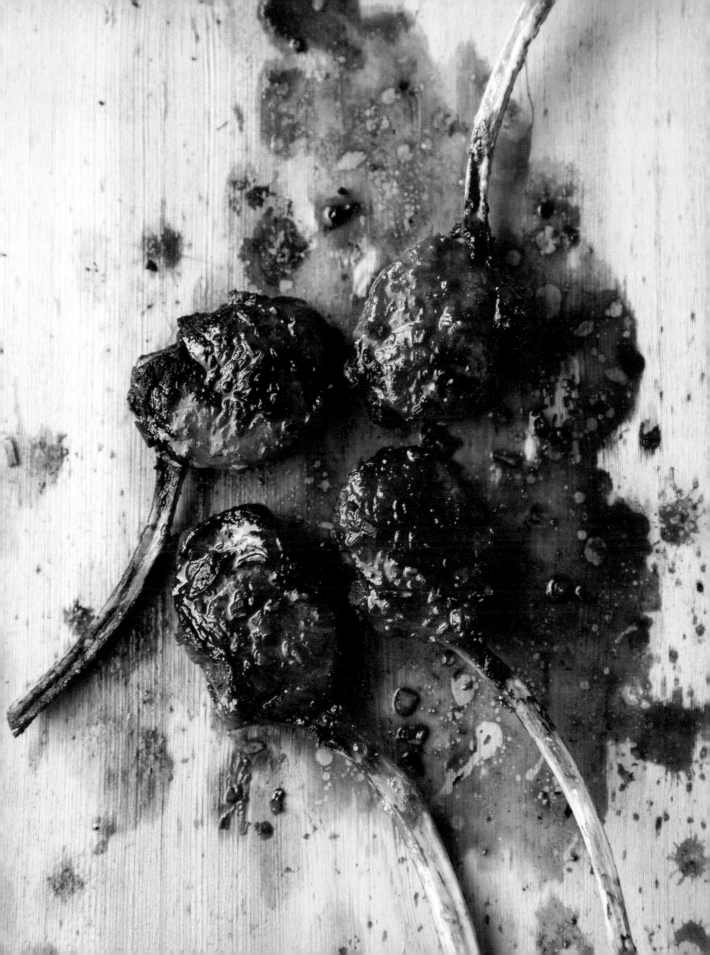

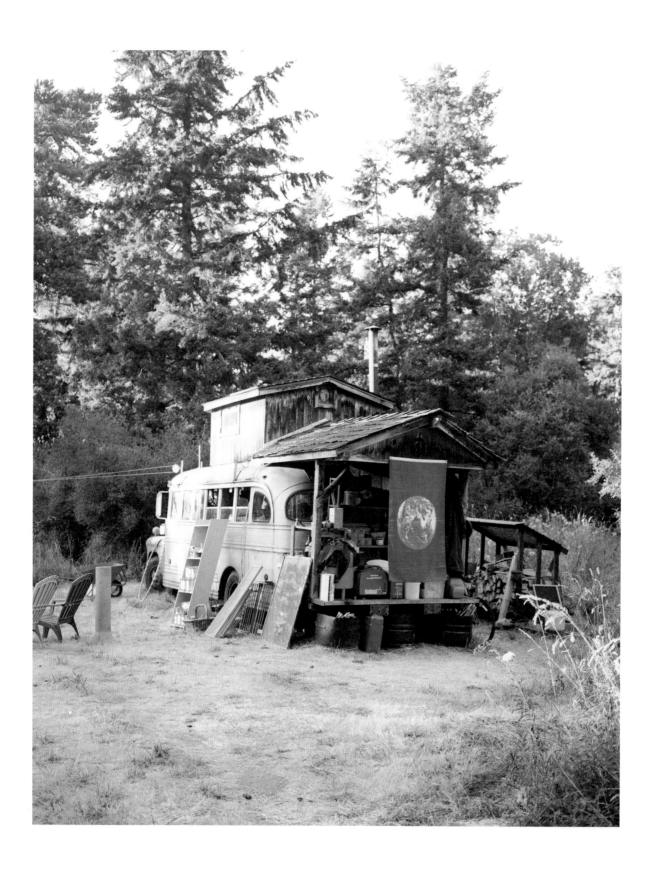

LINDSEY & ZACH, LOPEZ ISLAND, WA

Lindsey and Zach live on Lopez, a tiny island in the Salish Sea in northern Washington. They inhabit a 1955 Chevy school bus, equipped with three built-in ashtrays at the steering wheel—just in case they decide to take up chain-smoking someday—and a ceiling too low for Zach to ever fully stand up. Despite these quirky faults, which are really very minimal, this bus is the homiest of homes and is painted turquoise, which also happens to be Lindsey's power color. It was converted from a working bus to a home by a woodworker from mainland Washington in 1987. A chap named Huck bought the bus back in 1996 and drove all 30 feet of it from the southern tip of Washington to its current island home. Lindsey bought the bus in 2011 and really didn't need to make many changes. She refinished some metal siding and painted the belly of the bus the most soul-warming shade of yellow, the latter helping beat those rainy, midwinter Washington blues.

The bus is set up just right for living, with the kitchen using up an impressive three-quarters of the total space. Just the way it should be, if you ask us! These cooking-first proportions are likely because Lindsey is a baker by trade, her folks raise free-range cattle, and Zach is a fisherman, so you can only imagine the nosh that gets cooked up in their bus on the regular. There is, of course, a huge wood-burning stove, which pretty much burns around the clock during fall, winter, and spring. The heat rises and warms up their sleeping quarters—a miniature redwood cabin situated on top. In 2017, Zach built a covered porch that runs the entire length of the bus, and provides a dry home for their outside attire, muddy boots, and firewood. It's been a real game changer for them and has practically doubled the size of their home.

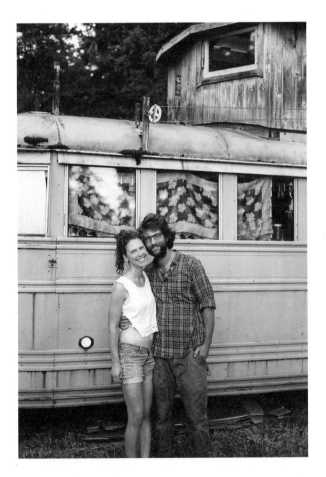

The kitchen is anything but typical, as it's not a boxed-off corner or a separate room and instead runs nearly the entire length of the bus. There's ample storage above and below the countertop and a little three-burner propane stove and oven, which they cook on interchangeably with the wood-burning stove, depending on the meal and the season. The woodstove also has these brilliant little extensions on it that hold pots and pans away from the heat, making it ideal for slow-cooking dishes and keeping stuff warm.

Like so many of the folks we visited for this book, Lindsey and Zach swear by cast-iron skillets and a sharp knife as the only true tiny-kitchen essentials. These two tools are so versatile, with the cast iron easily standing in as a makeshift tortilla press, pie pan, and pizza stone, and a singular sharp knife proving to be indispensable for nearly all kitchen cutting tasks. Lindsey's favorite knife was crafted by her father over 30 years ago! We were enthralled by it and photographed it about a million times.

However, unlike many of the movable homes we have visited, Zach and Lindsey's place is parked for the long haul, nestled in the woods on Lindsey's parents' property. This means Lindsey and Zach

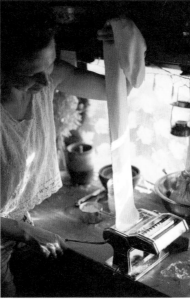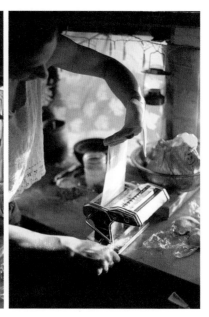

don't have to worry about having everything stashed and stowed away for turbulent times or bumpy roads. They have hooks for mugs and one of the best uses for a countertop-clamped meat grinder we've ever seen—it's their freakin' coffee grinder! After seeing this, Trevor's been scouring the thrift stores weekly for one of his own.

Their diet changes with the seasons thanks to the abundance of farms on the islands. With a population of just over 2,000 people, Lopez Island is home to over ten working farms, which provide residents with fruit, vegetables, cheese, meat, wine, and grains year-round. It's on these small islands that you can really get a sense of what a true farm-to-table food scene looks like in the real world. There is a cracking weekly farmers' market in the summer and bimonthly markets in the winter, as well as a well-stocked health food market and regular market.

Lindsey works part-time for Barn Owl Bakery, a local sourdough bakery. A bunch of the grains they use are grown on the island by various farmers and are milled by Steve at Island Grist, a local stone mill. It's a full-circle bread, using not only organic Lopez Island–grown grains, but the tangy wild yeast of the Salish Sea to raise it and a wood-fired oven to bake it. One perk of Lindsey's job is that she brings home fresh dough for pizzas and pasta regularly, and an endless supply of dark rye and other wild-leavened breads.

Lindsey and Zach are truly off the grid. They have a small Honda generator, which they fire up only when Zach needs to use power tools or Lindsey wants to use a hand mixer for baking. They have battery string lights strung up throughout the bus. When combined with soft candlelight, the string lights provide plenty of light to see and cook by. Of course, there are always headlamps in the mix, too. Zach has Makita batteries for his power tools with a clever adapter on them that allows them to charge cell phones as well—a great little trick, since the island finally got cell towers! They haul in their water and haul out their sewage in big 55-gallon drums about a quarter of a mile to the other side of the woods, where it's completely broken down and can be added back to the soil.

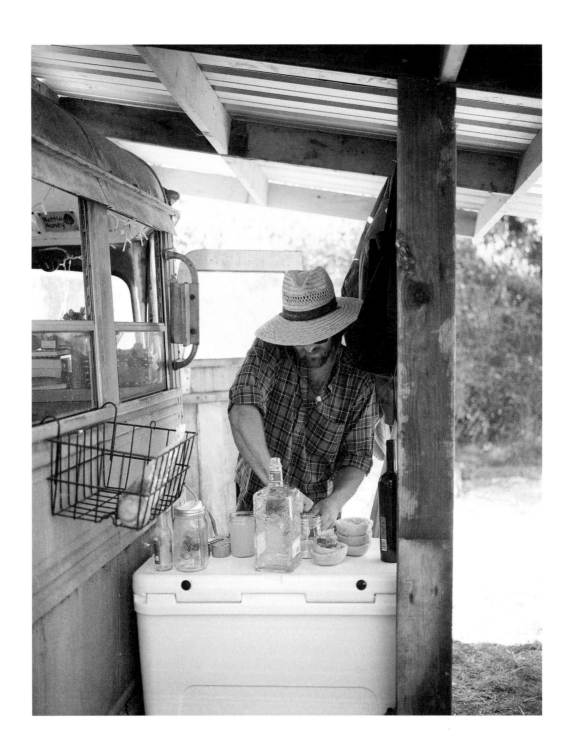

FRESH PASTA

The making of this book dispelled the myth that you need a full-size kitchen to make homemade pasta. Not only did Lindsey pull it off in her bus home, but Tommaso and Eva (see page 132) also made fresh pasta on their sailboat! When we showed up to Lindsey and Zach's, they had pasta laid out over chairs and along their entire countertop (which runs the whole length of the bus). If you don't have a pasta maker, don't fret, you can do this by hand. In fact, we tested this recipe by hand and it turned out great—you just have to put in a bit more elbow grease. Fresh pasta is much more delicate than dried and is truly worth the extra effort required.

SERVES 6

3 cups all-purpose flour,
plus more as needed

4 eggs

1 teaspoon sea salt,
plus more as needed

Olive oil

IF YOU'RE NOT GOING TO EAT YOUR PASTA ALL AT ONCE, CUT PASTA CAN BE WRAPPED AND FROZEN FOR LATER. FROZEN PASTA WILL COOK IN THE SAME AMOUNT OF TIME AS FRESH PASTA.

On the countertop or in a large bowl, mix together the flour, eggs, and salt and knead for 5 minutes.

Form the dough into a ball, wrap it in plastic wrap, and let it rest for 20 minutes at room temperature. Cut the dough into 6 even pieces. Work with one piece out at a time and leave the rest wrapped so the dough doesn't dry out.

If rolling the dough through a pasta machine, set the rollers at their widest setting, flatten the dough with lightly floured hands into a rough rectangle, and feed it through the rollers.

Fold the dough into thirds, then feed it through the rollers again. Repeat the folding and rolling five times, using flour as needed if the dough becomes sticky.

Turn the roller one notch thinner, only this time you'll be folding the dough in half, not thirds. Remember to keep dusting with flour and repeat this step twice if needed.

Turn the roller one notch thinner and feed the dough through without folding. Continue making the pasta thinner by changing the settings on your machine as necessary. The dough is thin enough when you can see the color of your hand through it. You may find that the dough is thin enough before you reach the last setting on the machine.

Place the sheet of pasta on a floured surface to prevent sticking and start on the next piece of dough, repeating the steps above. When all the dough has been rolled out, cut each sheet crosswise into 6- to 8-inch sections and let dry for 10 minutes.

Feed the pasta sheets through fettuccine cutters, turning the handle slowly and steadily, guiding the delicate pasta strands with your other hand. Lay the noodles on a floured surface and continue with the rest of the batch.

Bring a pot of water to boil, add some salt and oil, and cook half the pasta for 3 to 4 minutes. Remove the pasta gently and transfer to a colander to drain. Let the water come back up to a full boil, then repeat to cook the remaining pasta. Drain and serve with your favorite sauce.

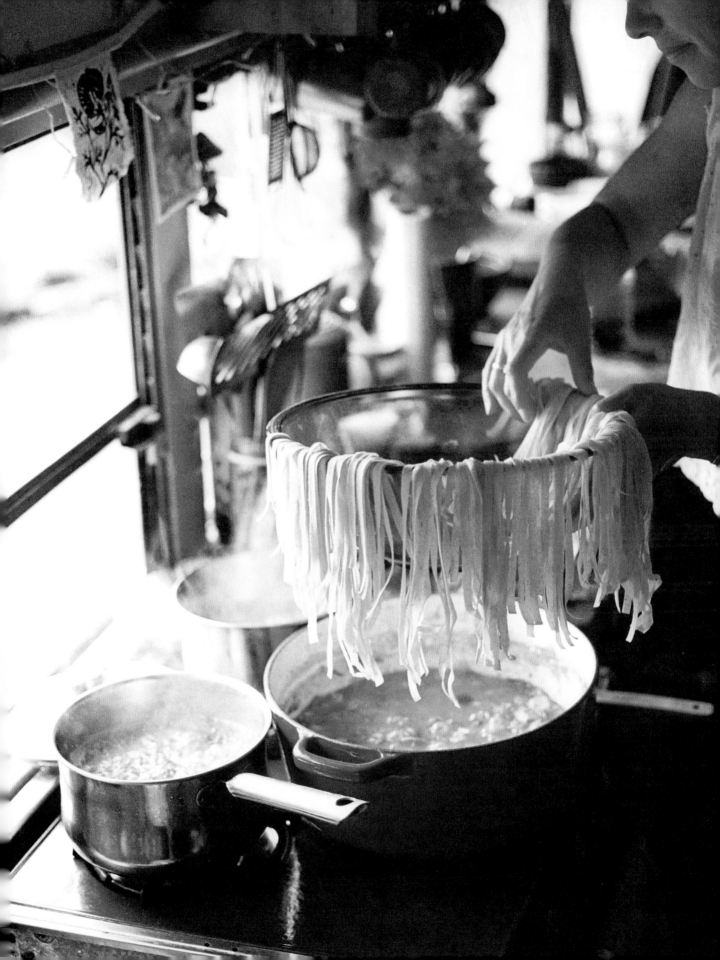

BLUEBERRY & LIME PIE

Everybody loves homemade pie, and folks with small kitchens are no exception. This pie, however, is extra-special as it is studded with tapioca pearls. The tapioca pearls hold the pie together and thicken the blueberry juice just like cornstarch would—except you get to eat the little pearls, too. The recipe calls for frozen blueberries. We tested this with fresh and frozen, and there really is no comparison—frozen is the way to go. You could freeze fresh blueberries or use a frozen wild variety. The latter are smaller and work the best. The piecrust is the best piecrust we've ever tasted and, well, it should be with all the butter that's involved. This is the last piecrust recipe you will ever need. It's great for savory applications, too!

MAKES ONE 9-INCH PIE

Double piecrust

2 cups all-purpose flour, plus more for dusting

½ teaspoon sea salt

1½ cups (3 sticks) butter, cubed and chilled

¼ cup ice-cold water

Filling

8 cups frozen blueberries

Zest and juice of 1 lime

½ teaspoon vanilla bean powder

¾ cup sugar

¼ teaspoon sea salt

¼ cup small tapioca pearls

1 egg, beaten, for egg wash

Preheat the oven to 375°F. Grease a 9-inch pie dish.

To make the piecrust: In a large bowl, mix the flour and salt together. Cut the cold butter into the flour and mix lightly with your fingertips until the butter is well dispersed and the mixture resembles coarse bread crumbs. Put it in the freezer (or fridge) for 20 minutes to chill. Remove from the freezer and add the cold water slowly while continuing to mix until you can just form the dough into a cohesive ball. If more water is needed, add it 1 tablespoon at a time. Divide the dough into two balls.

On a floured surface, roll out each piece of dough to a round about 2 inches bigger than the pie dish. Lay the first round of dough in the greased pie dish and set aside.

To make the filling: Mix the blueberries, lime zest, lime juice, vanilla bean powder, sugar, and salt together in a bowl. Pour the filling into your prepared piecrust and evenly sprinkle the tapioca pearls over the berries. Fold them in gently so that they are dispersed throughout.

Lay the second round of dough over the pie and tuck the excess top crust under the bottom crust. Flute the edges or use a fork to crimp them, and then cut several vents in the top crust.

Brush the dough with the beaten egg and bake for 1 hour 15 minutes or until golden brown. Allow to cool for at least 8 hours before slicing. Honestly, we know that's a long time to wait for pie, but this is a crucial step if you want your pie to hold up.

ROLLING OUT PIE DOUGH WITH A LINEN PASTRY CLOTH HELPS IT FROM STICKING AND KEEPS YOUR COUNTER CLEANER.

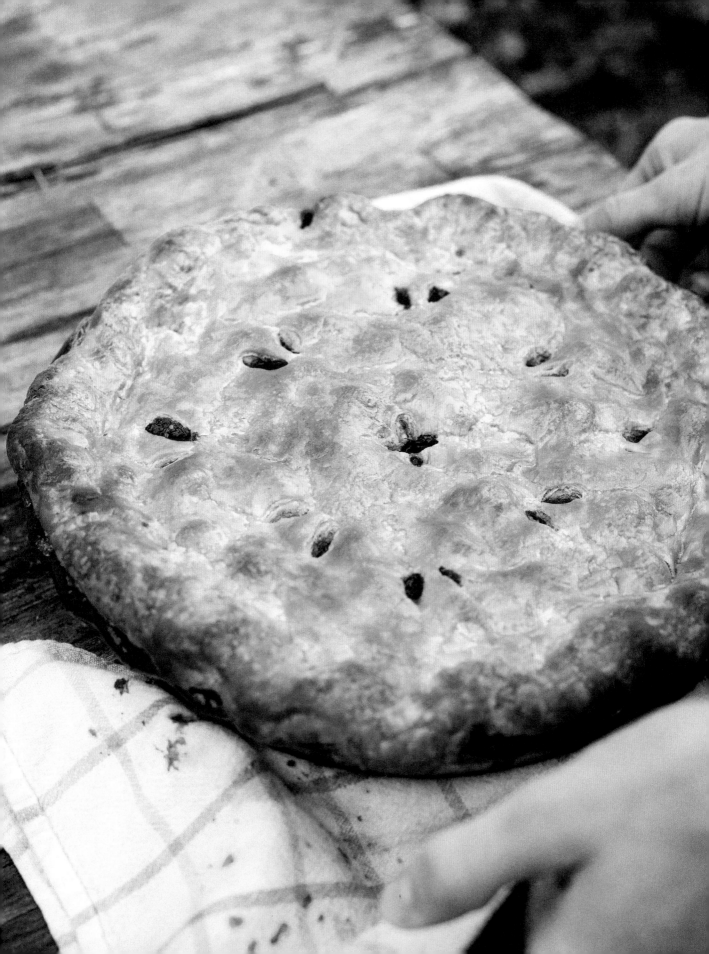

SERENA & JACOB, VENTURA, CA

Serena and Jacob have figured out the secret to living in a tiny home with a baby. Turns out, the secret is that there is no secret! As they soon found out after bringing their little babe, Uma, home, it makes no difference at all how big your house is if you have the outdoors, lots of love, and a little ingenuity. Perched on a hilly outcropping somewhere between the Pacific Ocean and 1.7 million acres of National Forest land, this family of three happily calls a 40-foot fifth-wheel trailer home.

Living in less-than-large spaces is not new to Jacob and Serena. They have logged some real miles on the ocean aboard a 38-foot 1967 Pearson Invicta sailboat. To them, their trailer feels much like a boat, in that it's tucked in somewhere quiet and remote with the option to "up-anchor" and head somewhere different should they feel like it. Like the old boat home they still fondly reminisce about, the trailer also runs on solar, has 12-volt electricity, and has a similar plumbing setup. Their story is a good one and is perhaps best summed up by Jacob himself:

"I bought the boat in Oakland, and worked on it for a year. There was no engine, so I put one in. I added a wind generator and other odds and ends. I sailed down the coast to Santa Barbara for a solid shakedown cruise. Along the way, stopping in Morro Bay, I reconnected with Serena, who I had known since college when studying abroad in Singapore. I spent a few weeks in Santa Barbara getting ready for the passage to Hawaii as I had to rebuild the engine, which had seized around Point Conception. It ended up failing again as my crew and I began our journey to Hawaii. Oh well, we were sailing and on our way. We almost turned around the second day because the weather was so gnarly and we were wet, tired, and cold. We pushed through, rested, and had an amazing voyage. It was twenty-one days to Hawaii, and we sailed all the way into Hilo Bay.

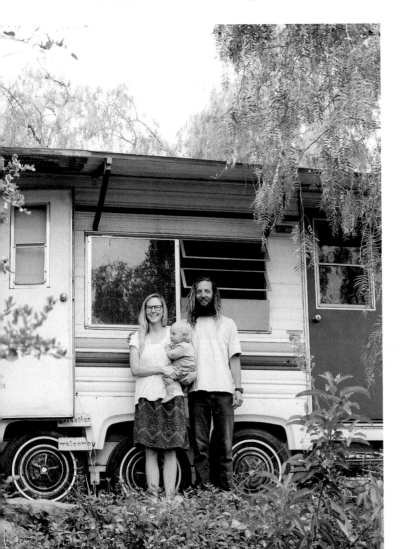

"I stayed in Hawaii for a few months and Serena visited for some island adventure. Soon, I was ready to voyage on (and yes, I had definitely fixed the engine this time). It was December, and although I really wanted to sail to the South Pacific, it was the middle of their cyclone season, so I decided to stay north of the equator. I looked at a chart and noticed a bunch of little dots 2,000 miles to the west-southwest of Hawaii: the Marshall Islands. Two buddies flew in, and we packed up the boat and set sail. We had big winds and big seas for twenty days but lots of fish, too, so we were well fed. We sailed into Majuro atoll and tied up to a mooring. My second big passage was over. It is so strange being offshore for so long, then suddenly on solid land. Like waking up from a dream; it is very fresh right upon wakening but then it quickly fades. It is a different place offshore. A different state of being.

"I loved the Marshall Islands—the people, the beauty, the tropics, the atolls. Serena flew in and we sailed to another atoll about 60 miles away.

We stayed there for three weeks and never saw another boat.

"Soon it was time to voyage on again. I had one buddy sailing with me for this passage, and we headed south to Vanuatu with a stopover on the two easternmost islands of the Solomon Islands, Anuta and Tikopia. Anuta was my favorite place of the whole trip. Time forgotten.

"Spent a couple of months sailing Vanuatu before I put the boat up on the hard in a marina. I flew back to California to work and connect more with Serena. After about a year, we both returned to the boat, got a bunch of work done on it in a couple months, then sailed onward to the Solomon Islands. We spent seven months there. It was the most remote we had been for the longest period of time, seeing no other sailboats for months on end. We fished daily and traded the local villagers our canned goods for fresh fruits and veggies. Uma was conceived here but we didn't know it until we arrived in Australia some time later—though we suspected as much when Serena was seasick the entire eight day passage getting there.

"Considering our new, future addition, we decided to sell the boat and head home to California. And now here we are, and Uma is almost a year and a half old."

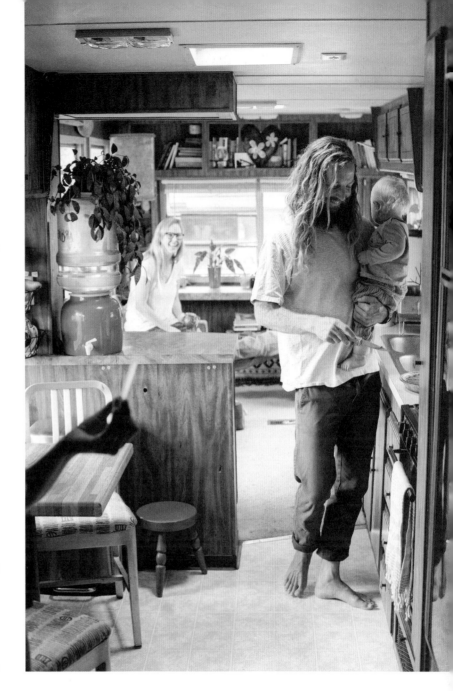

The 1981 trailer they have moved into is exceptionally spacious, as it has zero built-in furniture. Instead, the living room opens up straight into the kitchen, which runs along a third of the back wall of the trailer. Jacob tells us that he and Serena are nourished, balanced, and elevated by food and that the making of it is somewhat meditative for them. We totally get this. There are rarely times for us when the preparation of food seems like a burden. It serves as a medicine when we eat it, and the preparation of it is an opportunity to slow down, check in, and serve ourselves. The quality of the food Jacob and Serena eat is paramount to them. They enjoy cultured and alkalizing foods and, on occasion, local, humanely raised and butchered meat. Sugar is something they try not to eat but this does not stop them from indulging in tasty desserts. When we rolled up to their little slice of heaven, Jacob pulled the richest avocado pie we've ever eaten out of the freezer. Chocolaty, honey sweetened, and super creamy, this frozen dessert was the bomb, and we knew after the first bite that we had to ask them for the recipe.

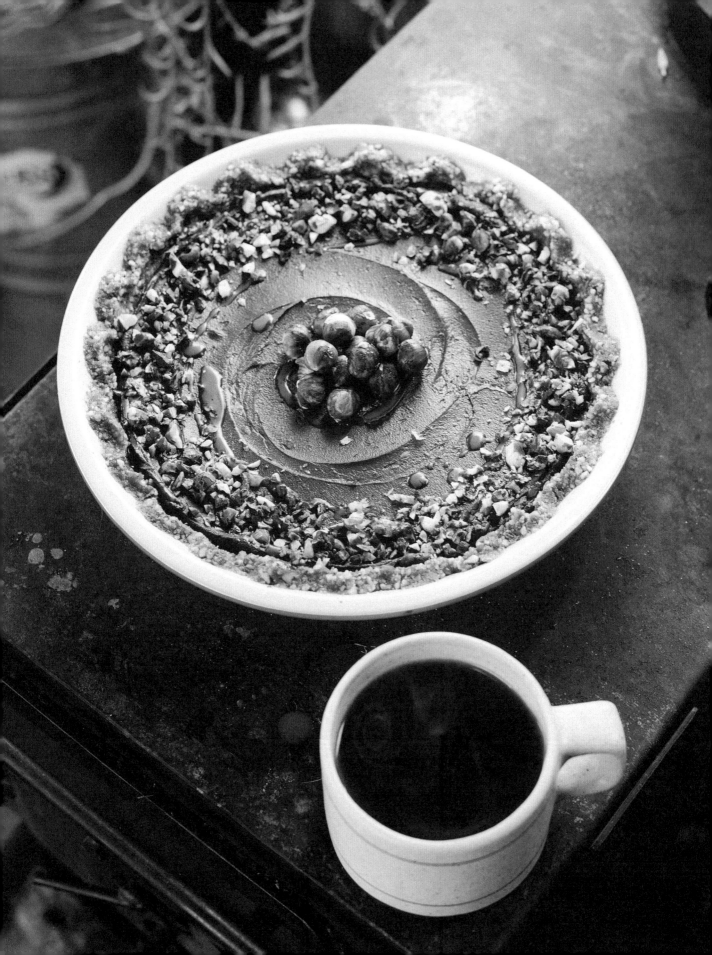

MOCHA FUDGE PIE WITH TOASTED HAZELNUTS

Before we visited with Jacob and Serena, we were a bit apprehensive about including a raw dessert. Although we adore the flavors typically achieved in raw desserts, they tend to be a bit finicky to make in smaller spaces. This pie is different, though. Firstly, it is incredibly simple and requires no soaking of nuts. Secondly, this is not an overly sweet dessert, and once frozen, it takes on the most divine texture. Oh, and because the filling is made creamy with avocados, it's completely dairy-free!

MAKES ONE 9-INCH PIE

Crust

2 cups pecans

8 dates, pitted

½ teaspoon sea salt

Filling

2 large avocados

1 cup unsweetened cocoa powder

½ cup honey

¼ cup strong brewed coffee, cooled

¼ cup coconut butter or coconut oil, at room temperature

1 cup hazelnuts, toasted and coarsely chopped

Smoked flaky sea salt, for sprinkling

To make the crust: In a food processor, combine the pecans, dates, and sea salt and process, scraping down the sides as needed, until you have a coarse paste. Press the crust into a greased 9-inch pie dish and refrigerate while you make the filling.

To make the filling: In the food processor, combine all of the ingredients and process until smooth and creamy. Spoon into the chilled crust, top with the chopped toasted hazelnuts and smoky salt flakes, and freeze. Eat frozen or leave at room temperature for 20 minutes for a softer pie. You could even skip the crust and eat this like a pudding.

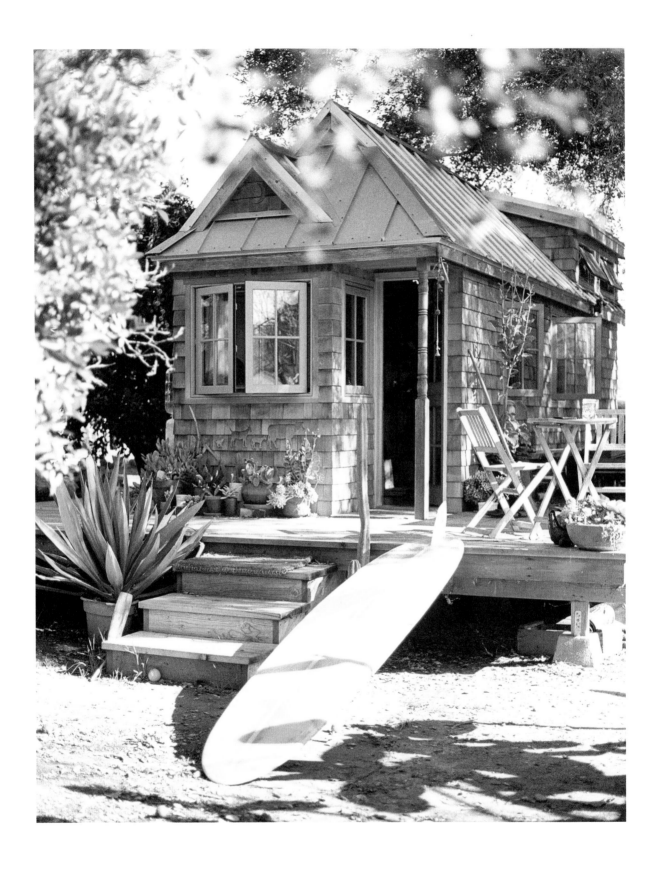

MEG, OJAI, CA

This tiny home is only about 180 square feet with a sleeping loft above the kitchen. It took nine months to build and features Forest Stewardship Council wood, wool insulation, and goat-milk paint! Yes, you read that right. Goat-milk paint. It is made from flaxseed oil, chalk, and goat's milk and it's biodegradable and edible (maybe not delicious, but edible nonetheless). This unique paint choice is particularly appropriate considering that the home is located on Poco Farm, a small, educational, family-owned farm that specializes in goats!

The plans for this smart little house were bought from Tumbleweed, a company that creates trailer-mounted tiny homes and plans. It is hooked up to a gray water system and runs entirely off solar power. Most of the large fixtures and fittings inside are reclaimed, including the kitchen sink, propane stove, and outdoor bathtub.

When we visited Grace and Dan's farm, Meg was living in the tiny house and helping out with work and assorted farm duties. With access to the best raw goat's milk you can find, fresh eggs, and more citrus than you can shake a stick at, Meg had everything she needed to conjure up mouth-watering meals on a daily basis, and best of all, it was just outside her front door. Meg is a talented ceramicist, and her humble home was filled with spectacular handcrafted vessels and plates.

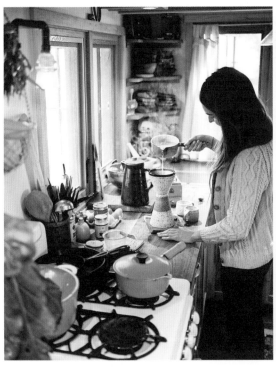 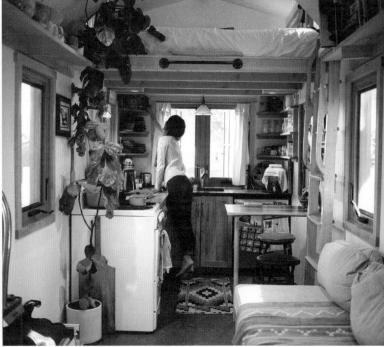

ALLY & ANDREW, SANTA BARBARA, CA

You would be hard-pressed to find a couple better suited for *The Tiny Mess* than Ally and Andrew. She is a permaculture landscaper and he is a chef, and together they live in a pair of old converted railroad cars. In the 1930s, these railcars used to take people around Santa Barbara, but now they provide a bedroom, living room, and exceptionally well-appointed kitchen for the young couple with heaps of natural light and long, luxurious formica counters.

Also, Ally and Andrew are "freegans"! Though not as hard-core as some, the couple enjoy Dumpster-diving in search of discarded food and produce. For them, rummaging through the Dumpsters at local grocery stores and restaurants both saves money and helps them reduce their personal waste stream, all while filling their cabinets and freezer with some delicious and free eats. It's estimated that more than a third of all food in the United States is wasted. Ally and Andrew are making the most of this unfortunate trend, and based on our visit, they don't seem to be suffering too much! It is not uncommon for trips to their local "dumpstore" to yield everything from almond butter, bananas, and honey to wine, eggs, and cases of frozen meat. For them, it gets even better when they can share their Dumpster bounty with friends.

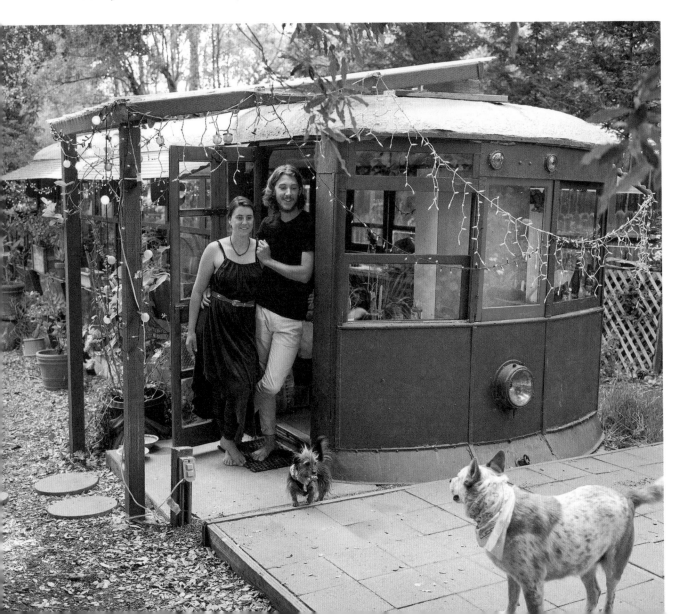

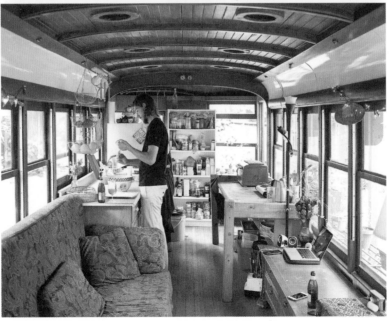

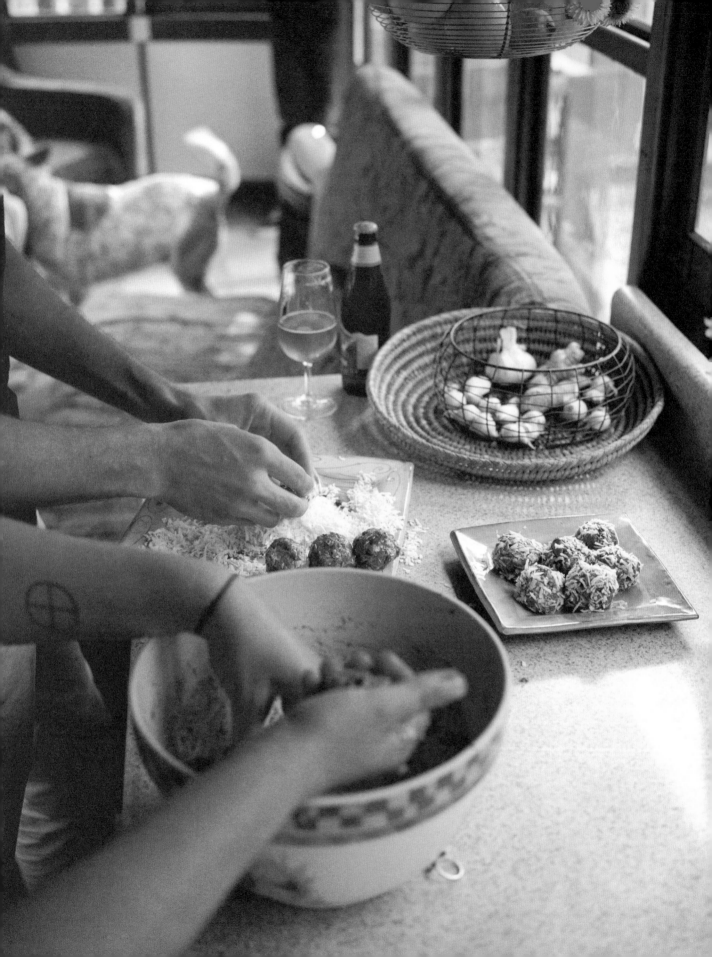

SUPERFOOD BALLS

It's balls like these that remind us that we should never again pay $3 for an energy bar that's full of sugar and other junk. In a single bowl, using up the random dried fruit, nuts, and seeds in your pantry, you can knock out these grain-free, protein-packed power balls and customize them to your taste. Switch up the fats, nut butters, sweeteners, fruits, nuts, seeds, and spices every time for something different.

MAKES ABOUT 20 BALLS

¼ cup plus 1 tablespoon goji berries

½ cup dried cranberries

¼ cup pecans

1 cup nut butter

2 tablespoons coconut oil, melted

¼ cup maple syrup

¾ cup unsweetened shredded coconut, plus more for rolling

¼ cup hulled hemp seeds (hemp hearts)

1 tablespoon sesame seeds

1 tablespoon flaxseeds

1 tablespoon chia seeds

1 tablespoon maca powder

½ teaspoon ground cinnamon

½ teaspoon ground ginger

½ teaspoon cacao nibs

½ teaspoon sea salt

In a food processor, combine the goji berries, cranberries, pecans, nut butter, and coconut oil and pulse until the mixture is sticky yet still retains a relatively coarse texture. In a large bowl (or just the food processor bowl minus the blade, if you're feeling lazy), combine the nut-fruit mixture, maple syrup, shredded coconut, hemp seeds, sesame seeds, flaxseeds, chia seeds, maca, cinnamon, ginger, cacao nibs, and salt and mix to combine, using your hands if necessary.

Place extra coconut on a large plate. Form the nut-fruit mixture into small balls, roll in the coconut, and place them on a plate or tray. Refrigerate for 1 hour, or until the balls have set, then transfer them to an airtight container. They keep well in the refrigerator for up to 10 days.

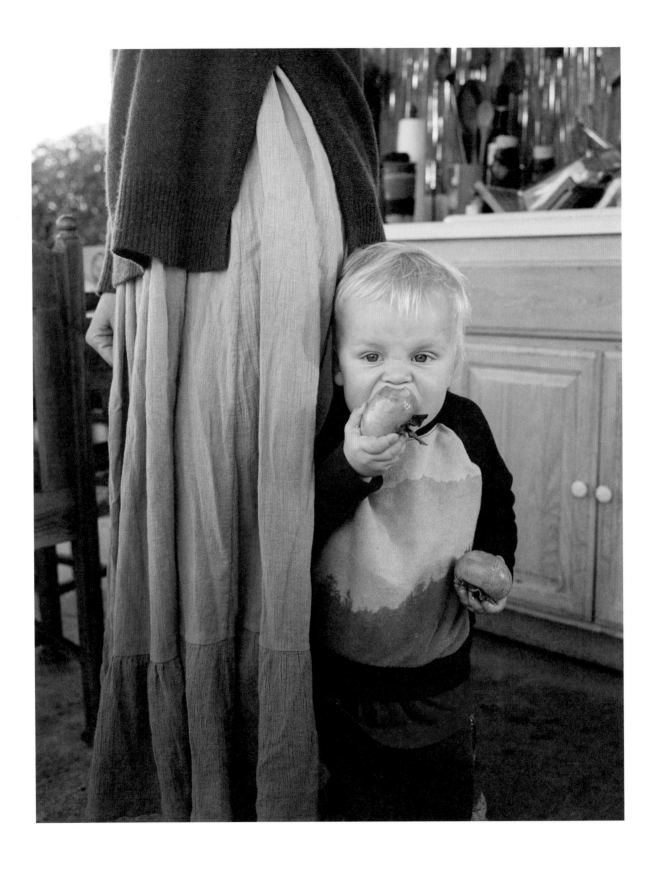

ASHLEY & RYAN, CARPINTERIA, CA

Ashley and Ryan's living situation is unique to this book. They are currently renovating their dream home a couple of miles outside of the small coastal town they grew up in in Southern California. They have three children (it's debatable, though, as these kids might actually be flower fairies), a grumpy little dog that is actually a nice guy, and a soft floppy puppy that wants nothing more than to be in physical contact with you at all times. What makes them unique to this book is that their petite outdoor kitchen is a temporary structure for them. That is to say, it isn't permanent. They won't necessarily be tearing it down when their house is done, but it will not remain their everyday kitchen. But you know what? It doesn't matter, because they have built such a practical and purposeful space that works so incredibly well that we simply had to share it.

Ashley is an herbalist at Women's Heritage, a collective of ladies dedicated to keeping homesteading skills alive and accessible to all women in all places. She uses her extensive knowledge of healing herbs, native florals, and botanicals to create skincare products and delicious food. More to the point, she is all about passing these skills along to her children. From making wild-harvested salves side by side with her kids to teaching them how to identify edible snacks while out hiking, nature becomes the classroom when Ashley is in charge.

Their outdoor kitchen is situated immediately next to the Airstream that all five of them call home for the moment. Although they only need the space for a while, it had to be designed with some serious planning and purpose. After all, when you're juggling three hungry kids and a bustling coffee shop, with prevailing winds and regular outdoor dinner duty, your kitchen had better work. Also, they didn't want to spend a bunch of money building a temporary space, so nearly the entire kitchen is crafted from salvaged and reclaimed materials. The fridge is from Craigslist, family donated the cabinets, and the sink is plumbed to a bucket, which is then pumped out to their fruit trees. They have a small toaster oven, which does nearly everything a full-size oven does, and a wood-burning stove.

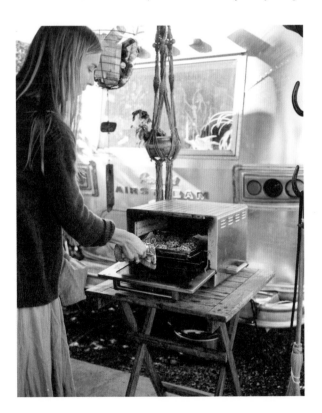

Of course, there are always downsides to a tiny kitchen, and this factor grows significantly when you're sharing your space with creatures and critters of the open air. Ashley explained how animals often sneak in and steal food if it isn't stored properly and how the wind sometimes whips through and blows things right off the shelves, making it impossible to cook over gas. Despite all this, Ashley and Ryan are committed to keeping the space for the long haul, even if it is just for the occasional dinner on a summer evening or a Saturday breakfast. "Nothing beats crisp mornings in front of the woodstove or the kids playing happily to birdsongs in the dewy grass while I make some morning oatmeal," said Ashley.

No visit to this place would be complete without some mention of Ashley's witchy ways and intimate plant knowledge. It comes through in both her medicine cabinet and her cooking. Her favorite native herbs to hunt are yarrow, woolly blue curls, and sages of all sorts. Take a hike with her and you are certain to come home with something wonderful for dinner and some new plant knowledge.

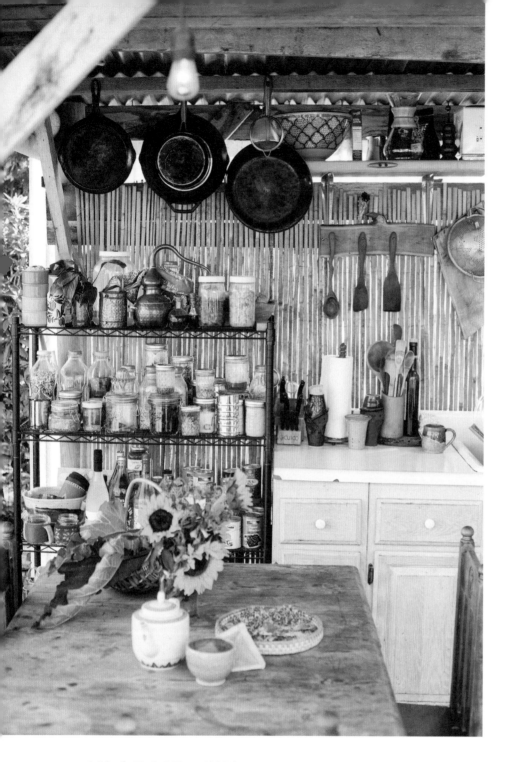

Ashley's Herbal First-Aid Kit

· An all-purpose salve made with Saint-John's-wort, plantain, and calendula

· A sore-muscle salve or oil made with arnica or a bruise oil made from comfrey

· Powdered yarrow to sprinkle directly on cuts and scrapes

· Herbal bitters, a digestive tincture made with dandelion root, burdock root, orange peel, and ginger, for upset tummies

· Diluted calendula tincture to clean wounds

· Lavender essential oil or hydrosol for an endless amount of everyday uses

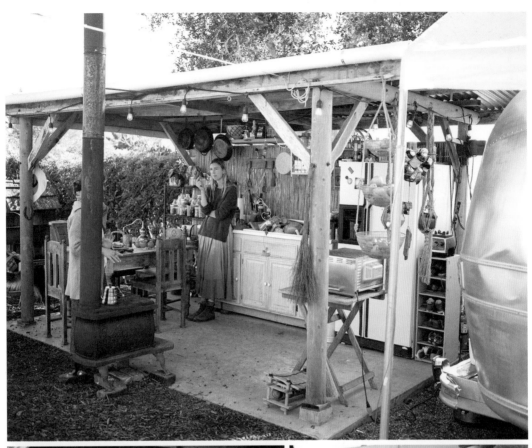

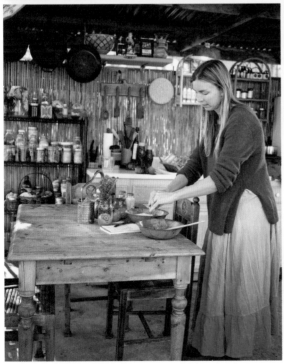

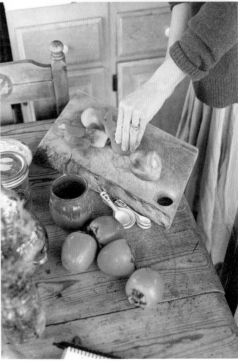

HONEY-PERSIMMON SPICE COOKIES

These cookies are the epitome of our California fall and remind us of our bustling and bright markets adorned with the *hoshigaki* (dried persimmons) before the holidays. The persimmon and honey add a rich sweetness without the need for refined sugars, and the spice is too perfect for the colder months. These cookies are softer than your regular cookie and simply melt in your mouth.

MAKES EIGHTEEN 3-INCH COOKIES

2 large or 3 small Hachiya persimmons

1 tablespoon baking soda

2 cups gluten-free flour blend

½ teaspoon salt

½ teaspoon ground cinnamon

½ teaspoon ground cardamom

½ teaspoon ground nutmeg

½ teaspoon ground ginger

1 egg

½ cup honey

½ cup (1 stick) butter or coconut oil, melted

Preheat the oven to 350°F.

In a large bowl using your hands, squish the pulp of the persimmons. Discard the skins. Mix in the baking soda and set aside. In another bowl, combine the flour, salt, and cinnamon, cardamom, nutmeg, and ginger.

Stir the egg, honey, and melted butter into the persimmon mixture. Combine the dry ingredients with the wet ones, and then drop 18 blobs of cookie dough onto a parchment paper–lined cookie sheet and bake until lightly browned on top, about 20 minutes.

MAKE SURE YOU USE THE HACHIYA PERSIMMON AND NOT THE CLOSELY RESEMBLING FUYU PERSIMMON, WHICH HAS A TEXTURE SIMILAR TO AN APPLE. THE HACHIYA IS SUPERSOFT AND GOOEY WHEN RIPE.

ROSEMARY-HONEY GIN & TONIC

This cocktail is a refreshing take on a traditional gin and tonic. Free of icky sweeteners and instead packed with fresh citrus, honey, and rosemary, this adult beverage is the ideal balance of sweet and sour. The rosemary blossoms add a fantastic floral note that complements the juniper in the gin.

Rosemary-honey simple syrup

MAKES ABOUT 1 CUP

2 cups water

1 cup rosemary blossoms

1 cup honey

Gin and tonic

MAKES 1 COCKTAIL

1 ounce gin

¼ cup fresh grapefruit juice

1 tablespoon rosemary honey simple syrup

Natural tonic water

Fresh rosemary sprigs, for garnish

To make the simple syrup: In a small saucepan, combine the water and rosemary blossoms, bring to a boil, and cook until reduced by half. Remove from the heat and stir in the honey until it has completely dissolved. Transfer to a glass jar, and store in the refrigerator for up to 1 month.

To make one cocktail: Fill a small jar or rocks glass with ice. Add the gin, grapefruit juice, and simple syrup and stir well. Top off with tonic water and garnish with rosemary sprigs.

ASHLEY USED FEVER TREE BRAND TONIC AND IT WAS DELICIOUS!

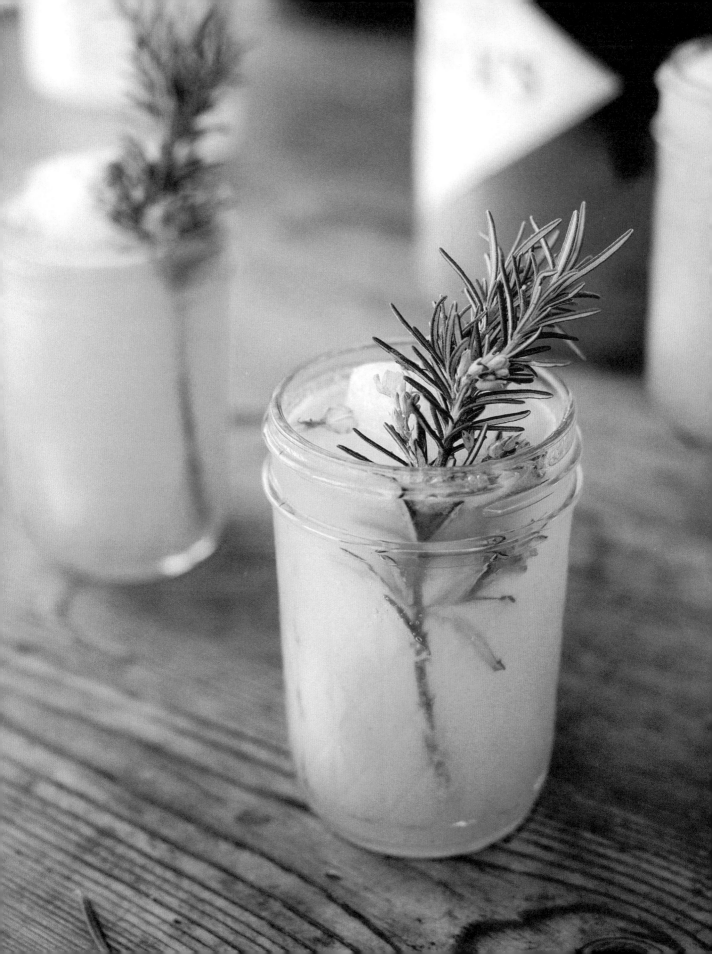

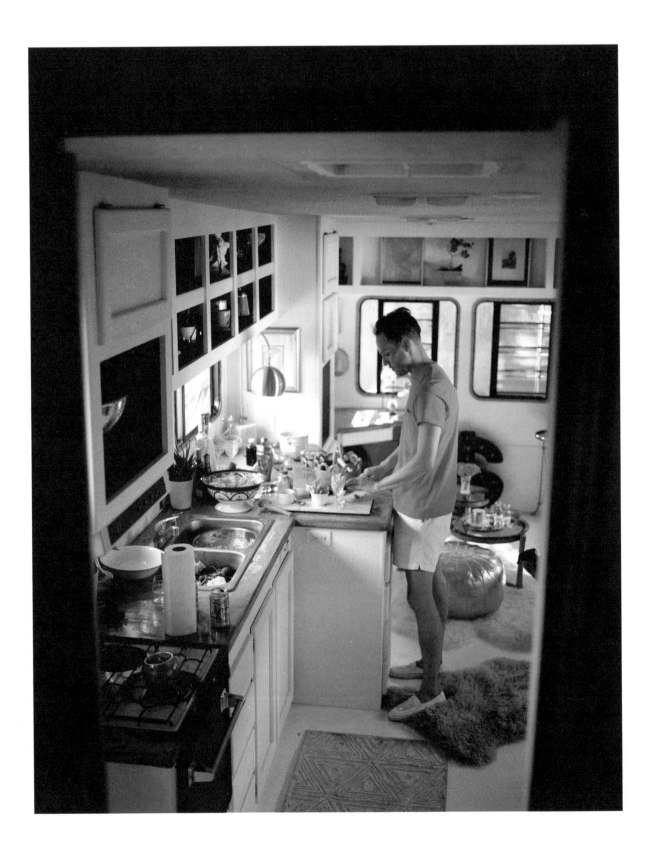

ZACHARY, CARPINTERIA, CA

Whether he likes it or not, Zachary is an interior designer. Technically speaking, he owns his own creative consulting business and handles all ilk of brand development services. But should you ever visit his home, a smartly rebuilt fifth wheel, you will quickly understand why Zach is a self-confessed "interior design enthusiast."

For the past couple of years, Zach has been calling a stunning farm in the Carpinteria backcountry home. He has access to plenty of stone fruit, persimmons, citrus, berries, avocados, and just about anything and everything you might need to make an amazing salad. There are over one hundred chickens and roughly eighty pigs where he lives, and it's rare that he sits down to a meal that doesn't feature something from the farm. This piece might suggest that Zachary lives solely off cocktails (he doesn't), but he's a bit of a whiz in the kitchen, too! He made sure we were well-fed with heaps of guacamole and crudités. The addition of frozen corn to the guacamole kept it chilled on the sweltering afternoon of our visit, a tip that we won't soon forget!

As for the trailer that he calls home, it is your average-looking fifth wheel from the outside. However, once you're inside, you have traveled to the most glamorous cocktail lounge conceivable. In fact, Zach's fellow farm-mates literally call his place "the Cocktail Lounge." Everything on the inside appears to be reflective or mirrored. Glistening, even. There are kitschy furnishings, plush rugs, and a kitchen that doesn't feel anything like a kitchen. It feels more like a bar or an overgrown extension to the living room than a place to make dinner, which made perfect sense when Zach began showing us his take on storage solutions. Expecting to see bulk food items or large appliances, we were surprised when Zach's cupboard tour revealed a liquor collection to end all liquor collections. This place was like nowhere else we had visited, and we were excited to photograph a home that was so heavily styled.

Given his obvious love of a well-curated cocktail, we asked Zach how a tiny-kitchen dweller should go about making one. The chef in us typically wants to get right to it and experiment with all kinds of unusual ingredients, but Zach's advice was to stick to a classic, like a margarita or a martini, and switch out a few key ingredients. If you start with small servings, he adds, you will have ample room to add more liquor or juice as taste demands. The trickiest part is getting the ratios of sweet, tart, and alcoholic right so your drink is actually enjoyable.

BLACKBERRY CADILLAC

Zachary shook up these fabulous blackberry Cadillacs using wild blackberries and top-shelf liquor. We don't recommend substituting any of the ingredients in this recipe, especially the booze, but once you have the ingredients stocked, they should last you quite a while . . . maybe. In Zachary's words, "Don't mess with something that already works. Margaritas are already margaritas. They work. They taste good. Don't reinvent the wheel here, just enhance it."

Blackberry simple syrup

MAKES ABOUT 3 CUPS

5 cups washed blackberries

1½ cups sugar

¾ cup water

1 tablespoon lime juice

Zest of 1 lime

Cadillac

MAKES 1 COCKTAIL

2 ounces silver tequila

1 ounce Cointreau (no substitutes!)

2 ounces fresh lime juice

1 ounce blackberry simple syrup

Lime wedge, for rimming the glass

Margarita salt, for rimming
the glass

1½ ounces Grand Marnier

To prepare the simple syrup: Combine all of the syrup ingredients in a pot over medium heat, bring to a simmer, and cook for 10 minutes. Lower the heat if the syrup stats to boil. After 10 minutes, mash the berries into the syrup, let cool for 10 minutes, then strain into a container or jar. This makes a fair bit so you'll be able to use this for plenty of cocktails (or even on pancakes)! It will keep in the refrigerator for up to 1 month.

To make one cocktail: Time is of the essence because you don't want your ice to melt! Fill a shaker or jar with ice, pour in the tequila, Cointreau, lime juice, and the blackberry simple syrup, and shake it like you mean it. Slide the lime wedge around the rim of a glass, then dip the rim in margarita salt. Pour the cocktail into the glass. Serve with a sidecar shot of Grand Marnier to be added at the consumer's convenience.

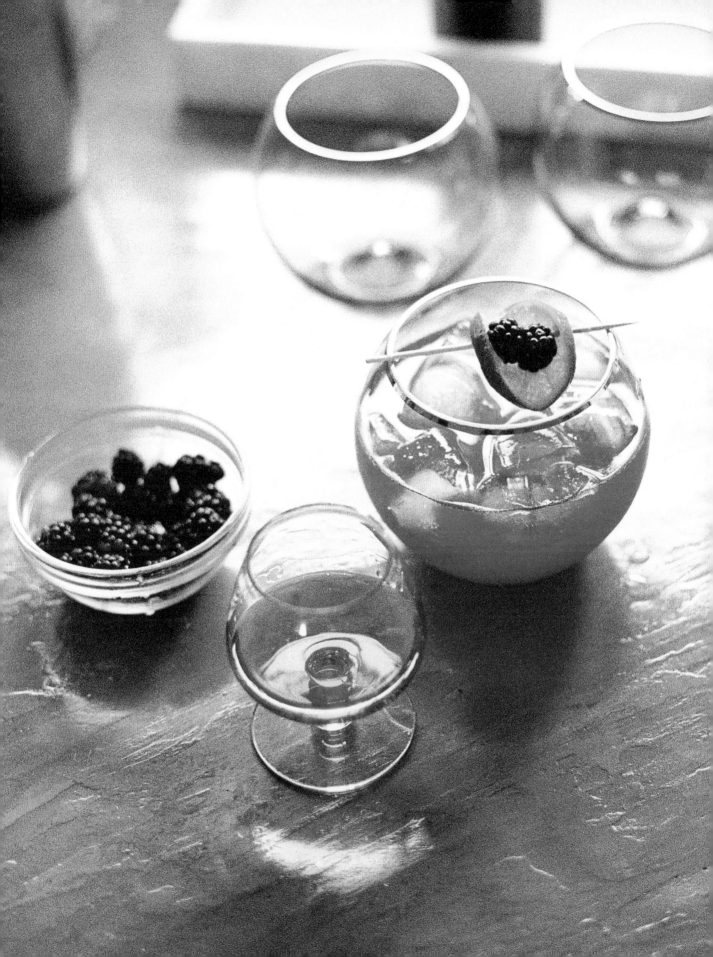

DAWN, SANTA BARBARA, CA

Aurora is a 50-foot Grand Banks powerboat that currently calls Santa Barbara Harbor home. With big views of the Los Padres mountains and the Pacific Ocean, she is a superscenic roost for Dawn, a musician, architect, and fellow small-kitchen enthusiast. Dawn has lived in the harbor for 17 years, and when faced with a decision a few years ago to either find a new boat or move back into the traditional trappings of onshore life, she doubled down on the liveaboard life and found *Aurora*.

Dawn is a busy lady. She juggles a successful architectural firm while playing in an all-girl rock band and still manages to cook on her boat almost every day. As far as galleys go, *Aurora*'s is far from miniature, but when compared to kitchens found in most on-land homes, it is positively tiny. Although *Aurora* spends most of her time docked in the harbor, a short paddleboard away from the beach, she does occasionally make it out to the Channel Islands when weather permits. After all, cooking on a boat is not only a matter of maneuvering around a tiny galley, but maneuvering around a *moving* galley as well. With the potential for almost anything to happen at sea, cooking tools and equipment need to be both space efficient and extremely stowable. Dawn swears by collapsible silicone mixing bowls, stacking All-Clad pots and pans, stout mason jars, and small, minimalist gadgets. She also loves her handled pot drainer, which stores easily, unlike traditional colanders.

So what's usually cooking on *Aurora*? Dawn adores the ease and efficiency of one-pot meals when she's cruising. By cooking slow and low over gas all day, she does away with the need to ever start her generator for cooking purposes. If you are familiar at all with boating, this little trick is huge, as a generator can be quite a buzzkill when you're anchored in a beautiful remote cove somewhere and instead of seals and seagulls, all you can hear is the guttural rumble of your own power source. Dawn's favorite cruising meals are cassoulet, pot au feu, boeuf bourguignon, and French onion soup. Warming soups and stews are ideal for fighting the inevitable chill from spending all day on and in the water. It also seems to be common knowledge among boaters that being on the ocean makes you crave salty and savory dishes. Dawn feeds her high-seas cravings with bagels topped with hard-boiled eggs, smoked salmon, capers, fresh tomatoes, red onion, and a squeeze of lemon. Lastly, if we learned one thing from Dawn about what goes into a good boating kitchen, it is that at least one of your precious cupboards should be dedicated to liquor. Who needs provisions when you've got martinis?

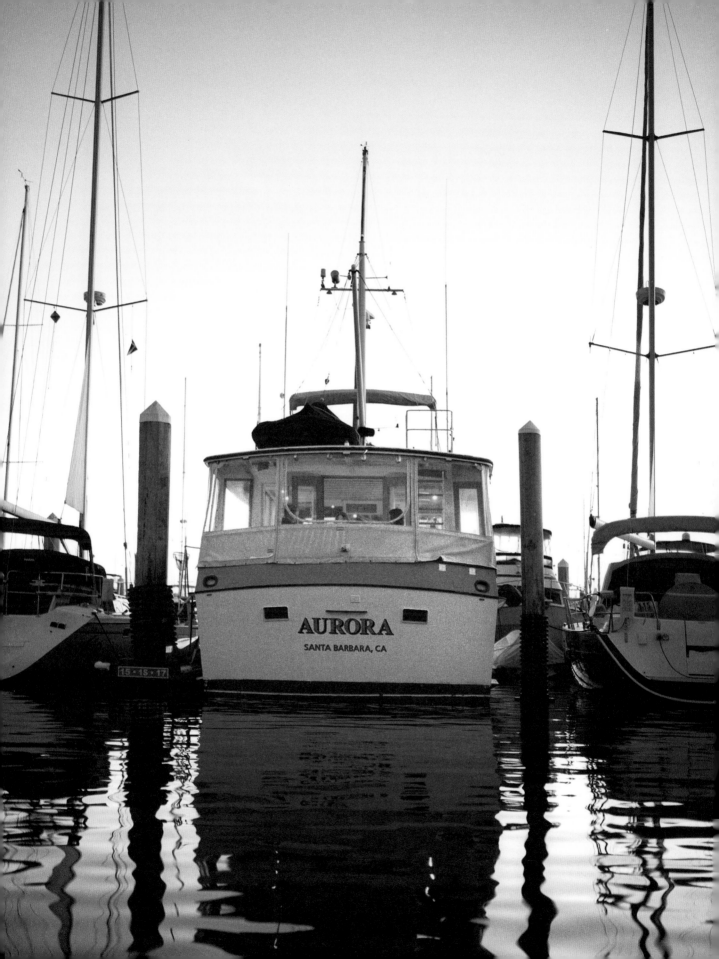

THE AURORA COCKTAIL

Just like Dawn, this cocktail is groovy and sophisticated. You can drink this out of mugs but feel like you're sipping out of crystal. Dawn used homemade limoncello and she's shared that recipe with us, too. The sugar content varies in the limoncello recipe; it really depends on how sweet you'd like to make it. The limoncello requires two weeks to infuse, so plan ahead!

Limoncello

MAKES JUST OVER 2 LITERS

20 organic lemons or any tart citrus fruit

2 liters vodka

2 to 4 cups sugar (your personal preference)

2 to 4 cups water

The Aurora

MAKES 1 COCKTAIL

2 ounces vodka

½ ounce Campari

½ ounce limoncello

Twist of lemon peel, for garnish

To make the limoncello: Zest the lemons and place the zest in one or two large clean jars. Pour in the vodka, cover, and let sit for 2 weeks. Keeping it at room temperature is okay, but the hooch needs to be out of direct sunlight.

After the infusing period, combine the sugar and an equal amount of water in a large pot and bring to a boil to make a simple syrup. When the sugar has dissolved, remove from the heat and set aside. Strain the infused vodka through a triple layer of cheesecloth to remove the zest. Repeat if necessary to remove all the zest. Stir in the simple syrup, bottle, and store in the freezer indefinitely. Use the limoncello to make cocktails like this one, or serve it on its own in chilled shot glasses.

To make one cocktail: Fill a martini glass with ice. Fill with water to the rim and let sit while mixing your cocktail. Add the vodka, Campari, and limoncello to a cocktail shaker or mason jar with ice and shake well. Pour out the ice water from the martini glass and strain the cocktail into the chilled glass. Garnish with a twist of lemon peel and drink with confidence.

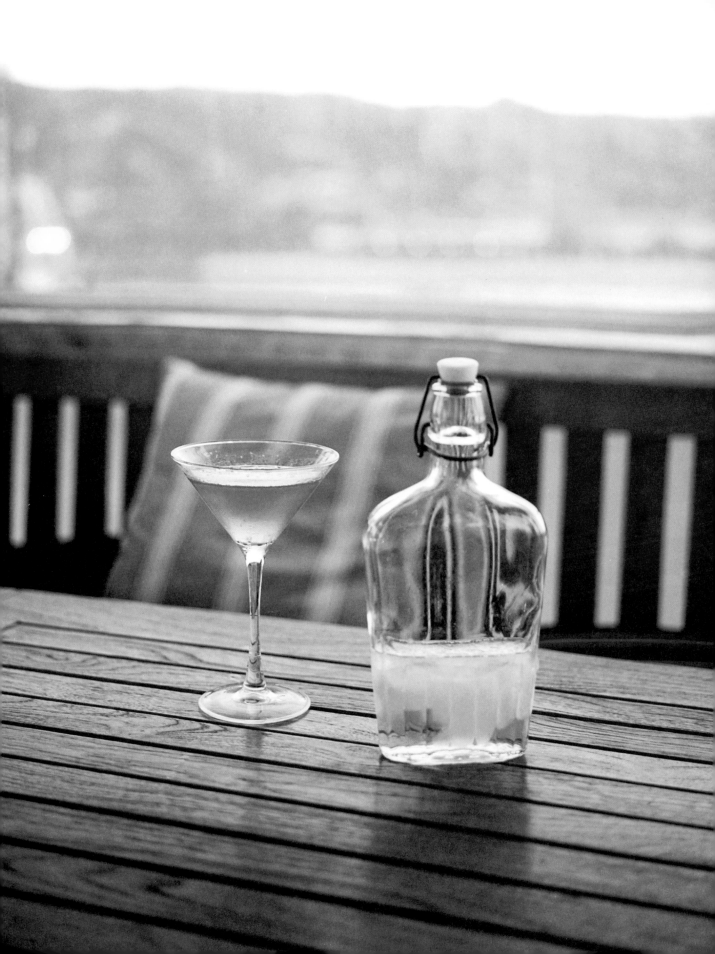

NOTES ON INGREDIENTS

We want to include a couple of notes about the ingredients used in this book. We think it's always best to support local farmers and businesses, but also know that it's not always possible. If you don't follow these guidelines, that's okay, but we personally believe you will taste the difference, and the planet will thank you for it, too.

Vegetables and fruits: Organic and washed produce.

Sugar: Organic, unrefined sugar or organic cane sugar. Substitutes can be made, but be careful if switching out dry sweeteners for wet. Be sure to hold back on other liquids in the recipe to compensate if using wet sweeteners instead of dry.

Eggs: Organic, pasture-raised eggs. These eggs are richer, contain more nutrition per egg, and are collected from humanely raised hens. This is especially important when the eggs will not be cooked, like in mayonnaise.

Grains: Always organic and non-GMO. Store in glass.

Nuts and seeds: Store in a cool, dry place. Try sprouting and dehydrating seeds in recipes for a nutritional boost.

Liquid oil: Organic and, when possible, unrefined and/or cold-pressed.

Coconut oil: Unrefined, virgin coconut oil for everything except frying savory food. Then we use filtered, refined coconut oil to impart less of a coconut flavor.

Salt: Sea salt or Himalayan pink salt are what we like to use. Fine salt for cooking and flaky for finishing dishes. Maldon sea salt is our favorite.

Honey: Always raw and unfiltered in raw applications. This is less important in cooked or baked recipes, but the taste of raw honey is far superior.

Dairy: Always full-fat, grass-fed, and pasture-raised, raw when possible. We never use nonfat, low-fat, or ultra-pasteurized dairy. If you are looking for dairy-free recipes, we encourage you to swap out dairy ingredients for substitutes like full-fat coconut milk/cream or nut-based milk/cream.

Meat: Free-range, pasture-raised/grass-fed, and organic when possible. We cannot preach this enough. If this quality of meat is not in our budget at the time, we simply don't buy it.

Fish: Local, sustainable, and/or wild-caught.

Sourdough starter: A couple of recipes call for a sourdough starter. It might sound like a lot of work, but making and maintaining a starter is actually really easy. Say good-bye to commercial yeast and hello to soaked and fermented grains, tangy loaves, and rich dough. A sourdough starter is essentially the result of fermented flour and water. Wild yeasts from the air infiltrate the flour-water slurry, turning it into an environment teeming with lactic acid and good bacteria. Bad bacteria hate this environment, and as long as you keep up with daily feedings or refrigerate/freeze your starter, it'll stay that way. Research how to get your starter going online—it's really simple. To maintain it, feed it with ¼ cup each of flour and water, dumping some of the starter out each time if you're not using it. Oh, and don't forgot to give it a name.

Interesting and unusual ingredients: You might find some ingredients you aren't familiar with in this book, like baharat spice blend, pomegranate molasses, ume plum vinegar, gomasio, ponzu, ghee, abalone, and guanciale, to name a few. These ingredients are imperative to the recipes they are in, so if you are unsure about what an ingredient is or where to find it, Google it!

ACKNOWLEDGMENTS

This book has been a true labor of love and has only been made possible thanks to the help of so many people. It's impossible to list everyone, but we've tried our hardest.

Firstly, we would like to thank everyone who backed and shared *The Tiny Mess* project on Kickstarter. You helped bring this book to life and we simply could not have done this without you.

We'd like to give a huge shout-out to every single person who invited us into their homes and cooked for us during this project. We are so inspired by you and overwhelmed by your kindness and generosity. Thank you from the bottom of our hearts.

Ethan Stewart, thank you for making our rambles and intentions sound good on paper.

Thanks, Scott Gordon (Trevor's dad), you are the best. Thank you for putting in so many hours editing photos and for getting this book ready to print. Your help has been huge.

Dick Owsiany, you have been invaluable. You made self-publishing far less daunting thanks to your knowledge, expertise, and attention to detail.

Glen and Gabe at Color Services of Santa Barbara, many thanks for scanning, organizing, and taking care of the mountains of film we've thrown your way. We highly recommend them for your photo and film needs!

Tom Adler, for your experience and advice from the get-go.

Shipping books is no easy feat, so we'd like to send a huge thank you across the pond to Keith, Elena, and Lewis Joyce, Ros and Graham Gordon, Janet Fernee, Annie Harmstone-Weller, Naomi Hemsley, and Amy Thomas for all of your physical and technical help. You are the Great British Dream Team.

Sarah Wade and Ole Kils, Leo Basica and Taiana Giefer, Erin Feinblatt and Brina Carey, Roxanne Rosensteel and Raymond Douglas, Madi Manson, Susi Gonzalez, Spencer Gordon, and Joanne Gordon, thank you for letting us trash your kitchens! You've all been immensely helpful and supportive, whether it's lending us your spaces, equipment, a helping hand, props, or advice, or simply assisting us in eating all the freaking food we've made. You are all dear to us.

Fermie Gonzalez, Mary's father and owner of the magic mountaintop that she calls home. Thank you for all of your love, support, and encouragement.

Thank you to everyone who let us crash in their driveways during this project. You kept us out of Walmart parking lots and creepy RV parks.

Hill Top and Canyon, Roots and Earthrine Farms, we are so very grateful for all of your organic produce contributions during the recipe-testing process.

Bon Apétite, *Edible Santa Barbara*, *Santa Barbara Magazine*, *Loam* magazine, *Casa Brutus* magazine, *Coastal News*, and *Stay Wild* magazine, for your kind words and support in editorials.

Thanks, Benji Wagner from Poler Stuff, for the continued support.

Finally, we'd like to thank those who have inspired us. Hugh Fearnley-Whittingstall, your food philosophy, your gastrowagon, and the deep, important connection that you have with food has encouraged us no end. Thank you for celebrating real people and real food and being consistent with your message. Gill Meller and Roger Phillips, for creating wonderful books and delicious foods that harness the wild and native ingredients at our fingertips. There needs to be more people like you. Kristy Wright, thanks for inspiring us to capture real people in real kitchens.

INDEX

A

Abalone Meatballs with Citrus
 White Wine Cream Sauce, 104
Airstream trailers, 22, 171
Amatriciana Sauce, 134
The Aurora Cocktail, 186
avocados
 Hippy Dippy, 44
 Land & Sea Breakfast Salad, 15
 Mocha Fudge Pie with Toasted
 Hazelnuts, 163
 Peach & Mint Spring Rolls with
 Honey-Peanut Dipping Sauce, 41
 Tamales Steamed in Avocado Leaves,
 124–26

B

beets
 Boat Borscht with Soft Goat Cheese &
 Fresh Dill, 92
 Pickled Eggs, 86
 Rainbow Carrots with Beet Yogurt &
 Herb Oil, 121
 Smoked Mackerel Empanadas with
 Sourdough Crust, 60–62
 Sourdough Tempura Root Vegetables
 with Ponzu Dipping Sauce, 56
Berkeley, California, 88, 139
Big Sur, California, 17
Blackberry Cadillac, 182
Blueberry & Lime Pie, 158
Bolinas, California, 26
Borscht, Boat, with Soft Goat Cheese &
 Fresh Dill, 92
Broth, 24-Hour Chicken, 108

C

cabbage
 Boat Borscht with Soft Goat Cheese &
 Fresh Dill, 92
cabins, 8, 11, 13, 29
Cactus Salad, Nopal, with Radish &
 Jalapeño, 79
Campari
 The Aurora Cocktail, 186
camper, 65
Carpinteria, California, 42, 113, 171,
 181, 184
carrots
 Carrot-Coconut Slaw with Macadamia
 & Chile Dressing, 54
 Rainbow Carrots with Beet Yogurt &
 Herb Oil, 121
 Sourdough Tempura Root Vegetables
 with Ponzu Dipping Sauce, 56
cashews
 Yerba Santa Ice Cream, 128
cave, 37

cheese
 Boat Borscht with Soft Goat Cheese &
 Fresh Dill, 92
 Kitchen Sink Quiche, 34
chicken
 Stovetop-Roasted Chicken with Pilsner
 & Sweet Potato, 143
 24-Hour Chicken Broth, 108
chocolate
 Mocha Fudge Pie with Toasted
 Hazelnuts, 163
 Rich Chocolate Jars with Mulberry-
 Chocolate Ganache, 130
Cider Vinegar, 103
cocktails
 The Aurora Cocktail, 186
 Blackberry Cadillac, 182
 Rosemary-Honey Gin & Tonic, 176
coconut
 Carrot-Coconut Slaw with Macadamia
 & Chile Dressing, 54
 Superfood Balls, 169
coffee
 Mocha Fudge Pie with Toasted
 Hazelnuts, 163
Cointreau
 Blackberry Cadillac, 182
Cookies, Honey-Persimmon Spice, 175
cottages, 33, 69, 82–83, 94

D

dates
 Mocha Fudge Pie with Toasted
 Hazelnuts, 163
 Sweet Ginger-Date Dressing, 97
dips
 Hippy Dippy, 44
Dolmas, Mallow, Filled with Fragrant
 Rice & Fresh Herbs, 70
dressings
 Macadamia & Chile Dressing, 54
 Sweet-Ginger Date Dressing, 97

E

Ebelskivers with Fruit & Yogurt, 20
eggs, 188
 Land & Sea Breakfast Salad, 15
 Pickled Eggs, 86
Empanadas, Smoked Mackerel, with
 Sourdough Crust, 60–62

F

fish, 188
 Marinade for Low-in-the-Food-Chain
 Underrated Sustainable Fish, 59
 Smoked Mackerel Empanadas with
 Sourdough Crust, 60–62
float house, 147

fruits, 188
 Ebelskivers with Fruit & Yogurt, 20
 Stovetop Skillet Granola, 24
 Superfood Balls, 169
 See also individual fruits

G

Gaviota, California, 37
Gin & Tonic, Rosemary-Honey, 176
Ginger-Date Dressing, Sweet, 97
grains, 188
 Stovetop Skillet Granola, 24
Grand Marnier
 Blackberry Cadillac, 182
Granola, Stovetop Skillet, 24
greens
 Kitchen Sink Quiche, 34
 Peach & Mint Spring Rolls with
 Honey-Peanut Dipping Sauce, 41
guanciale
 Amatriciana Sauce, 134

H

Hazelnuts, Toasted, Mocha Fudge Pie
 with, 163
Hippy Dippy, 44
honey, 188
 Honey-Persimmon Spice Cookies, 175
 Peach & Mint Spring Rolls with
 Honey-Peanut Dipping Sauce, 41
 Rosemary-Honey Gin and Tonic, 176

I

Ice Cream, Yerba Santa, 128

J

Jam, Tomato, 103

K

Kitchen Sink Quiche, 34

L

Lamb, Marinated, Cooked on Coals, 148
Land & Sea Breakfast Salad, 15
lemons
 The Aurora Cocktail, 186
 Limoncello, 186
lettuce
 Land & Sea Breakfast Salad, 15
limes
 Blackberry Cadillac, 182
 Blueberry & Lime Pie, 158
Lopez Island, Washington, 151
Marinade for Low-in-the-Food-Chain
 Underrated Sustainable Fish, 59

M

Macadamia & Chile Dressing, Carrot-
 Coconut Slaw with, 54

Mackerel Empanadas, Smoked, with
 Sourdough Crust, 60-62
mallow, 72
 Mallow Dolmas Filled with Fragrant
 Rice & Fresh Herbs, 70
Marinade for Low-in-the-Food-Chain
 Underrated Sustainable Fish, 59
Marin County, California, 144
masa harina
 Tamales Steamed in Avocado Leaves,
 124-26
Mayonnaise, Stinging Nettle, 53
Meatballs, Abalone, with Citrus-White
 Wine Cream Sauce, 104
Mill Valley, California, 33
Mocha Fudge Pie with Toasted
 Hazelnuts, 163
Montauk, New York, 111
Mulberry-Chocolate Ganache, Rich
 Chocolate Jars with, 130
mushrooms
 Tamales Steamed in Avocado Leaves,
 124-26

N

Nopal Cactus Salad with Radish &
 Jalapeño, 79
nuts, 188
 Stovetop Skillet Granola, 24
 Superfood Balls, 169
 See also individual nuts

O

Oakland, California, 132
Orcas Island, Washington, 8
outdoor kitchen, 171

P

Pancakes, Sourdough, 67
pasta and noodles
 Abalone Meatballs with Citrus-White
 Wine Cream Sauce, 104
 Amatriciana Sauce, 134
 Fresh Pasta, 156
 Peach & Mint Spring Rolls with
 Honey-Peanut Dipping Sauce, 41
Peach & Mint Spring Rolls with Honey-
 Peanut Dipping Sauce, 41
pecans
 Mocha Fudge Pie with Toasted
 Hazelnuts, 163
 Superfood Balls, 169
Peppers, Smoky Dried, Slow-Stewed
 Rabbit Tacos with Red Wine,
 Molasses &, 80
Persimmon Spice Cookies, Honey-, 175
pies
 Blueberry & Lime Pie, 158
 Mocha Fudge Pie with Toasted
 Hazelnuts, 163
Poke, Watermelon, 118

Potatoes, Overnight Vinegar, 85
powerboat, 184

Q

Quiche, Kitchen Sink, 34

R

Rabbit, Slow-Stewed Tacos, with Red
 Wine, Molasses & Smoky Dried
 Peppers, 80
radishes
 Land & Sea Breakfast Salad, 15
 Nopal Cactus Salad with Radish &
 Jalapeño, 79
railcar, 166
Roseburg, Oregon, 82
Rosemary-Honey Gin and Tonic, 176

S

sailboats, 30-31, 47, 49-51, 88, 91, 106-07,
 132, 139-40, 160-61
salads
 Carrot-Coconut Slaw with Macadamia
 & Chie Dressing, 54
 Land & Sea Breakfast Salad, 15
 Nopal Cactus Salad with Radish &
 Jalapeño, 79
salt, 188
San Francisco, California, 27, 30
Santa Barbara, California, 47, 69, 94,
 106, 166
Santa Cruz, California, 100
school buses, 74, 77, 151, 153
Seattle, Washington, 22
seeds, 188
 Hippy Dippy, 44
 Stovetop Skillet Granola, 24
 Superfood Balls, 169
Skamania County, Washington, 74
Slaw, Carrot-Coconut, with Macadamia &
 Chile Dressing, 54
soups
 Boat Borscht with Soft Goat Cheese &
 Fresh Dill, 92
 Wild Weed Soup, 122
sourdough
 Smoked Mackerel Empanadas with
 Sourdough Crust, 60-62
 Sourdough Pancakes, 67
 Sourdough Tempura Root Vegetables
 with Ponzu Dipping Sauce, 56
 starter, 188
Spring Rolls, Peach & Mint, with Honey-
 Peanut Dipping Sauce, 41
Stinging Nettle Mayonnaise, 53
sugar, 188
Superfood Balls, 169
sweet potatoes
 Sourdough Tempura Root Vegetables
 with Ponzu Dipping Sauce, 56
 Stovetop-Roasted Chicken with Pilsner
 & Sweet Potato, 143

T

tacos
 Slow-Stewed Rabbit Tacos with Red
 Wine, Molasses & Smoky Dried
 Peppers, 80
Tamales Steamed in Avocado Leaves,
 124-26
Tempura Root Vegetables, Sourdough,
 with Ponzu Dipping Sauce, 56
tequila
 Blackberry Cadillac, 182
tomatoes
 Amatriciana Sauce, 134
 Mallow Dolmas Filled with Fragrant
 Rice and Fresh Herbs, 70
 Tomato Jam, 103
tortillas
 Slow-Stewed Rabbit Tacos with Red
 Wine, Molasses & Smoky Dried
 Peppers, 80
trailers, 42, 100-101, 113, 115-17, 160,
 161, 181. *See also* Airstream trailers
treehouses, 98
Truckee, California, 29

V

van, 137
Vancouver Island, British Columbia, 147
vegetables, 188
 Kitchen Sink Quiche, 34
 Sourdough Tempura Root Vegetables
 with Ponzu Dipping Sauce, 56
 See also individual vegetables
Ventura, California, 160
Vinegar, Cider, 103
vodka
 The Aurora Cocktail, 186

W

Watermelon Poke, 118
water tower, 17
Weed Soup, Wild, 122
wild rice
 Mallow Dolmas Filled with Fragrant
 Rice & Fresh Herbs, 70

Y

Yerba Santa Ice Cream, 128
yogurt
 Ebelskivers with Fruit & Yogurt, 20
 Marinated Lamb Cooked on Coals, 148
 Rainbow Carrots with Beet Yogurt &
 Herb Oil, 121
 Rich Chocolate Jars with Mulberry-
 Chocolate Ganache, 130

Published in the United States by Ten Speed Press,
an imprint of the Crown Publishing Group, a division
of Penguin Random House LLC, New York.
www.crownpublishing.com
www.tenspeed.com

Ten Speed Press and the Ten Speed Press colophon are registered
trademarks of Penguin Random House LLC.

Originally published in the United States by
The Tiny Mess, Santa Barbara, California, in 2017
@the_tiny_mess

Library of Congress Cataloging-in-Publication Data is on file with the publisher.

Hardcover ISBN: 978-0-399-58273-8
eBook ISBN: 978-0-399-58274-5

Printed in China

Photography, illustrations, and interior design by Trevor Gordon
Jacket Design by Emma Campion

10 9 8 7 6 5 4 3 2 1

First Ten Speed Press Edition

CONTRIBUTOR INFO

Brooke & Emmet
www.landseagomasio.com

Tyson
www.zombiesinbigsur.blogspot.com

Carie
www.londonmeier.com

Marie & Dean
@minoperez

Jessie & Hannah
@sleepingwillowfarm

Quincey & Mitchell
@thetinygalleyslave

Sierra & Colin
www.santacruzwoodworks.net
@santacruz_woodworks

Monique
@lovechildinthewild

Sonya & Jack
www.twothehorizon.com
@twothehorizon

Jeremy & Sarah
www.jeremykoreski.com
@jeremykoreski

Lindsey & Zach
@lindseydancing

Serena & Jacob
www.genesisearthling.com
@jivesurf

Zachary
www.zacharayallenthompson.com
@zatcharyallen